MUST BE ABLE TO STRIKE TERROR INTO THEIR HEARTS. I MUST

BE A CREATURE OF THE NIGHT,

# "BAT-[

## THE COMPLETE HISTORY

by LES DANIELS

Art Direction
and Design by
CHIP KIDD

N THE STUDY OF DOCTOR
LATER TO BE MORE WIDEL
DOCTOR DEATH!

CHRONICLE BOOKS
SAN FRANCISCO

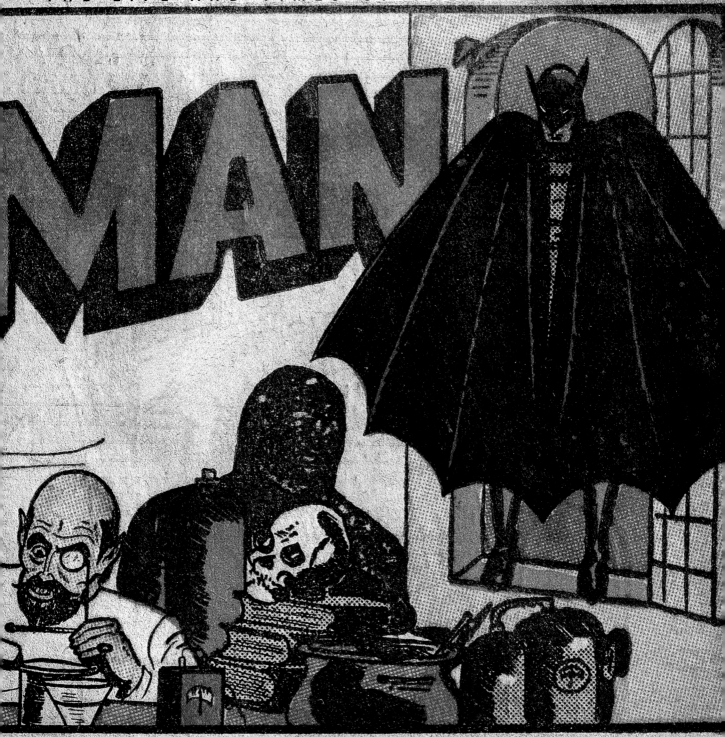

RL HELLFERN,
KNOWN AS

JABAH, I HAVE AT LAST
COMPLETED ALL MY LABORATORY
EXPERIMENTS. MY DEATH BY POLLEN
EXTRACT IS DEFINITE. I AM READY TO

CONFIDENTIAL **OFFICIAL**

# BATMAN

## THE COMPLETE HISTORY

PHOTOGRAPHS BY GEOFF SPEAR • DESIGN ASSISTANCE BY CHIN-YEE LAI

ISBN-10: 0-8118-4232-0  ISBN-13: 978-0-8118-4232-7
The Library of Congress has cataloged the previous edition as follows:

Daniels, Les. 1943-
Batman : the complete history / Les Daniels.
p.    cm.
Includes index.

1. Batman (Fictitious character) in mass media—History. I. Title.
P96.B37D36 1999                                          700'.451—dc21
98-32409                                                              CIP

ISBN 0-8118-2470-5 (hc)

Manufactured in China

Distributed in Canada by Raincoast Books
9050 Shaughnessy Street
Vancouver, British Columbia V6P 6E3

10 9 8 7 6 5 4

Visit DC Comics online at keyword DCComics on America Online or at http://www.dccomics.com

Chronicle Books
680 Second Street
San Francisco, California 94107

www.chroniclebooks.com

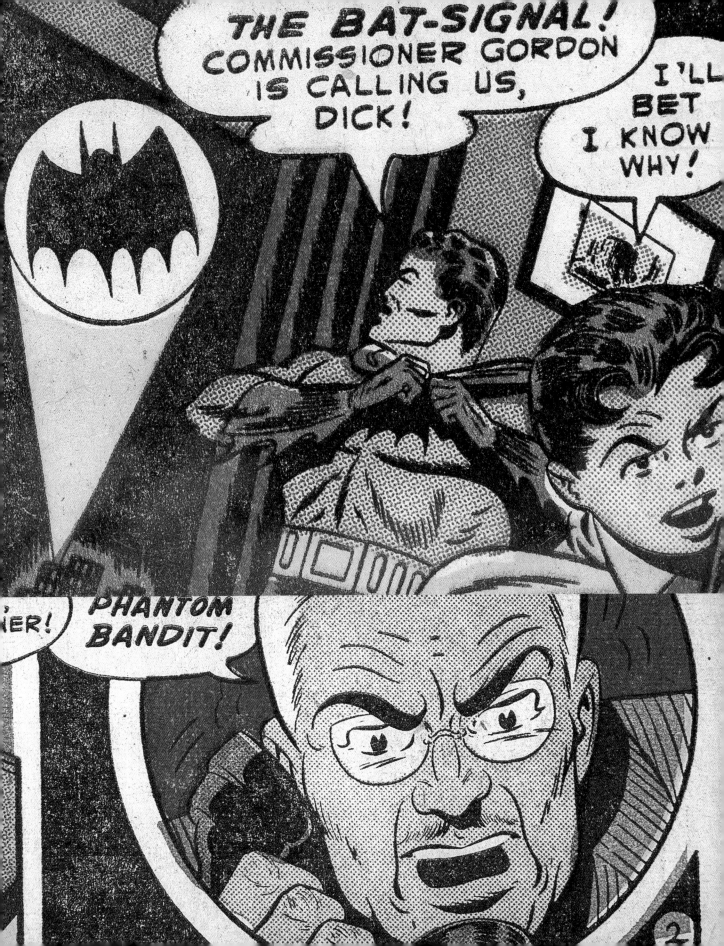

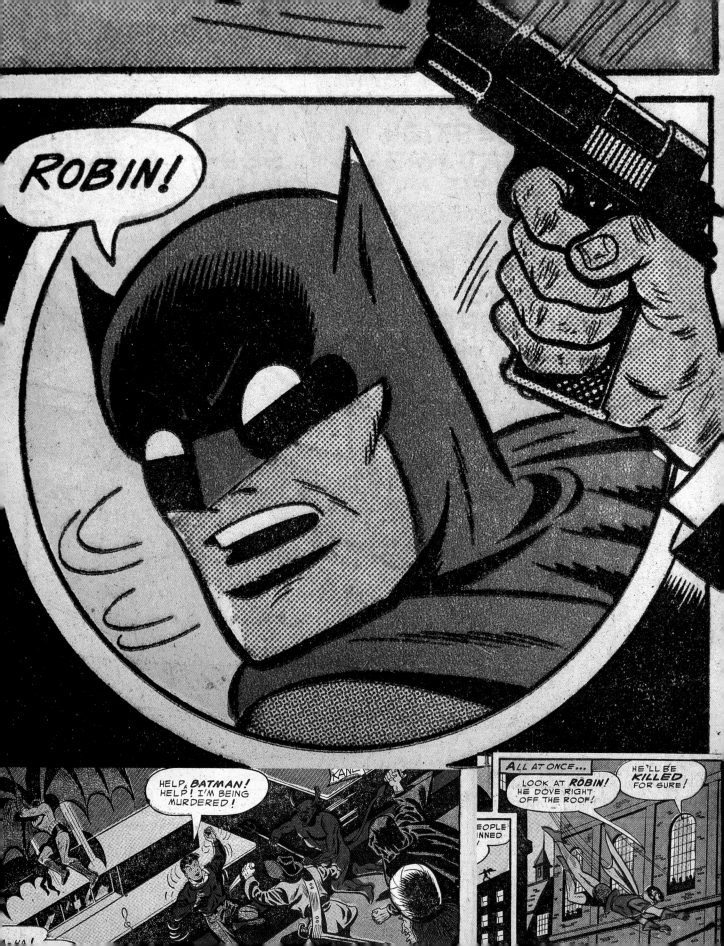

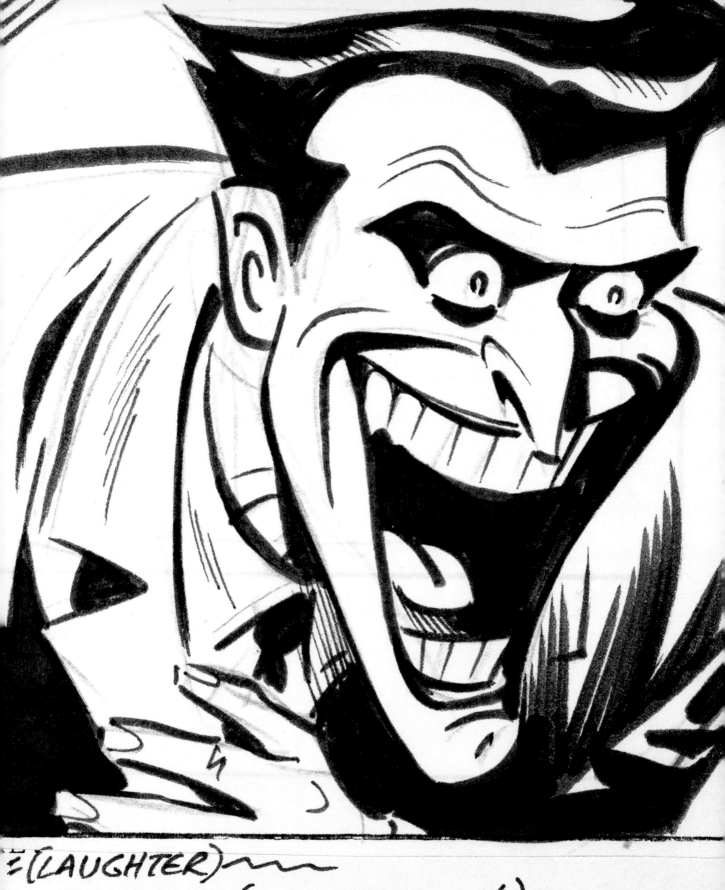

# SHADOWS

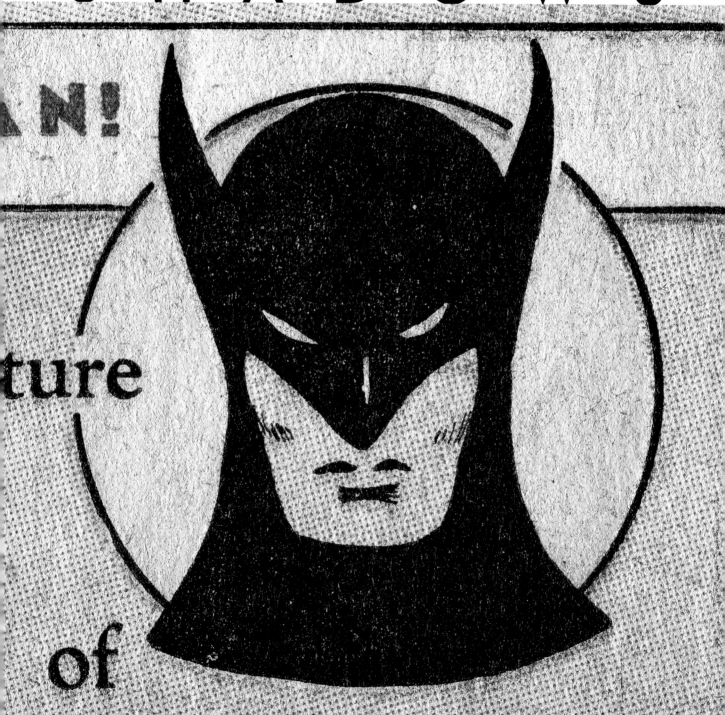

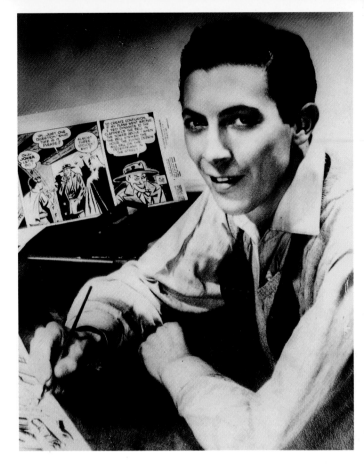

Batman came out of the darkness, out of the collective unconscious where visions of avenging angels dwell, but he also came out of the shadows cast by imaginary heroes who had gone before. A compelling synthesis of several figures lurking in the dark corners of popular culture, Batman would eventually outrun all of his inspirations to become an instantly recognizable icon, one of the most widely known fictional characters ever created. Alternately presented as redeemer, clown, and demon, Batman has transcended any simplistic explanation of his appeal, but the key to his success may lie in the very variety of the roles he has played. "Maybe every ten years Batman has to go through an evolution to keep up with the times," suggested Bob Kane, the artist who originated the hero. "I *am* Batman," Kane once proclaimed, yet many other artists, writers, editors, and actors have found something in the Caped Crusader that they could call their own, and so has an audience of untold millions that has developed over the past sixty years.

Born Robert Kahn in 1916, Bob Kane was the son of an engraver for the New York *Daily News*. His father regularly brought home the color comics sections and encouraged his son's ambition to be a cartoonist. A self-proclaimed "copycat," Kane taught himself to draw by imitating newspaper strips, and was creating ads for neighborhood merchants while still in high school. He worked briefly on Betty Boop cartoons for the Max Fleischer studios but devoted most of his efforts to the fledgling comic book industry. The first of these new ten-cent magazines reprinted old newspaper material, but experimentation and economics eventually brought new talent into the field. Kane tried his hand at everything from "Peter Pupp" to "Ginger Snap" (his first love was humor), then began to drift toward more serious stories. He sold "Rusty and His Pals" to

*Adventure Comics* in 1938 and "Clip Carson" to *Action Comics* in 1939. Both strips were written by Bill Finger, two years Kane's senior, and also a graduate of DeWitt Clinton High School in the Bronx. After an initial encounter at a party, the pair met at Edgar Allan Poe Park and decided to collaborate on comics.

Born in Denver, Bill Finger had hoped to be an artist, but his parents expected him to become a doctor. The financial crunch of the Depression had put an end to their ambitions, however, and Finger was working as a shoe salesman. A long childhood illness had encouraged him to become a voracious reader, and it was as a writer that he would finally make his mark. However, his work always retained a strong visual element, and artists who worked on his scripts considered him the best comic book writer of his generation. Finger was certainly the dreamer of the team, while

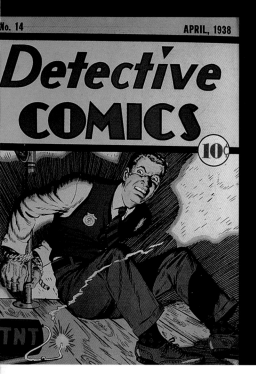

No. 14     **APRIL, 1938**

*Detective* COMICS 10¢

TNT

The company that would become Batman's publisher got its start in 1935 as National Allied Publishing. Major Malcolm Wheeler-Nicholson, a pulp writer and former army officer, observed how successful comic books were in reprinting old newspaper strips, and decided to get in on the ground floor of the new business. Lacking the capital to purchase established properties, he was obliged to print original comics in his periodicals *New Fun* and *New Comics*. With his distributor, Harry Donenfeld, the major formed a new corporation named for a third publication, *Detective Comics*. The major's artists and writers were beginners working for low rates, people like Jerry Siegel and Joe Shuster, the creators of Superman. Unfortunately that character didn't show up fast enough for Wheeler-Nicholson, who went bankrupt in 1938, and left the field owing money to young artists like Bob Kane.

Donenfeld bought up his former partner's interest in Detective Comics, Inc., while a business associate, Jack Liebowitz, acquired the rights to National. Another of their interests was the Independent News Company, which Liebowitz called "the largest distributor of magazines and paperbacks" in the United States. Donenfeld also had a hand in pulp magazines through the ironically named Culture Publications, home to such sexually suggestive pulps as *Spicy Detective*. Such salacious material became secondary when Superman appeared in a new title, *Action Comics*, in June 1938. It sold better than the pulps, and Batman's success in *Detective Comics* confirmed the conviction that comics were the coming thing. A circular "DC" bullet was appearing on the company's covers by 1940, and fans have known the company by that name ever since.

Kane was the go-getter who had a head for business.

Vin Sullivan was an editor at DC Comics, publisher of both *Adventure Comics* and *Action Comics*. The company's most successful character was Superman, who became the lead feature in *Action* after his debut in 1938. Created by writer Jerry Siegel and artist Joe Shuster, Superman was an alien with amazing powers who battled oppression on his adopted planet, Earth. Dressed in Technicolor tights and a flowing cape, Superman had captured the imaginations of American kids, and Sullivan was looking for something similar for DC's *Detective Comics*. He said as much to Bob Kane, who credits Sullivan's suggestion with being "instrumental" in the creation of Batman. Kane returned to DC's Manhattan offices in a few days with some sketches, and shortly after getting Sullivan's okay he showed up with a complete story. "It started with an idea that he suggested," Sullivan recalled. "Then he

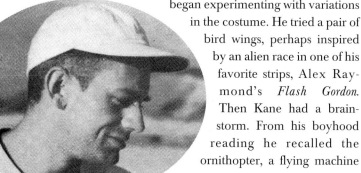

came back with pages of this new character. And it looked pretty good to me, too. It seemed like an interesting character. I don't think anybody realized that it would develop into what it has become today. In fact, I'm sure they didn't."

What Sullivan missed was the process in which first Bob Kane and then Bill Finger ransacked their memories for ideas from the past that they could incorporate into a comic book hero. When Kane sat down at his drawing board in the Bronx, he immediately sketched in a figure similar to Superman's, complete with the tights and trunks that he instinctively seemed to feel were mandatory. Then he overlaid a piece of tracing paper and began experimenting with variations in the costume. He tried a pair of bird wings, perhaps inspired by an alien race in one of his favorite strips, Alex Raymond's *Flash Gordon*. Then Kane had a brainstorm. From his boyhood reading he recalled the ornithopter, a flying machine

Above: Creig Flessel depicted a typically tense situation on this pre-Batman cover for *Detective Comics* #14 (April 1938).

Bill Finger, Batman's original writer.

Right: Kane and Finger created Clip Carson, a typical hero from the days before costumed characters took flight, for *Action Comics* in 1939.

# THE FIRST BATMAN?

Cover by H. J. Ward.

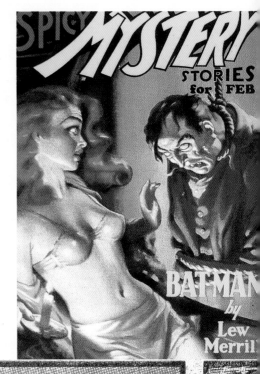

Over a year before the first issue of *Detective Comics,* and over three years before Batman appeared in its pages, the hero's future publisher, Harry Donenfeld, unleashed another character called Batman upon an unsuspecting world. The venue was the February 1936 issue of the notorious *Spicy Mystery Stories,* home to torture, terror, and half-naked women. Writing under the pen name Lew Merrill, prolific writer Victor Rousseau Emmanuel contributed a twelve-page tale that he called simply "Batman." It's a story that asks its heroine this pressing question: "Why should she have wanted to hide her lovely body from a bat, even though it had a human brain?"

This is the narrative of one John Charters, doomed to suffer from a split personality after his rival Roger Dean "operated on me in the hospital, removed my brain, and placed it in the skull of a bat." This is quite a stunt even for the small-minded *Spicy Mystery Stories,* but like so many of the ghastly situations in the magazine, it turns out to be a fake. Charters is suffering from delusions, a side effect from blowing out part of his brain when he suspects an affair between his sweetheart and the dreaded Dr. Dean. Charters suddenly recovers his senses as the story ends, but the reader may have a harder time, especially after scenes in which the hero alternates between snuggling up to a female bat and climbing into windows to ogle sleeping women. He even finds a victim with apparently hyperactive breasts, "one of which drooped slightly against her arm, while the other pointed invitingly toward me." With its klutzy prose and crazy premise, this "Batman" could never have launched a modern myth, but in its own way it's unforgettable.

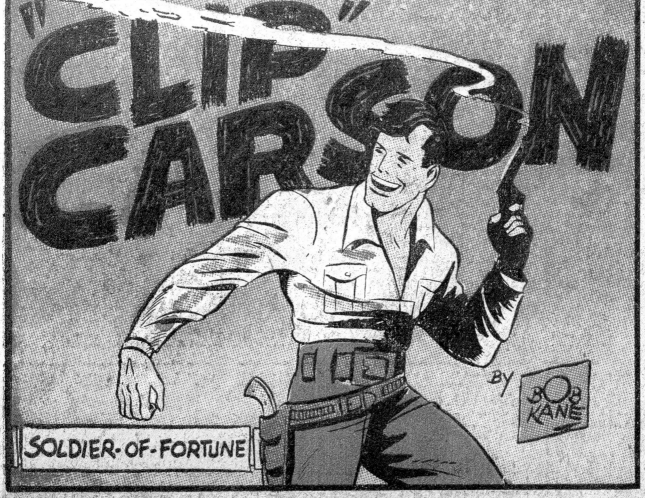

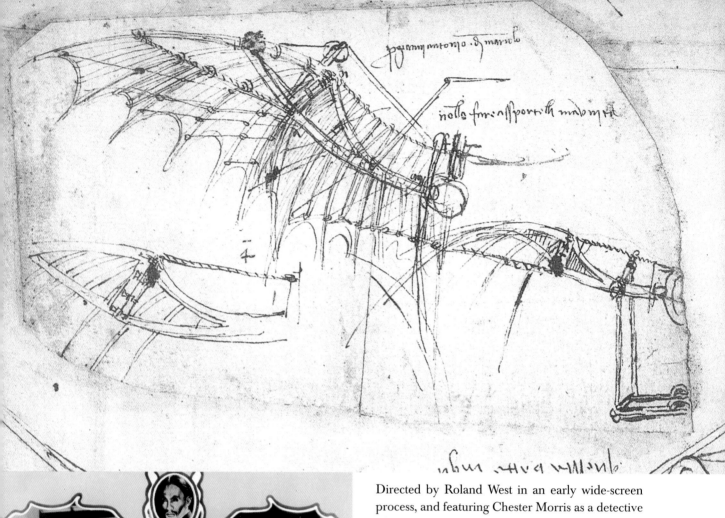

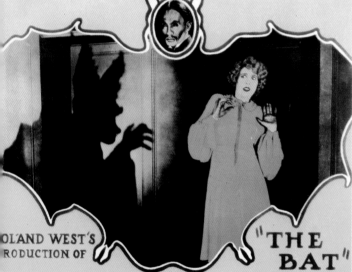

"THE BAT"

Directed by Roland West in an early wide-screen process, and featuring Chester Morris as a detective who is secretly a costumed killer known as the Bat, the film was an adaptation of a classic thriller whose influence is still being felt today.

The character of the Bat was the creation of Mary Roberts Rinehart, who was one of the most successful mystery writers of her time. Her best-seller *The Circular Staircase* (1908) was turned into a smash Broadway play by Rinehart and Avery Hopwood in 1920 under the title *The Bat*. The play was filmed under its own title in 1926 and 1958, in addition to the 1930 version. It also inspired innumerable similar plays about fiends in animal guise, including John Willard's *The Cat and the Canary* (filmed in 1927, 1930, 1939, and 1979), and Ralph Spence's *The Gorilla* (filmed in 1927, 1931, and 1939). The formula of shadows, thunderstorms, and masked men still influences horror films today, but Kane's inspiration lay in using this ambience to create the background for a slightly sinister good guy.

designed by Leonardo da Vinci. This device was essentially a glider, with wings built like those of a bat, and it sent Kane off in the right direction. By process of association, he was also reminded of one of his favorite films, *The Bat Whispers* (1930).

Above: In the silent film version of *The Bat* (1926), Louise Fazenda is menaced by a shadow suspiciously similar to a future Batman villain, Man-Bat.

A third source of inspiration for Kane came from a movie he'd seen as a boy: *The Mark of Zorro* (1920). This film featured an athletic, flamboyant performance by Douglas Fairbanks, which turned him into the biggest action star of the silent screen; the story, about a wealthy fop who transformed himself at night into a masked crusader for justice in Old California, stuck with young Kane. Even such details as the hero entering his hideout through an old grandfather clock were carried over from the film. "It left a lasting impression on me. Later, when I created the Batman, it gave me the dual identity," said Kane. "You're influenced at one point by another character, but then you embellish and bring your own individuality into it."

At this point Kane had designed a hero with a black mask like Zorro's, stiff black wings like Leonardo's ornithopter, and red tights reminiscent of Superman's. He then called in Bill Finger for advice. With the reliance on visual references that would characterize his work from then on, Finger reached for a dictionary, found a picture of a bat, and called attention to its ears. Kane's simple mask was transformed into a black cowl with the distinctive points that were echoed in the wings and (eventually) in the design of the gloves that Finger suggested. The repetition of this triangular motif made for an immediately memorable image and may have helped to account for Batman's success. "Almost every famous character ever created had a kind of simplistic, definitive design that was easily recognizable, and that's what I

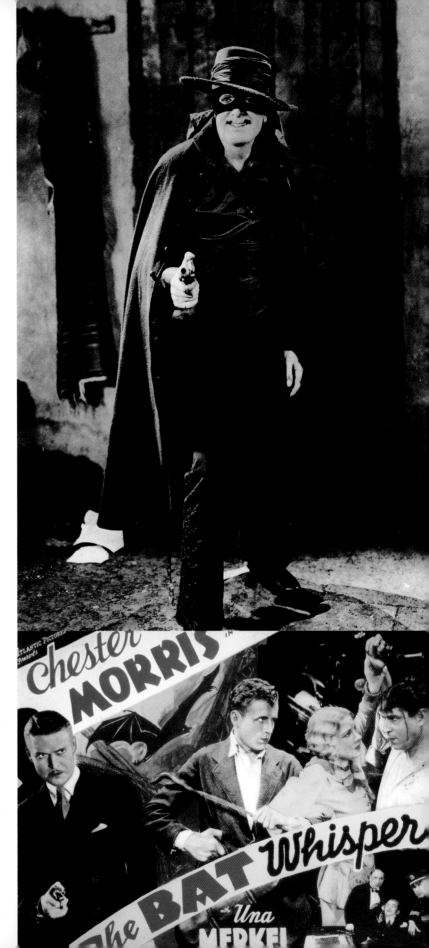

Top: As a masked man with a secret identity, the acrobatic Douglas Fairbanks made his mark on Batman with *The Mark of Zorro* (1920).

Right: With its forced perspectives, miniature sets, and bizarre camera angles, *The Bat Whispers* influenced Batman's visuals as well as the hero's costume.

CHESTER MORRIS

THE BAT WHISPERS

Una MERKEL

The night-prowling Shadow, an influence on Batman, was up in the air on the cover of his December 15, 1937, pulp magazine, painted by George Jerome Rozen.

was striving for with Batman," Kane recalled.

Finger had ideas for Kane about the ungainly appendages protruding from the hero's shoulders. "I didn't like the wings," Finger said, "so I suggested he make a cape and scallop the edges so it would flow out behind him when he ran and would look like bat wings." Finger also objected to the way the eyes behind the mask appeared and urged Kane to turn them into simple white spots. "It looked more like a bat at night when the eyes glow," conceded Kane. Finger later acknowledged the influence of the Phantom, introduced to newspaper readers in 1936 by Lee Falk and Ray Moore. The Phantom

wore a black mask that revealed no visible eyeballs, and he also sported a cowl and tights combination that was tinted purplish gray. Finger suggested that Batman's costume be changed from red to gray. The cowl and cloak remained black, but since comics conventions demand that black objects be highlighted in blue, Batman's uniform in effect became blue and gray.

This was the figure of Batman that was presented for editor Vin Sullivan's approval, which it promptly received. "I thought it was something that would pep up the magazines," he said, but someone still had to turn the image into an idea. "When I created the Batman," admitted Bob Kane, "I wasn't thinking of story. I was thinking, I have to come up with a character who's different," and as an artist he was clearly more concerned with pictures than plot. Finger, however, was a born story man, blessed with enough pictorial sense to realize what would work in comics. He also had a good working knowledge of lurid literature past and present. While Kane's main sources for Batman were two movies and a blueprint, Finger saw the character as a combination of Alexandre Dumas's swashbuckler D'Artagnan from *The Three Musketeers* (1844) and Sir Arthur Conan Doyle's detective Sherlock Holmes, who first appeared in 1887.

Finger's interests went beyond nineteenth-century classics to include contemporary pulp magazines. The pulps are history today, but in the first half of the twentieth century these inexpensive magazines had big audiences and a substantial influence on American culture. Although the pulps were predominantly prose, their covers featured richly rendered paintings that inspired many a comic book artist. The fiction they printed

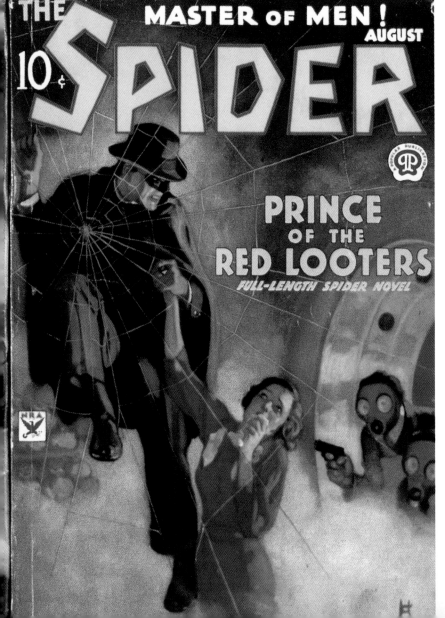

The Spider fends off a gas attack, perhaps an obsession of the pulp era because of World War I atrocities. Cover by John Newton Howitt.

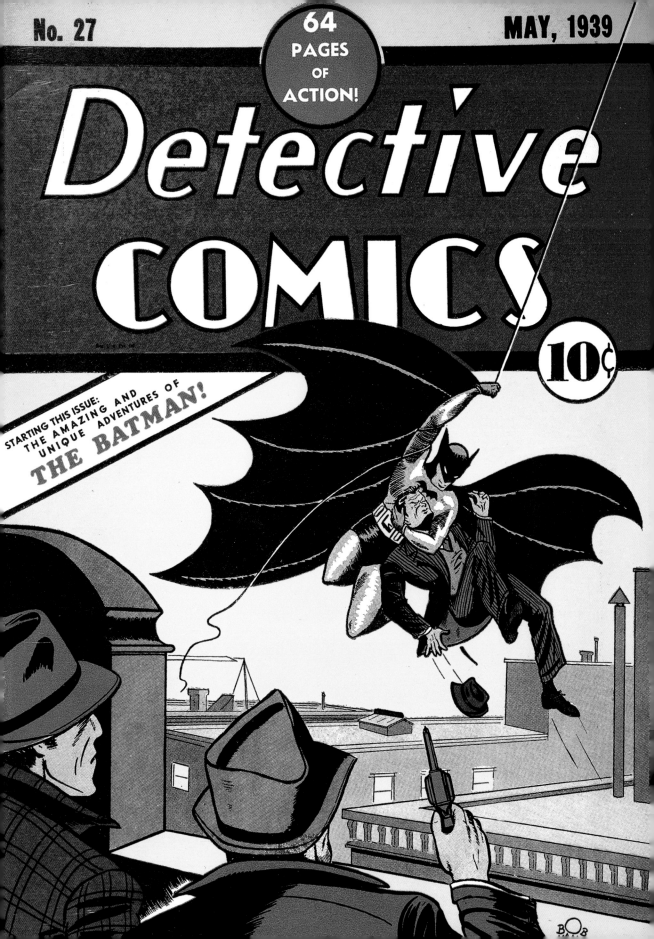

Some of Bob Kane's early design for a winged hero was still in evidence on the cover when Batman made his first appearance, in *Detective Comics #27* (May 1939).

embraced genres from romance to horror, but they are most often remembered for the array of fanciful heroes they introduced. Even Zorro got his start in the pulps, when Johnston McCulley's novel *The Curse of Capistrano* began serialization in the August 9, 1919, issue of *All-Story Weekly,* the same magazine that had introduced Tarzan.

"Batman was written originally in the style of the pulps," said Bill Finger, and the pulp character most often cited as Batman's predecessor is the Shadow, who appeared in his own magazine from 1931 to 1949. Clad in a black cloak and a wide-brimmed hat, the Shadow was a take-no-prisoners crime fighter who frequently arrived with guns blazing, and his secret identity was so secret that readers could never quite figure it out. His adventures were written by Walter Gibson under the guise of Maxwell Grant (publishers liked pseudonyms, since they created a sense of continuity even if the author was replaced). Bob Kane preferred the very different radio version of the Shadow: a wealthy playboy named Lamont Cranston who had the hypnotic power "to cloud men's minds" so they couldn't see him.

The popularity of *The Shadow* paved the way for a rash of similar magazines about mystery men, many of whom added a mask to their basic black costumes. The Phantom Detective loomed into view in 1933, another rich idler who was a master of disguise. This hero had a secret crime lab and could be summoned by a flashing red light atop a tower. However, he couldn't hold on to a writer, and it took several scribes to craft his career under the alias Robert Wallace. The Spider came along later the same year. Named for a creepy creature like a bat, he nonetheless wore the usual drab costume of the nocturnal pulp hero, and any webs he wove were strictly metaphorical. Probably the most cold-blooded of his breed, the Spider left his emblem emblazoned on the bodies of the crooks he killed. Norvell Page chronicled most of this masked man's exploits under the name Grant Stockbridge.

Well-known characters like the Shadow, the Spider, and the Phantom Detective helped provide springboards for Batman's storylines, but the pulp magazines also produced several less notable figures who were bats themselves. Most were probably inspired by the Bat of stage and screen, and there's no way of knowing now if Finger had seen any of them. One of the earliest appeared in *Black Bat Detective Mysteries,* a minor magazine that

Perhaps the Black Bat, a noncostumed detective featured in this October 1933 issue, knows what the chauffeur saw.

The Bat made his pulp debut in November 1934 with both guns blazing; one shot gas, and the other shot boring old bullets.

The second pulp character called the Black Bat was near the end of his long career when this cover by Paul Orban appeared in Winter 1951.

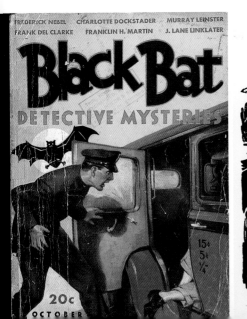

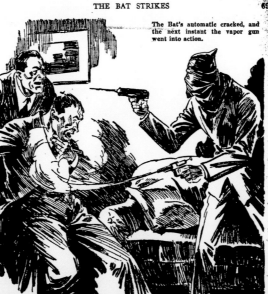

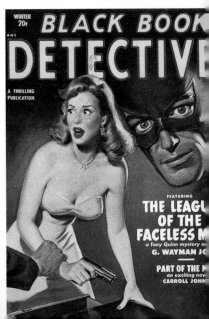

Below, far left: Doctor Death, the first recurring villain of the series, showed up on Bob Kane's cover for *Detective Comics #29* (July 1939).

Below, center panels: Early issues like *Detective Comics #29* emphasized that Batman was not invulnerable, but nonetheless he had gas.

included a mixture of mystery stories. The publication's title was evidently only an attempt to create some spooky atmosphere, but a few issues starting in 1933 featured a nondescript detective known for no apparent reason as the Black Bat. Will F. Jenkins told the tales under the name Murray Leinster.

More interesting was the Bat, a character who showed up in the first issue of *Popular Detective* (November 1934). He was Dawson Clade, a reporter framed for murder by crooks he was about to expose. As the Bat, Clade wore a black hood with a white bat on the forehead. His weapon of choice was a gas gun (later popularized by the masked radio hero the Green Hornet), and he had the habit of using luminous paint or even a rubber stamp to leave the bat emblem behind him as "a warning and a threat to all the minions of crimedom." In a scene that will seem surprisingly familiar to Batman fans, Clade sat brooding over plans for a new identity when a bat flew in the window and startled him. "That's it," he cried, as he experienced an epiphany and established his alter ego. Although the handful of tales about the Bat were credited to the pen name C. K. M. Scanlon, several pulp experts suspect, on the basis of prose style, that the actual author was no less than Johnston McCulley, creator of Zorro. The editor of *Popular Detective* was Jack Schiff, who would later serve as Batman's editor.

Better Publications, the company behind *Popular Detective*, took another turn at bat in July 1939, when their magazine *Black Book Detective* published the first story about their character the Black Bat (not to be confused with the 1933 Black Bat). Created by Norman Daniels under the name G. Wayman Jones, the Black Bat was Tony Quinn, a district attorney who worked behind a black mask after a thug's acid attack left him scarred and seemingly blind. With his ribbed and scalloped cape he looked so much like Batman that Bill Finger later recalled, "They were ready to sue us and we were ready to sue them. It was just one of those wild coincidences." Cooler heads prevailed, however, and Batman and the Black Bat maintained a wary coexistence until the latter folded his wings after appearing in more than sixty stories.

Batman made his debut in *Detective Comics #27* (May 1939), in a six-page story called "The Case of the Chemical Syndicate," which Bill Finger admitted was inspired by a Shadow story. It was a typical pulp murder mystery, but with all the excess verbiage removed (pulp writers were paid by the word, and it usually showed). Bob Kane's art was crammed into as many as eleven panels per page,

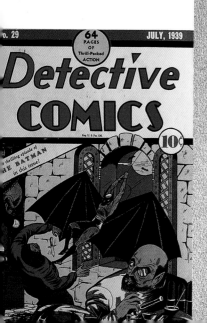

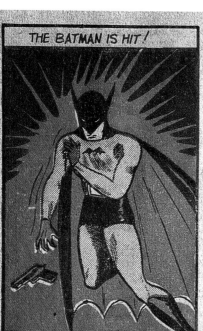

Below, far right: Batman sports a rare grin in one of his earlier grim adventures. Art by Bob Kane for *Detective Comics* #36 (February 1940).

and his style was still somewhat hesitant. "Of course the first sketches were very crude, but my drawing developed. Within six issues I elongated [Batman's] jaw, and I made the ears longer," said Kane. "I really improved fast. About a year later he was almost the full figure, my mature Batman."

"He can't stop bullets, you know," Bill Finger said of Batman, and that particular difference between Batman and Superman was demonstrated during "The Batman Meets Doctor Death," in *Detective Comics* #29 ( July 1939). "Your choice, gentlemen! Tell me! Or I'll kill you," Batman threatens a couple of thugs, and seconds later the Caped Crusader gets shot. This third Batman story also introduced the series' first recurring villain (apparently killed in a fire, Doctor Death returned horribly burned in the next issue), and the hero's famous utility belt full of crime-stopping gimmicks. The script for this story has been attributed to Finger, but authorship was claimed years later by Gardner Fox, who

is always acknowledged to have written the fifth and sixth Batman tales.

Fox would later script such characters as the Flash, Hawkman, Sandman, Dr. Fate, and the Justice Society of America, and his undisputed contributions to *Detective Comics* #31 and #32 also included some significant events. Batman was provided with a fiancée, Julie Madison (although she was soon forgotten), and with two new weapons. One was a stylized helicopter, "my Batgyro," as Batman put it, and the other was "the flying Bat-erang, modeled after the Australian bushman's boomerang." So Fox seems to have started the concept of Batman's ever expanding arsenal, and he also set Batman against the supernatural in this

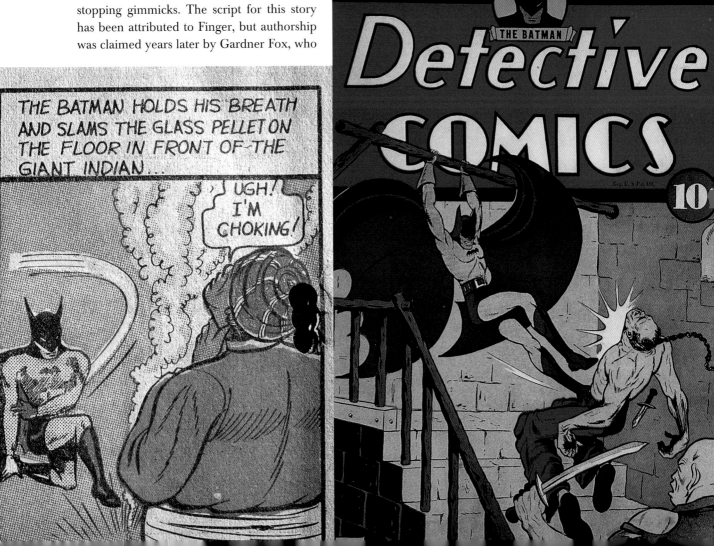

THE BATMAN HOLDS HIS BREATH AND SLAMS THE GLASS PELLET ON THE FLOOR IN FRONT OF THE GIANT INDIAN...

UGH! I'M CHOKING!

No. 36    FEBRUARY, 19

THE BATMAN

Detective COMICS

10

DID YOU GET THE PAPER?

YEAH!

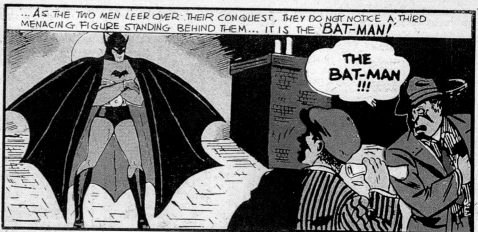

...AS THE TWO MEN LEER OVER THEIR CONQUEST, THEY DO NOT NOTICE A THIRD MENACING FIGURE STANDING BEHIND THEM... IT IS THE 'BAT-MAN!'

THE BAT-MAN!!!

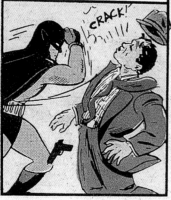

THE "BAT-MAN" LASHES OUT WITH A TERRIFIC RIGHT...

CRACK!

..HE GRABS HIS SECOND ADVERSARY IN A DEADLY HEADLOCK... AND WITH A MIGHTY HEAVE....

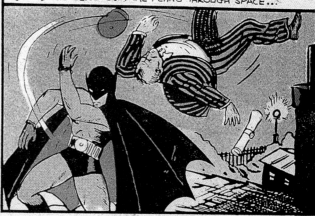

SENDS THE BURLY CRIMINAL FLYING THROUGH SPACE...

THE "BAT-MAN" SWIFTLY PICKS UP THE PAPER THAT THE MURDERER STOLE FROM STEVEN CRANE'S SAFE...

... MEANWHILE THE COMMISSIONER DRAWS UP IN HIS CAR...

IT'S THE BAT-MAN! GET HIM!

MR. CRANE HAS BEEN MURDERED, SIR - IT'S HORRIBLE

THAT'S TWO DEAD PARTNERS OUT OF THE FOUR THAT HAVE RECEIVED THREATENING NOTES THE OTHER TWO MUST HAVE RECEIVED THEM TOO .. LET'S GO TO ROGERS NEXT!

THE "BAT-MAN" READS THE PAPER HE SNATCHED FROM THE KILLERS AND A GRIM SMILE COMES TO HIS LIPS

HE SPEEDS HIS CAR FOWARD TO AN UNKNOWN DESTINATION

two-issue story. The villain was the Monk, who turned out to be a vampire, so Batman shot the bloodsucker and his sultry concubine with silver bullets. The business with guns was troublesome, and after one more recurrence DC's editorial staff decided to disarm Batman as far as deadly weapons were concerned, lest youthful fans take arms against a sea of troubles. The use of supernatural events would also be discouraged in the future, perhaps on the grounds that nobody should be scarier than Batman. He was a grim figure in his first years, casually killing criminals, and Bob Kane liked this dark version best—but it was not to last.

As for Bill Finger, nobody knows what he felt when Gardner Fox replaced him for a few issues. Bob Kane had made his deal with DC Comics on his own, and Finger was merely Kane's employee. DC would eventually hire Finger to write scripts for Kane and other artists, but for most of his life he worked on Batman without credit. "I always felt rather badly that I never gave him a byline," said Kane recently. "He was the unsung hero."

One way Finger reasserted his control was to define Batman's environment. Gardner Fox had called Batman's previously unnamed hometown "New York," but Finger didn't like that, and struggled until 1941 to come up with a substitute that had the right mythic ring. He considered Civic City, Capital City, and Coast City, before finally settling on Gotham City. "We didn't want to call it New York because we wanted anybody in any city to identify with it," he said.

When Finger returned in *Detective Comics #33* (November 1939), it was with the most famous Batman tale of all time, the origin story. This two-page narrative, "The Batman and How He Came to Be," was presented as a preface to "The Batman Wars Against the Dirigible of Doom," but it completely overshadowed that aerial adventure. The typical comic book series began with an elaborate explanation of the hero's background, but Kane and Finger had neglected that tradition, and nobody even remembers why they eventually got around to it six months into the run. "Bill and I discussed it," recalled Bob Kane, "and we figured there's nothing more traumatic than having your parents murdered before your eyes." The idea that Batman became a wealthy orphan after the senseless slaughter of his mother and father seemed to strike a nerve, and the scenario was presented with sufficient conviction to make it plausible that a crime fighter would dress like a bat because one flew in his window. After all, it had worked for the Bat five years earlier.

There is still one more influence that must be acknowledged, and that is Chester Gould's phenomenally popular comic strip *Dick Tracy,* which got its start in 1931. Bob Kane started out trying to imitate the styles of draftsmen like Alex Raymond and Milton Caniff, but Batman really came into his own when Kane and other artists began to emulate the simpler, cartoony style employed by Gould. Even before Batman's distinctive look developed,

## DETECTIVE STORIES

When Bob Kane and Bill Finger started their collaboration at Edgar Allan Poe Park in the Bronx, they were unconsciously paying tribute to the classic American writer (1809–1849) who is credited with inventing the detective story. Batman, after all, made his debut in *Detective Comics,* and is remarkable among super heroes because he relies on deductive powers as much as physical prowess. Poe's short stories inspired many themes that would recur in Batman's adventures: the hideous, inhuman culprit ("The Murders in the Rue Morgue," 1841), scientific analysis of clues ("The Mystery of Marie Roget," 1842), the deciphering of hints deliberately left by an ingenious criminal ("The Gold Bug," 1843), the insane killer ("The Black Cat," 1843), the apparently supernatural intimidation of the guilty party ("Thou Art the Man," 1844), and the hero's admiring assistant ("The Purloined Letter," 1845).

Poe's detective, C. Auguste Dupin, inspired a more colorful and popular character when Arthur Conan Doyle introduced Sherlock Holmes in *A Study in Scarlet* (1887). Poe's detective was pure intellect, but Holmes was sometimes surprisingly active. Chester Gould's Dick Tracy, the great detective of the newspaper strips, shared a razor-sharp profile with Holmes, but was a professional policeman and definitely a man of action. The acrobatic Batman inherited something of his appearance from these forebears, and continues their tradition of what Poe called "ratiocination." And however much it may dismay some purists, it's just possible that today Batman is the most famous fictional detective in the world.

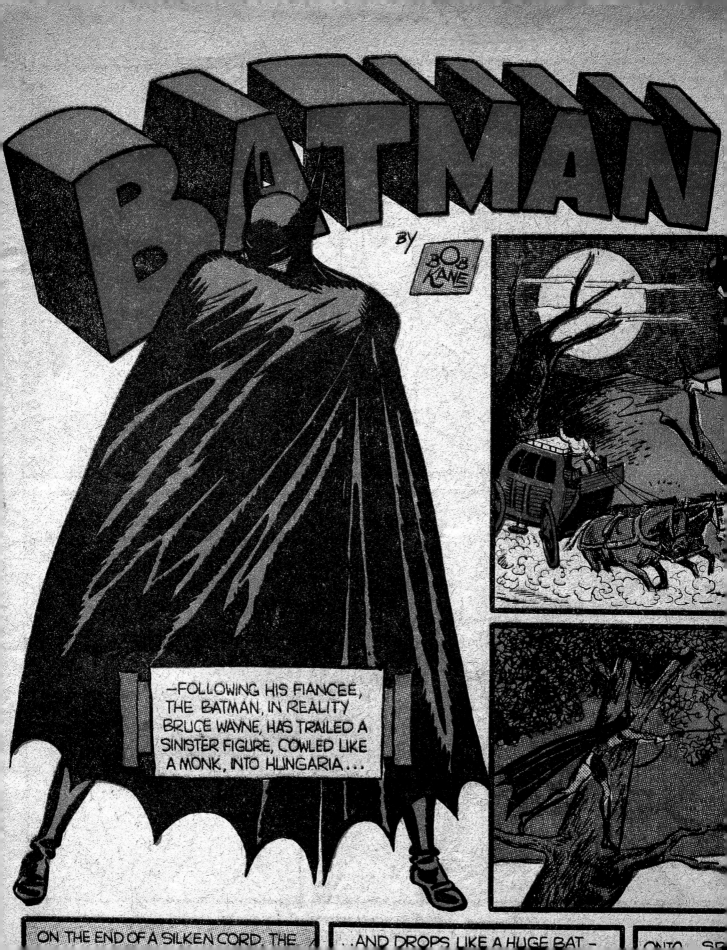

however, Gould's detective stories were having another effect. Dick Tracy faced a spectacular array of bizarre villains, and to some extent Batman followed his lead. A case in point was Gould's first great bad guy, the Blank, an assassin of assassins who appeared in the newspapers from October 1937 to January 1938. The gimmick was that he had no face, only a blank expanse of flesh under his big black hat. This grotesque appearance turned out to be a mask, but there was no such subterfuge when Kane drew a similar character in *Detective Comics* #34 (December 1939), a poor soul who really had no face and was a good guy despite it. The point must be made, however, that after this one incident, Batman and Dick Tracy were on separate tracks. Batman's classic antagonists were appearing just as fast as Tracy's lineup of fiends like the Mole (1941), Pruneface (1942), Flattop (1943), and the Brow (1944). In fact it was Batman's bad guys who would eventually become international icons.

The Batman comics had absorbed so many influences, so many borrowings, that they were ready to explode. The character had become a seething nuclear stockpile of a society's dark dreams and desires. Batman may have taken off in 1939, but it was in 1940 that he would really begin to fly.

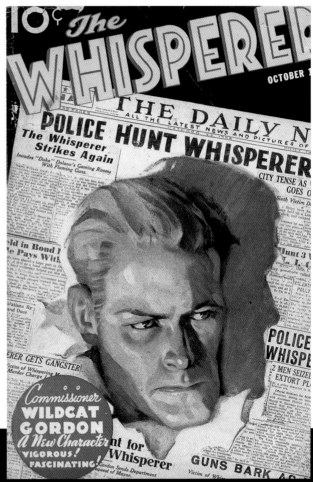

# GORDON'S LAW

The first page of the first Batman story shows the hero's alter ego Bruce Wayne visiting with his friend Police Commissioner Gordon, the first of the many supporting characters who helped make the feature so memorable. Surprisingly, Gordon also has a predecessor in the pulp magazines. The comic book Gordon was gray-haired and bespectacled, but his prose counterpart was young and blond. He made his debut in the first issue of the pulp *The Whisperer* (October 1936) and his creator was Zorro's Johnston McCulley. The Whisperer was a typical pulp vigilante "who dares to do what others have thought of doing," and his secret identity was Police Commissioner James W. Gordon, nicknamed "Wildcat." The Gordon who appeared in *Detective Comics* initially had no first name. "I felt it wise just to give Commissioner Gordon an official title," said Bill Finger. "There was a chance that Batman might reveal his own secret identity by referring to the Commissioner by his first name. And besides, it lent that much more of an official tone to the storyline by not having Batman on familiar terms with Commissioner Gordon." When the Commissioner eventually acquired a full name, however, it was James W. Gordon.

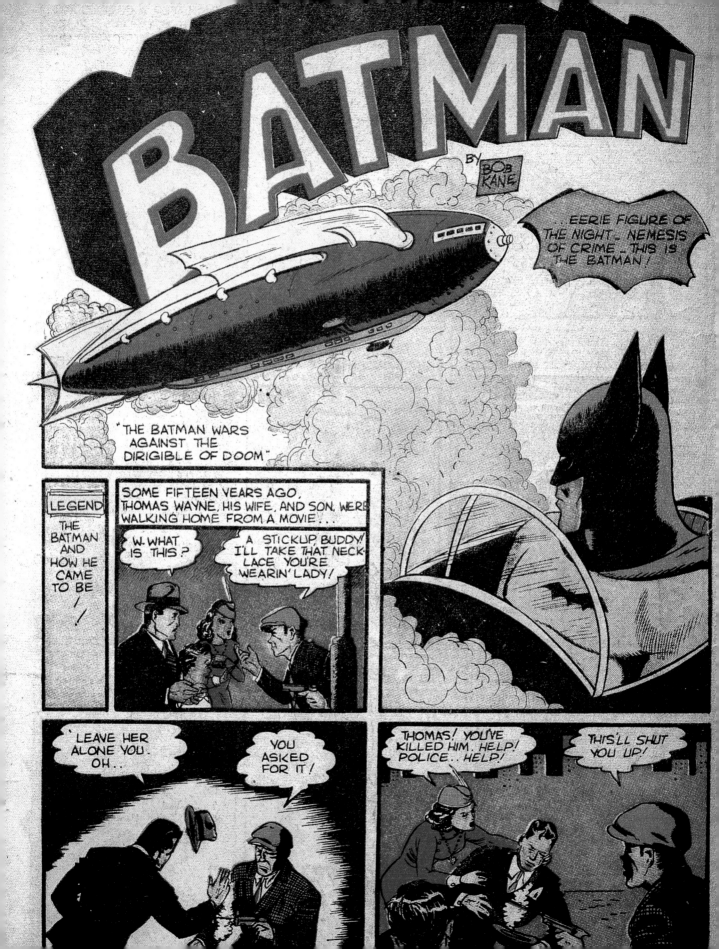

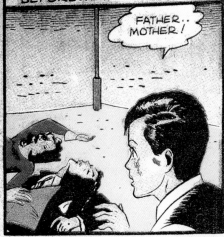

THE BOY'S EYES ARE WIDE WITH TERROR AND SHOCK AS THE HORRIBLE SCENE IS SPREAD BEFORE HIM.

FATHER.. MOTHER!

...DEAD! THEY'RE D..DEAD.

DAYS LATER, A CURIOUS AND STRANGE SCENE TAKES PLACE

AND I SWEAR BY THE SPIRITS OF MY PARENTS TO AVENGE THEIR DEATHS BY SPENDING THE REST OF MY LIFE WARRING ON ALL CRIMINALS.

AS THE YEARS PASS BRUCE WAYNE PREPARES HIMSELF FOR HIS CAREER. HE BECOMES A MASTER SCIENTIST.

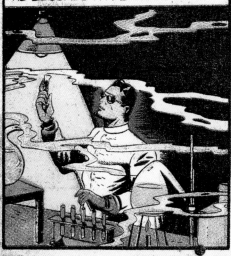

TRAINS HIS BODY TO PHYSICAL PERFECTION UNTIL HE IS ABLE TO PERFORM AMAZING ATHLETIC FEATS.

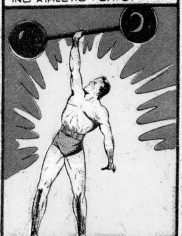

DAD'S ESTATE LEFT ME WEALTHY. I AM READY.. BUT FIRST I MUST HAVE A DISGUISE.

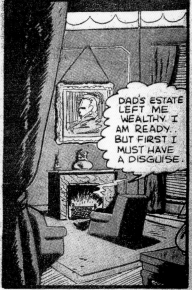

CRIMINALS ARE A SUPERSTITIOUS COWARDLY LOT, SO MY DISGUISE MUST BE ABLE TO STRIKE TERROR INTO THEIR HEARTS. I MUST BE A CREATURE OF THE NIGHT, BLACK, TERRIBLE..A..A...

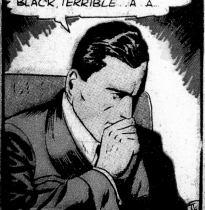

..AS IF IN ANSWER, A HUGE BAT FLIES IN THE OPEN WINDOW!

A BAT! THAT'S IT! IT'S AN OMEN. I SHALL BECOME A BAT!

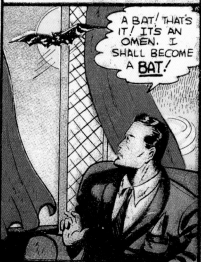

AND THUS IS BORN THIS WEIRD FIGURE OF THE DARK.. THIS AVENGER OF EVIL.. THE BATMAN

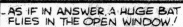

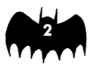

# W I N G S

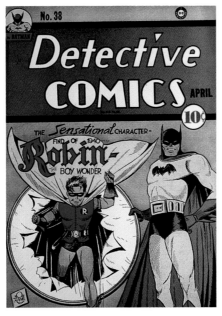

The kid sidekick who kicked off a trend in comics got his start in *Detective Comics #38* (April 1940). Cover by Bob Kane and Jerry Robinson.

Soon after Batman was launched, it became clear that the character was going to be too big for just two people to handle. "I used to get nose-bleeds from working on it sixteen hours a day," said Bob Kane. Bill Finger had been replaced by another writer after only a few stories, and before long Kane was taking on art assistants. One of the first was Sheldon Moldoff, who spent some months in 1939 lettering and inking background on Kane's pencilled pages. As the comic book business was growing by leaps and bounds, Moldoff was soon recruited by DC's new sister company, All American Comics. There he drew Hawkman, the Flash, and the initial cover appearance of a new super hero called Green Lantern (Bill Finger was the first writer on that series). Moldoff recalled telling Kane about an idea he had to create a boy super hero, and then experiencing some dismay when one subsequently showed up in Kane's work. "You can't really say he took it from me, because you don't know that he wasn't thinking of the same thing at the same time," Moldoff said.

When "The Sensational Character Find of 1940 . . . Robin, the Boy Wonder," made his debut alongside Batman in *Detective Comics* #38 (April 1940), Kane's new assistant was young Jerry Robinson, whose work helped pay his expenses while he attended Columbia University. "Bob was a few years older than I was and I had a great deal of respect for his abilities,"

Artist Jerry Robinson.

recalled Robinson. "To a young kid from a small town, Bob was awe-inspiring: tall, handsome, sophisticated, and extremely personable." Robinson started out working on lettering and backgrounds, "and pretty soon Bob would just pencil the strip and I would do the complete inking." The look of Batman began to change, and Bob Kane, while acknowledging the quality of his assistant's draftsmanship, was not entirely pleased. "He immediately went to his style, which was very illustrative," observed Kane, who favored a simpler, cartoonish approach. "I still think to this day that, in comics, stylization is greater than master illustration." Whatever tension was caused by the conflict in techniques manifested itself as a strong artistic synthesis, which was well established by the time Robin arrived to change the look of things once again.

"It was Bob's idea to give Batman a kid sidekick," Robinson said. "He wanted someone the young readers could identify with more readily than this masked, mysterious figure. It was a brilliant idea and we all saw enormous story potential in the new character." According to Kane, however, publisher Jack Liebowitz was skeptical about the idea of throwing a mere boy into harm's way, and from a realistic perspective he had a point. But Batman and Robin were fantasy figures, and readers responded enthusiastically to the death-defying kid. Sales doubled, but at the same time

Kane regretted the disappearance of the solitary and sinister Batman of the early days, a figure who would not return again for almost thirty years.

Bill Finger was definitely pleased. He had always compared Batman to Sherlock Holmes, and now the star of *Detective Comics* had his own Dr. Watson. "The thing that bothered me was that Batman didn't have anyone to talk to," Finger explained. With his bright red, yellow, and green costume, Robin altered the series visually, and his brighter personality also affected the mood of the comic. Robin was based on Robin Hood, another character played by the ebullient silent screen star Douglas Fairbanks. Although his parents had been murdered like Batman's, young Dick Grayson relished the chance to put on a costume and catch the killers; he cheerfully ended this first adventure by announcing, "I can hardly wait till we go on our next case. I bet it'll be a corker!" An orphan with an attitude, Robin demanded a voice of his own. "The pulps were grim, lacking in humor," Finger said, but the appearance of Robin changed that tone. "The puns were there; the dialogue easy, fluid, and flowing. It brightened up the strip and added char-

acterization to the main figure of Batman."

Administrative matters also played their part in the metamorphoses the Batman stories experienced in 1940. Vin Sullivan, the editor who had first published Superman and initially inspired Batman, had suggested a comic book tie-in to the 1939 World's Fair in New York. "I didn't have the money to actually publish it," said Sullivan. "First I went to the World's Fair people and secured the rights to produce a World's Fair comic. Then I went to Jack Liebowitz and Harry Donenfeld and asked if they wanted to participate with me in this joint venture." The result was *New York World's Fair Comics,* published in April 1939 and intended for sale on the fairgrounds. With a cardboard cover and ninety-six pages of comics, the issue sold at twenty-five cents but wasn't a success despite the appearance of Superman, and eventually fifteen-cent stickers were glued to the covers. Nonetheless a 1940 edition was

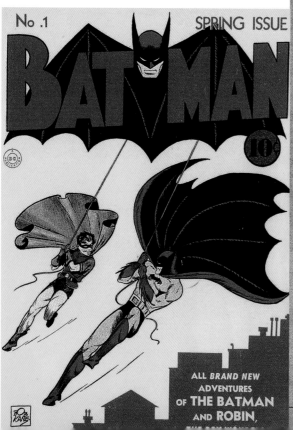

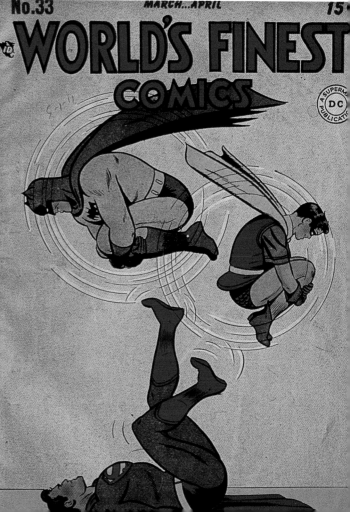

Below: Emphasizing Batman's status as a sleuth, this tale from *Batman #14* (December 1942–January 1943) parodied several famous fictional detectives. Art: Jerry Robinson.

produced, this one featuring a story in which Batman and Robin visited the fair in their civilian garb. More to the point, they appeared on the cover together with Superman. Poor sales for the two World's Fair comics led to a dispute with the publishers, and Sullivan took his leave of DC Comics. Yet the idea of a comic book featuring the medium's two biggest stars survived. *World's Best Comics #1* appeared in the fall of 1940 (although with a Spring 1941 publication date), and acquired the more familiar title *World's Finest Comics* with the second issue. Although Batman and Superman had separate stories on the inside, they were teamed on the covers of *World's Finest Comics* for years to come.

Meanwhile, DC Comics needed a new editor and quickly found one in Whitney Ellsworth. A writer and cartoonist, Ellsworth had briefly worked for the fledgling comics company during its earliest days, and now he returned to serve as DC's editorial director for the next fourteen years. His experience encouraged him to take an active interest in the careers of the comic book characters, and that changed things for the freewheeling creators who had survived the nascent industry's earliest days. For better or worse, comics were becoming a business. Decades later, Bill Finger was still lamenting the influence of editors and their use of story conferences. "You lack a certain amount of freedom in dealing with the character," he said. "I could usually do better on my own." Yet Ellsworth's planning and foresight would pay dividends when it came time to plot the stories for the first issue of a publication devoted solely to the Caped Crusader: *Batman #1* (Spring 1940). Just getting a comic named after him was quite an accomplishment for Batman, since in the early days comic books generally contained four or five stories featuring several different characters. Going solo was a sure sign of success.

The highlight of *Batman #1* was undoubtedly the introduction of the Joker, who broke precedent by showing up in the first story and then again in the fourth. This new villain was originally going to die at the end of the issue, accidentally

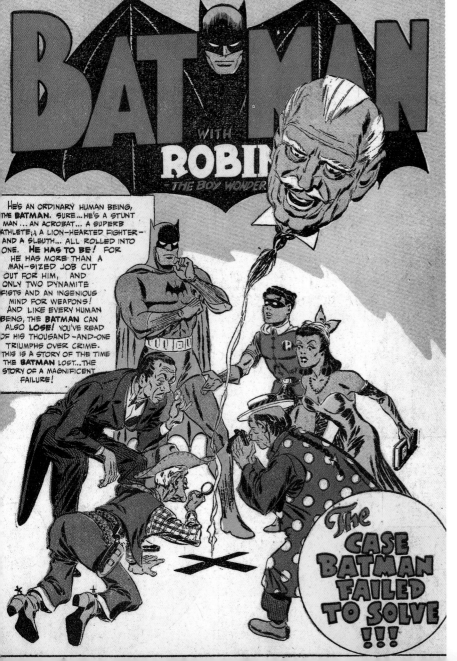

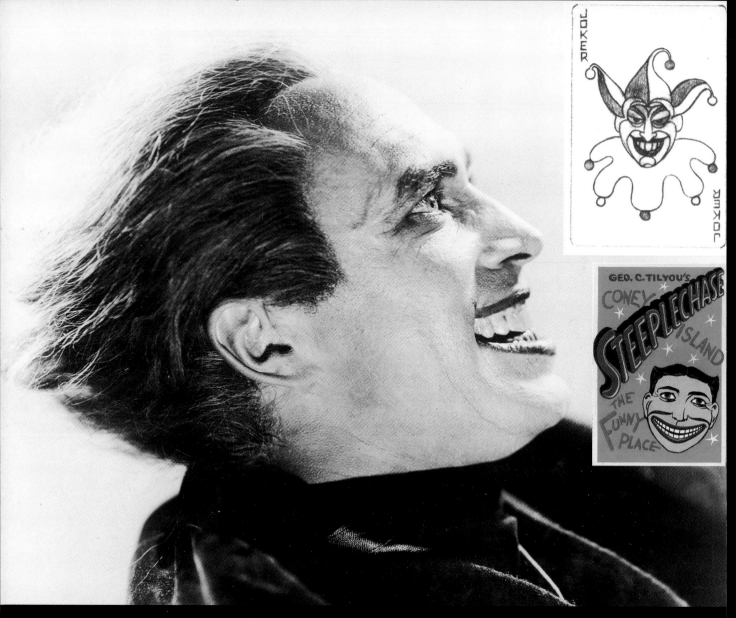

# W H O   L A U G H S   L A S T ?

Lon Chaney, the silent screen star whose classic horror films include *The Phantom of the Opera* (1925), used to say that although clowns can be funny, there's nothing funny about a clown at midnight. That's an observation that might have helped inspire the creation of the Joker, but in fact it's almost the only thing that has *not* been cited as a source for Batman's most famous foe. Jerry Robinson, working as Bob Kane's assistant when the Crime Clown first appeared, has repeatedly stated that he came up with the Joker, motivated by the wish to invent an archvillain and sparked by a deck of playing cards. He even designed a new Joker card, which showed up in the character's first story. Bob Kane acknowledged the card, but vociferously denied that Robinson created the Joker, insisting that he himself had already originated the macabre master of mirth in collaboration with writer Bill Finger. Both Kane and Robinson agree, however, that the Joker's ultimate appearance was based on photos that Finger provided, showing actor Conrad Veidt in the makeup he wore to play the disfigured hero of *The Man Who Laughs*, a 1928 film based on the 1869 novel by Victor Hugo. On the other hand, Bill Finger's son Fred claimed that his father said the Joker's appearance was actually based on an old New York landmark. A Coney Island attraction, George C. Tilyou's Steeplechase on Surf Avenue, had for decades been advertised by pictures of a man with a gigantic grin. According to Fred Finger, this "white-faced, evil clown" had given his father the idea for the most famous villain in comic books. Another Batman artist, Sheldon Moldoff, said Bob Kane himself "did have that long, lean face and that kind of a smile when he was much younger. I used to tell him he looked like the Joker." Amid all this confusion, it's hard to argue with a prediction the Harlequin of Hate made in *Batman #1*, when he promised the world that, no matter what, the Joker would have the last laugh.

stabbing himself while lunging at Batman, but Whitney Ellsworth stepped in and saved him. Ellsworth's motives this time were less humanitarian than mercenary: he recognized that this character was far too valuable to throw away. The Joker's purple suit, crimson lips, and green hair contrasted with clown-white skin to make an unforgettable first impression, reinforced by the fact that this villain's idea of a joke was to leave his poisoned victims with hideous grins frozen on their dead faces.

The Joker's homicidal habits were soon abandoned, evidently in exchange for his status as a recurring villain. Gradually he became an almost lovable egomaniac who wanted to be the world's greatest comedian as well as the world's greatest crook. Fixated on the idea that the only way to achieve both ambitions was to get the better of Batman, he began to imitate his enemy by driving a Jokermobile or wearing a utility belt filled with sneezing powder and exploding cigarettes. An endless battle developed to determine which of these two self-invented personalities could be the most flamboyant, and thus the Joker became the model for other Batman bad guys who were to follow: a seemingly endless parade of tormented, avaricious lunatics who would sacrifice anything to earn a place in the moonlight. A peculiarly American form of expressionism developed, in which characters lived surrounded by countless emblems of their obsessions, treated crime as a series of publicity stunts, and dressed up in crazy costumes as they struggled to dominate the night. Some critics have suggested that Batman was a more realistic hero than Superman because the former had no incredible powers, but Superman's stories generally followed the logical patterns of science fiction. Batman's world, by contrast, was sheer fantasy, featuring multiple maniacs striving to turn their dreams and nightmares into concrete reality, with only a man dressed as a bat to say them nay. It may be significant that so many villains first arrived on the scene the way the Joker had, without origin stories. They were granted

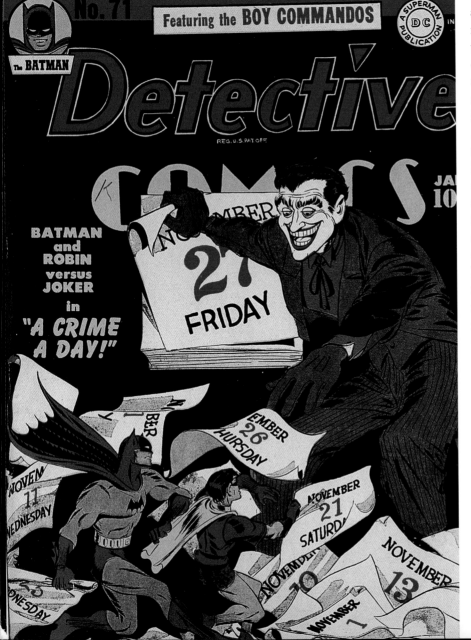

An oversize Joker appeared on Jerry Robinson's cover for *Detective Comics #71* (January 1943), which continued a trend toward depicting gargantuan bad guys.

Right: A homicidal, inexplicably blonde Catwoman wore the first prototype of her famous costume, drawn by Bob Kane and inked by Ray Burnley, in *Batman* #35 (June–July 1946).

the courtesy of being accepted as what they had chosen to become, and latter-day explanations of how they got that way sometimes seemed only to diminish them.

The Catwoman was the second classic villain introduced in *Batman* #1, but she was a work in progress. At first she was merely called the Cat, an obvious reference to the recently coined term "cat burglar," used to describe an especially sneaky and sophisticated thief. She had no other name and no costume (although she did spend most of this first story disguised as a little old lady), but Batman was smitten and actually let her escape after recovering her loot. "We'd make a great team," she suggested at one point, and many a fan shared the sentiment. "I always felt that women were feline," Bob Kane once confessed, and he intended the new character to bring some glamour to the series. He hoped boys would be attracted while girls could identify with her. Billed as "the beautiful, lithe, mysterious Cat-Woman" in *Batman* #2 (Summer 1940), she was the Joker's rival in pursuit of some ancient jewels. Both felons failed, but she seemed to have picked up at least one trick from this encounter with the Joker: when she returned in *Batman* #3 (Fall 1940) it was in full costume, complete with cloak and an unflattering hairy mask. It wasn't until 1946, when she appeared in a skintight purple costume that came close to mirroring Batman's, that Catwoman really hit her stride.

The first issue of *Batman* was notable for at least one other reason. Batman now had two new villains to fight, and he would soon be fighting a little more carefully. In the issue's second story, originally prepared for *Detective Comics* and clearly based on the 1933 film *King Kong*, Batman battled a gang of monstrous giants. At the climax he gunned them down, explaining, "Much as I hate to take human life, I'm afraid this time it's necessary!" That was a sentiment that Whitney Ellsworth didn't buy, and he decreed that in the future Batman would be forbidden to use a gun or kill anyone by other means. This ban was the first step in forming an ethical code that would stand DC in good stead when con-

troversies arose in the 1950s about violence and sex in comic books.

The Penguin, another major villain who arrived fully formed, made his debut in *Detective Comics* #58 (December 1941). Bill Finger said the character was inspired by emperor penguins, who reminded him of stuffy English gentlemen in tuxedos. The resulting caricature of an aristocratic type included a top hat, a monocle, a cigarette holder,

and an umbrella, with the latter developing into a signature method of disguising weapons like death rays or sleeping gas. Bob Kane, on the other hand, said this bad guy was derived from a cartoon: the little penguin who appeared in print to advertise Kool menthol cigarettes and also hawked them on the radio with his insistent falsetto slogan, "Smoke Kooools! Smoke Kooools!" In his first adventure, the fat little fellow was fatal a lot faster than nicotine, but he subsequently calmed down like so many of his peers, becoming merely an ingenious

Above: In some early adventures, Catwoman eschewed elegance and featured this furry feline mask as part of her costume. Script: Don Cameron. Pencils: Bob Kane. Inks: Jerry Robinson.

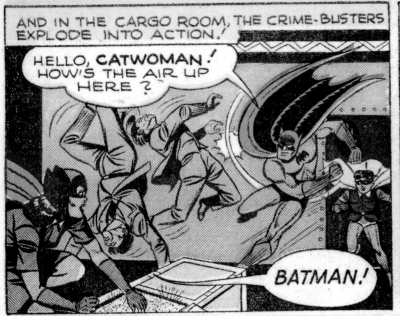

AND IN THE CARGO ROOM, THE CRIME-BUSTERS EXPLODE INTO ACTION!

HELLO, CATWOMAN! HOW'S THE AIR UP HERE?

BATMAN!

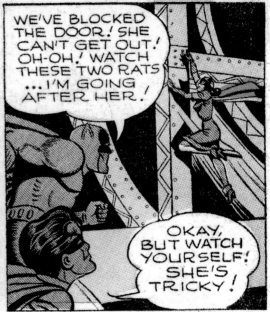

WE'VE BLOCKED THE DOOR! SHE CAN'T GET OUT! OH-OH! WATCH THESE TWO RATS ...I'M GOING AFTER HER!

OKAY, BUT WATCH YOURSELF! SHE'S TRICKY!

PADDING SWIFTLY ALONG THE CATWALK, THE CATWOMAN SEEKS ESCAPE FROM HER RELENTLESS PURSUER!

LIKE A BOLT OF BLACK LIGHTNING SHE STREAKS UP THROUGH AN EMERGENCY HATCH SET IN THE DIRIGIBLE ROOF...

I'VE GOT TO HAND IT TO THAT FEMALE SPITFIRE! SHE'S FAST!

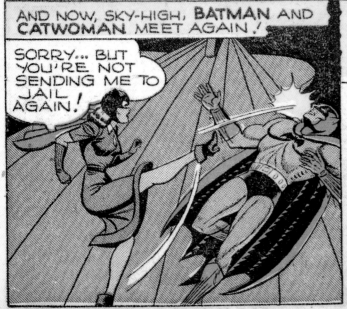

AND NOW, SKY-HIGH, BATMAN AND CATWOMAN MEET AGAIN!

SORRY... BUT YOU'RE NOT SENDING ME TO JAIL AGAIN!

THEN IT HAPPENS! A STRONG CROSS-WIND HITS THE DIRIGIBLE AND—

UHHH...

LOOK OUT!

6

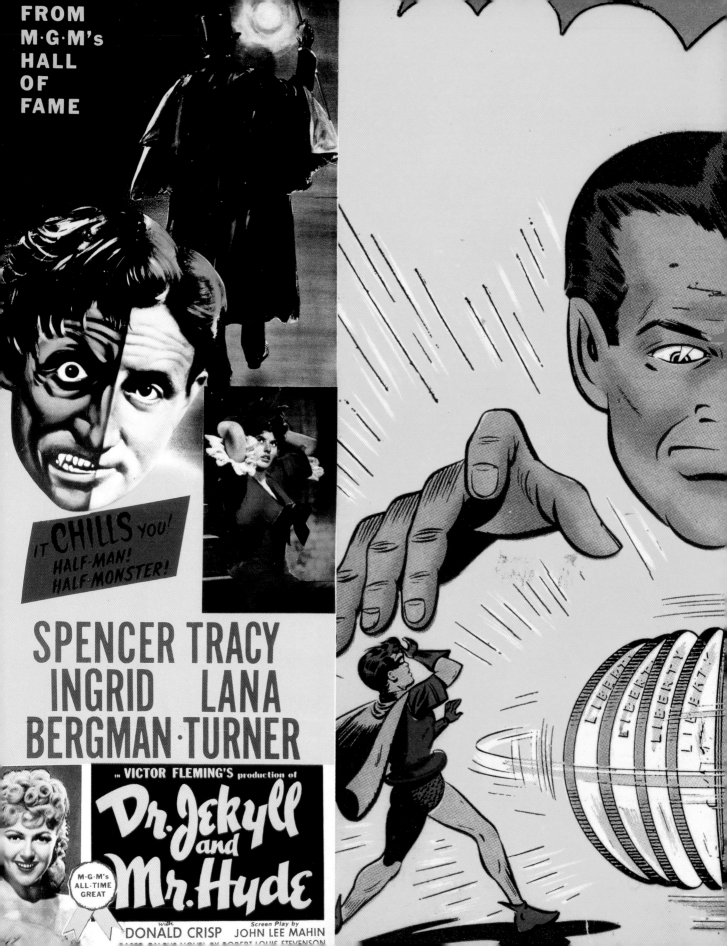

ONCE AGAIN **BATMAN** and **ROBIN** BATTLE THE MOST BIZARRE VILLAIN OF ALL TIME in "**The RETURN of TWO-FACE**"

thief who often used birds to help him in his crimes and who answered to the name of Oswald Cobblepot. A ludicrous figure composed of seemingly disparate elements, the Penguin may have worked because he represented a privileged class that an audience of Americans might resent. Of course the same charge could be hurled at Batman, or at least his wealthy alter ego Bruce Wayne, but Oswald Cobblepot deftly deflected whatever resentment readers might have felt against the rich.

Two-Face, by contrast, was the most deadly serious of Batman's foes. While the details involving the creation of some of these characters are in dispute, everyone seems to acknowledge that Two-Face was Bob Kane's brainchild exclusively. The obvious inspiration came from Robert Louis Stevenson's 1886 tale *The Strange Case of Dr. Jekyll and Mr. Hyde,* and Kane specifically credited the 1932 film version, which won an Academy Award for actor Fredric March. He may also have noticed publicity for the 1941 remake starring Spencer Tracy, featuring symbolic images of a face divided into good and evil halves. Two-Face was originally Harvey Kent, successful district attorney, a handsome man about town who was doomed to have half his face ravaged by a criminal's acid attack. Kent became a man divided against himself and, in contrast to his former friend Bruce Wayne, he allowed a trauma to turn him toward his dark side. Deranged by his spectacularly symmetrical deformity, he became the bad guy Two-Face in *Detective Comics* #66 (August

Two-Face, inspired by Hollywood's take on a classic tale, had a scar that varied from gray to green at a colorist's whim. This cover for December 1948–January 1949 is by Lew Sayre Schwartz, Bob Kane, and Charles Paris.

By the time this unusual page appeared in *Batman #4* (Winter 1941), Bob Kane was reprising highlights from over a year of previous adventures. Inks: Jerry Robinson and George Roussos.

By the time this unusual page appeared in *Batman #4* (Winter 1941), Bob Kane was reprising highlights from over a year of previous adventures. Inks: Jerry Robinson and George Roussos.

1942). A symbol of duplicity who regarded himself as the pawn of an arbitrary destiny, Two-Face repeatedly tossed a two-headed coin to determine what course his life should take. Greek tragedy disguised in a dime's worth of newsprint, Two-Face seemed to disturb even his creators, who cured him through plastic surgery at the end of his third appearance in 1943. Eventually, they just couldn't let him rest. He would return explosively a decade later, when horror in comics had become both a fashion and a pitfall.

The Batman staff continued to grow as fast as the cast. George Roussos came on board to do lettering and backgrounds, making his mark on Gotham by constantly including huge full moons looming over the landscape. Editorial director Whitney Ellsworth hired Jerry Robinson to work directly for DC and soon had him drawing covers and stories on his own. Robinson depicted symbol-

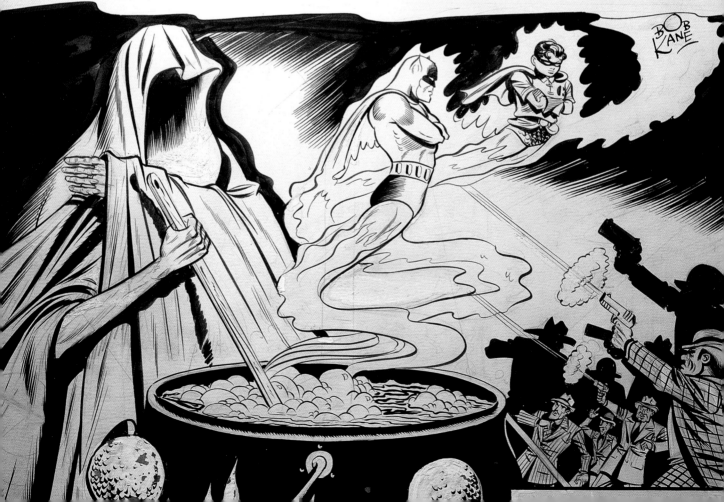

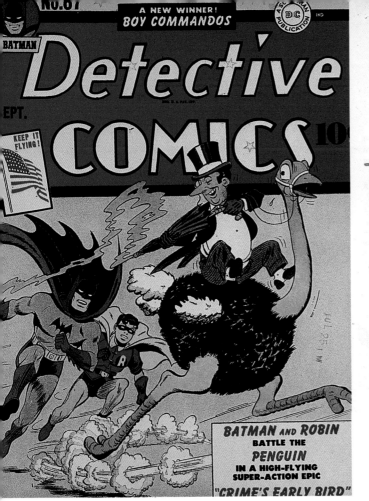

## That she couldn't ever bare to be without 'em

*Pinup this idea:*

## Switch from "Hots" to KOOLS

*—for good!*

BUY STAMPS AND BONDS

ically oversize villains towering above Batman and Robin, and such images became part of the Batman style. Ellsworth began sketching cover layouts for the artists, emphasizing bold, simple, posterlike designs. And he hired more and more people, partly because World War II had started and he was afraid that most of his young talent would be drafted. One artist, Dick Sprang, was hired in 1941, but recalls that "almost none of my work was published until about two years later. Whit wanted to stockpile all he could in case he lost the artists."

Dick Sprang would become perhaps the supreme stylist among those who delineated Batman's deeds during the character's early years. Kane, Robinson, Roussos, and others had worked toward developing the ideal look for the series, and for close to a quarter of a century, everyone who drew Batman under Bob Kane's name turned his talent toward emulating that style. "It was an established character," said Sprang, "so why not keep him that way?" Yet there were discernible differences among the artists, and Sprang's clean line and bold sense of design would set him apart. "I think it was just sort of a native instinct to try to be clear in my drawing," he said.

Born in Ohio in 1915, Sprang came to New York and found work writing and illustrating for the pulps; he also did a stint on a newspaper strip about another masked man, Western hero the Lone Ranger. "I could see the pulps were being driven out of business by the oncoming comic books," Sprang said, so he drew three pages as an audition for Ellsworth, then was promptly paid for his efforts and received his first assignment on the same day. The tremendous success of Batman and Superman enabled DC Comics to provide speedy payment and steady employment, which in turn attracted top talent.

Ellsworth, described by Sprang as "the driving force that made DC great," also hired more editors, bringing in Mort Weisinger from the pulp publisher Standard Magazines in 1940. When Weisinger was drafted in 1943, he was replaced for the duration of the war by his former colleague Jack Schiff. By the time Weisinger returned to civilian life in 1945, DC was such a big business that Schiff kept control of

Left: This page from *Batman #9* (February–March 1942) is one of the earliest surviving pieces of original Batman art. Pencils by Bob Kane. Inks by Jerry Robinson and George Roussos.

Above: Kools smokers' spokesbird Willie the Penguin (right) gave Bob Kane the idea for a dapper villain, who had his first cover appearance (left; September 1942) drawn by Jerry Robinson.

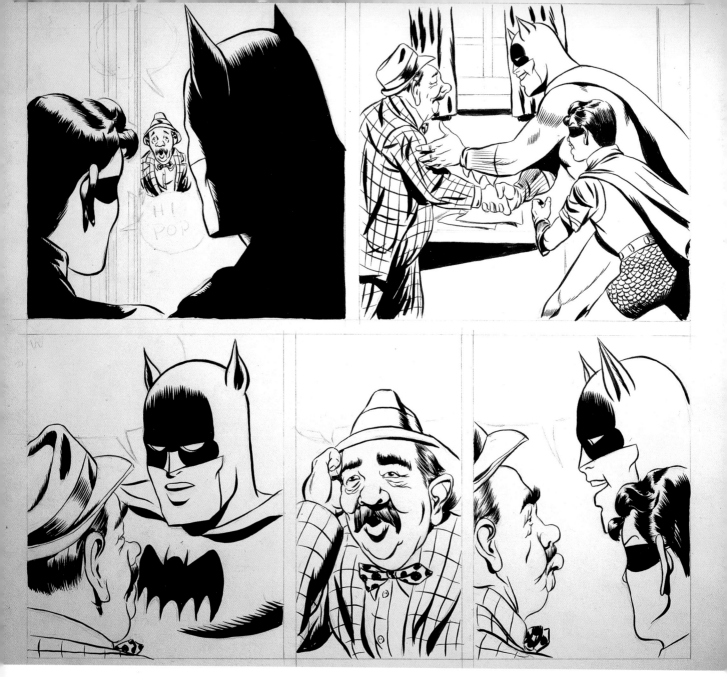

several characters, including Batman. As it turned out, Jack Schiff would be Batman's editor for more than twenty years. He had written a few Batman stories before he started, and came in with definite ideas about what constituted a good plot. "I thought my experience in the pulps would help if we could use that in the comics," said Schiff, "and we managed to get tight stories." He would ask writers to come in with several plot premises, "and then we'd take some idea and kick it around for a while."

Schiff would then request a written synopsis, and only after a conference on that would a final script be prepared. Then came more work. "Jack was a terrific copy editor," said Dick Sprang, "able to condense a scriptwriter's eighteen-word sentence into ten words that sang. That left the artist room to draw, which is always welcome." Yet Bob Kane, accustomed to earlier ways, was equivocal. "Whit would be more encouraging," he said. "Jack Schiff was more critical."

This tryout sequence, using the script for *Batman* #11 (June–July 1942), was drawn by unidentified hands.

A dummy Robin stands in for the real item in a page of original art from *Batman* #13 (October–November 1942). Script: Bill Finger. Pencils: Bob Kane and Jerry Robinson. Inks: George Roussos.

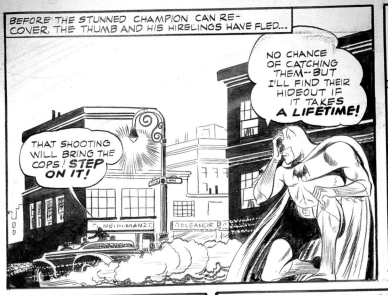

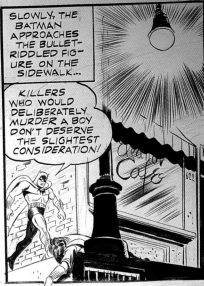

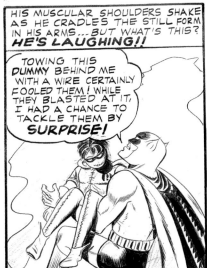

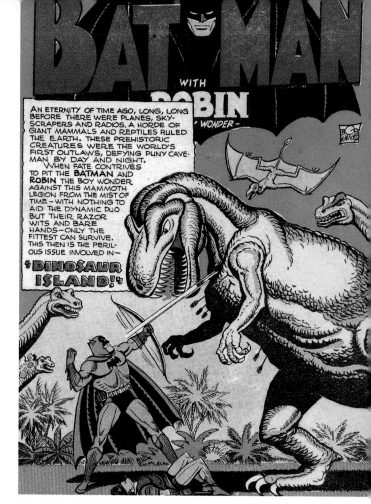

The script came broken down by pages and ﹍els, but it was up to the artist to determine the ﹍ and shape of the panels, the relationship ﹍ong them, and exactly what they would show. To master this elusive art, known in the trade as "storytelling," Sprang used to study kids at newsstands as they pored over comic books. It helped him to "decide what would be the more dramatic, the more interesting depiction, which would create the most sus-﹍se and the most fluidity to keep the pages ﹍ing." And then, just when DC personnel felt ﹍y were really mastering the art of the comic ﹍k story, they were suddenly called upon to ﹍ert to an earlier and more constricted form: the ﹍wspaper strip.

﹍nic strips inspired comic books, were genera-﹍s older, and commanded considerably more ﹍ect. Comic books were the poor relations, and ﹍r creators sometimes felt they were working in ﹍hetto. On bad days, Whitney Ellsworth would ﹍ortedly announce that this was no job for grown ﹍n. Later toilers in these vineyards would frankly ﹍e their work, but the people who set the medium ﹍ its feet were sometimes self-conscious, which perhaps helped to make them the consummate craftsmen they were. So it was a great day for the Batman staff when they learned that beginning on October 25, 1943, their hero would be syndicated in newspapers across the United States. "That's the big time," said Bob Kane.

# BATMAN'S RIDES

﹍y air, so it was perhaps only natural that the first of Batman's famous customized vehicles would take him flying. That ﹍atgyro, apparently inspired by Igor Sikorsky's introduction of the first practical helicopter in the same year. With its ﹍wings and huge horizontal propeller, this prototype was an impressive sight, but the ungainly overhead rotor was ﹍n a new Batplane was introduced in *Batman* #1. This craft had a nose shaped like a bat's head and a handy machine ﹍ for shooting monsters. Then the gyro made a comeback, in retractable form. For a while small design modifications ﹍most every time the Batplane took to the sky. After World War II, "jet tubes" and rocket "gadgets" were added, and at ﹍46, the Batplane acquired "aeraquamobile devices," which enabled it to retract its wings and become either a land ﹍ubmarine.

﹍ hardly needed a new way of getting around on the ground, however, since he already had the Batmobile. He had ﹍ around in a fast car since his first appearance, but then it was just a scarlet sedan. Later he had a blue convertible, ﹍t matched his color scheme; in 1941 a modest hood ornament in the shape of a bat was added, allowing captions at ﹍e car the "Batmobile," but it was red again. The first Batmobile really worthy of the name, a midnight-blue "super-﹍ with a scalloped tail fin and a bat's head battering ram, appeared in *Batman* #5 (Spring 1941). Both the Batplane ﹍e underwent elaborate updates in 1950 (the latter presaging the decade's coming fascination with fins), and revamps ﹍curring ever since.

Opposite: The Batmobile bursts through the comic book cover for *Batman* #20 (December 1943–January 1944), one of artist Dick Sprang's favorites.

BATMAN

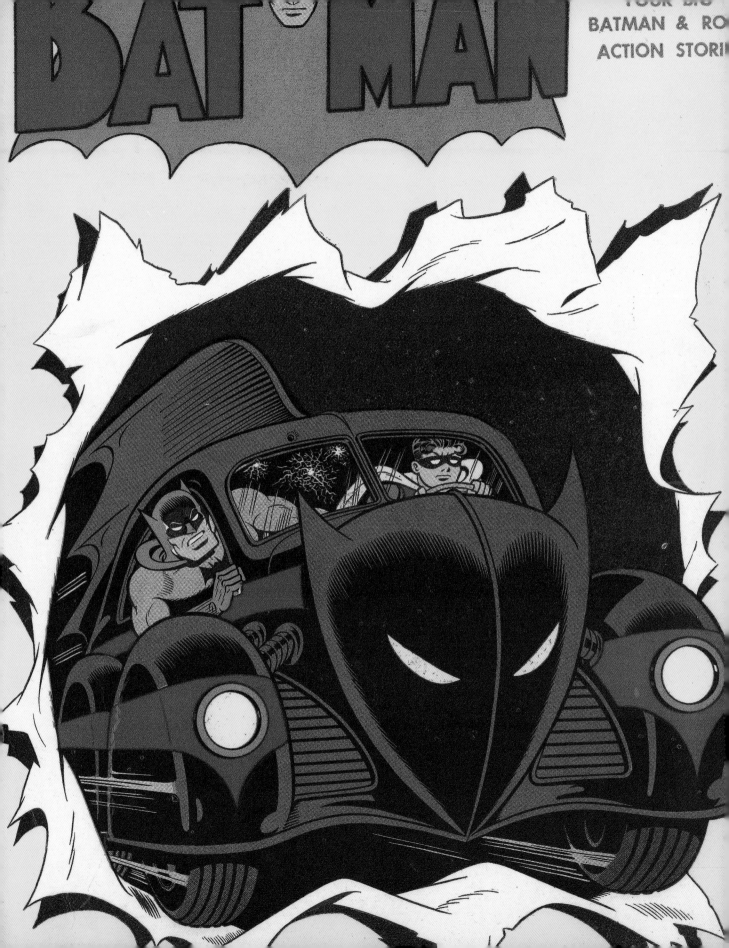

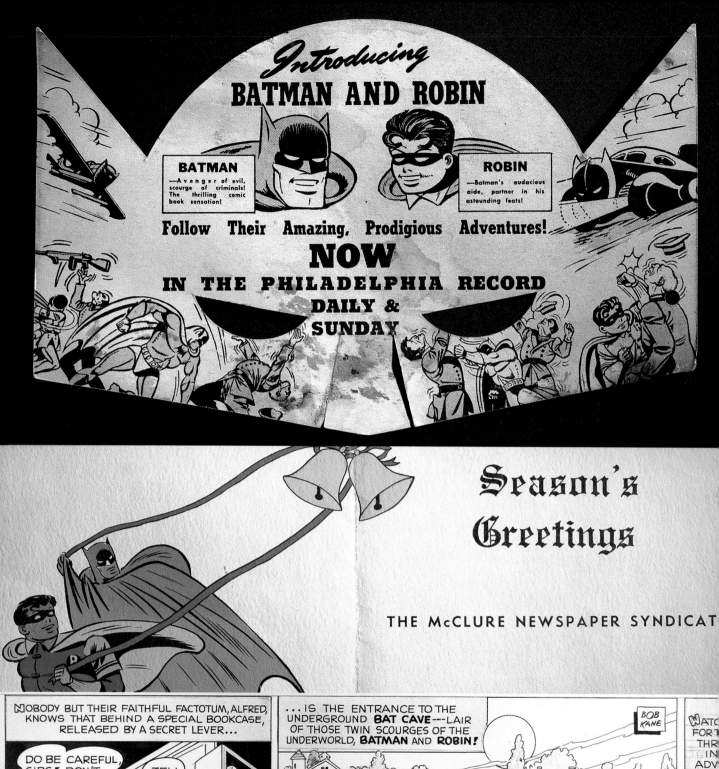

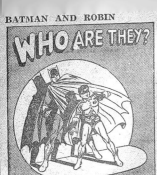

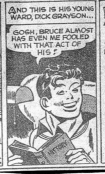
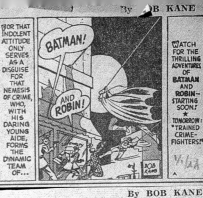
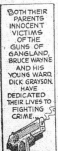
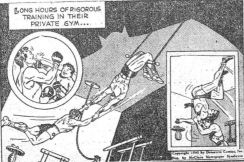

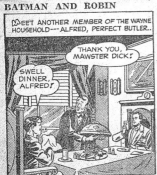
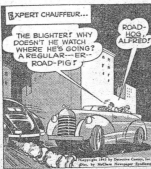

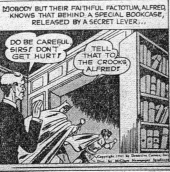
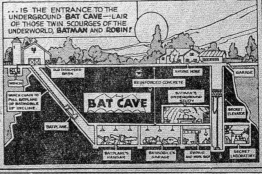

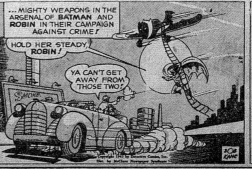

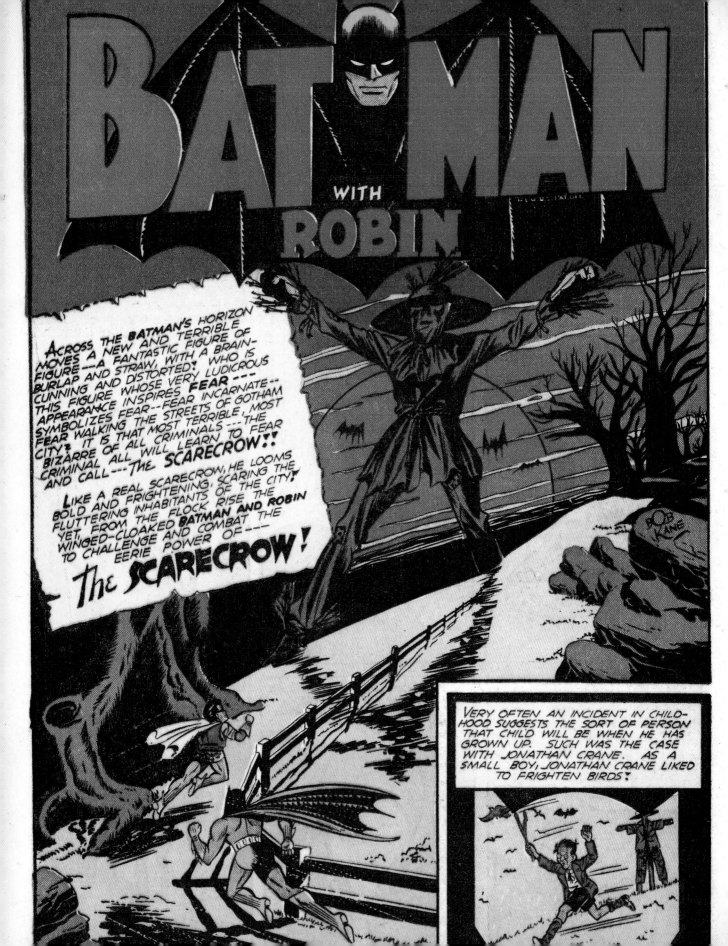

# BATMAN
## WITH ROBIN

ACROSS THE BATMAN'S HORIZON MOVES A NEW AND TERRIBLE FIGURE—A FANTASTIC FIGURE OF BURLAP AND STRAW, WITH A BRAIN-CUNNING AND DISTORTED! WHO IS THIS FIGURE WHOSE VERY LUDICROUS APPEARANCE INSPIRES FEAR--- SYMBOLIZES FEAR--FEAR INCARNATE-- FEAR WALKING THE STREETS OF GOTHAM CITY? IT IS THAT MOST TERRIBLE, MOST BIZARRE OF ALL CRIMINALS----THE CRIMINAL ALL WILL LEARN TO FEAR AND CALL----THE SCARECROW!!

LIKE A REAL SCARECROW, HE LOOMS BOLD AND FRIGHTENING, SCARING THE FLUTTERING INHABITANTS OF THE CITY! YET, FROM THE FLOCK RISE THE WINGED-CLOAKED BATMAN AND ROBIN TO CHALLENGE AND COMBAT THE EERIE POWER OF----

## — The SCARECROW!

VERY OFTEN AN INCIDENT IN CHILD-HOOD SUGGESTS THE SORT OF PERSON THAT CHILD WILL BE WHEN HE HAS GROWN UP. SUCH WAS THE CASE WITH JONATHAN CRANE. AS A SMALL BOY, JONATHAN CRANE LIKED TO FRIGHTEN BIRDS!

Twin miscreants Tweedledum and Tweedledee stroll toward the slammer in *Batman #24* (August–September 1944). Script: Don Cameron. Art: Dick Sprang.

"I got in touch with the McClure Syndicate about Batman," said Jack Schiff. The oldest syndicate in the business, McClure had been handling a Superman strip since 1939, but DC had hoped to sell Batman elsewhere, evidently fearing that McClure would view the characters as competitors. As it turned out, the strip, called *Batman and Robin,* didn't do nearly as well as *Superman,* perhaps because editors felt that one super hero was enough for one newspaper. The syndicate at least didn't do any damage by trying to enforce major changes, and in fact made the unusual decision to let DC supervise the strip with Jack Schiff editing.

Bob Kane jumped at the chance to pencil the black-and-white daily strips, which kept him so busy that he completely gave up comic book work. Even then, he found there wasn't time for him to handle the big Sunday pages, which were usually pencilled by Jack Burnley. Kane found the "big league" frustrating, because the space allowed in the papers each day was so constricted. Other pencillers like Dick Sprang or Fred Ray filled in occasionally, and the inking was almost always done by Charles Paris, whose precision and consistency helped define the Batman style. Many of the scripts were written by Alvin Schwartz and Don Cameron, both published novelists who found that comics offered the opportunity to supplement their incomes.

Bill Finger, a slow writer who probably wasn't suited for the daily grind of newspaper work, contributed a few strip scripts but preferred the comic books. So did Dick Sprang, who didn't like the format or the pressure of daily work. He and Finger sparked each other's imaginations, and their collaborations kept the comic books cooking, even though they rarely met, sending their work back and forth through the DC offices instead. "Bill Finger was an expert. He was fantastically good at maintaining a rising level of drama," said Sprang. After the strip folded in 1946, Charles Paris took over Sprang's inking chores in the comic books, and his clean, sharp lines made a strong contribution to an impeccably professional partnership.

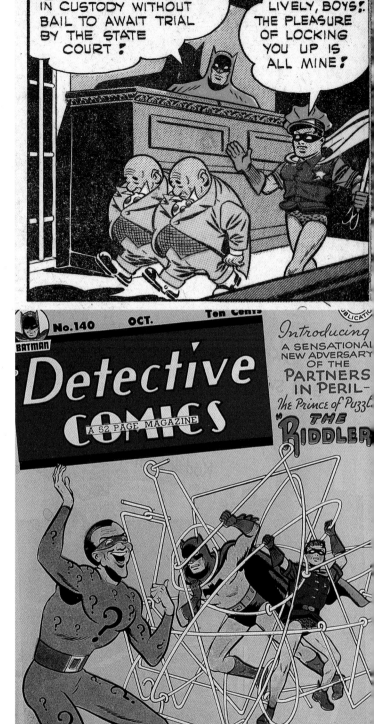

A Halloween mood pervades Bob Kane's spectacular panel, which introduced the Scarecrow in *World's Finest Comics #3* (Fall 1941). Script: Bill Finger. Inks: Jerry Robinson and George Roussos.

Fans got their first look at the Riddler on Win Mortimer's cover for October 1948, but this late-blooming malefactor, created by Bill Finger, didn't really take root for almost two decades.

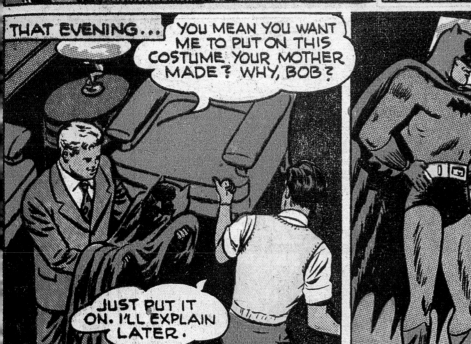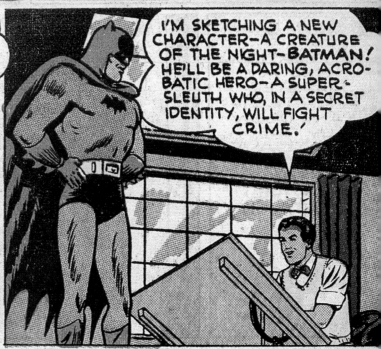

The most famous Batman villains had shown up in the strips, especially the spectacular color Sunday pages, which kicked off on November 7, 1943, by introducing a Penguin story. Two-Face arrived in one of the last sequences, where Bill Finger surprisingly decided to kill him off. Two-Face did of course return; it's not as if great villains were easy to find, and editor Jack Schiff was acutely aware that Batman needed "somebody powerful to fight against." Coming up with a gimmick that could carry a crook through a single story was comparatively simple, but creating a permanent addition to the pantheon was something else entirely. The old inspiration wasn't entirely there anymore, but a few criminals were strong enough to stage the occasional comeback.

The Scarecrow looked promising when he made his debut in *World's Finest Comics* #3 (Fall 1941), but burned out after only one more story. He was shabby psychology professor Jonathan Crane, who adopted a corny costume and embarked on a crime wave of intimidation and extortion. (Perhaps smarter than he seemed, the Scarecrow would resurface decades later and take up apparently permanent residence in Gotham City.) Criminal cousins Deever and Dumfree Tweed, better known as Tweedledum and Tweedledee, first showed up in *Detective Comics* #74 (April 1943) and lasted for three stories. The Rotund Rascals were obviously derived from the identical oddballs in Lewis Carroll's *Alice's Adventures in Wonderland* (1865), which also inspired a longer-lived knave, the Mad Hatter, in *Batman* #49 (October–November 1948). Not so lucky was the Cavalier, who got his start in *Detective Comics* #81 (November 1943). He was Mortimer Drake, a prominent playboy like Bruce Wayne who adopted the guise of a swashbuckling seventeenth-century swordsman and became a thief, seemingly out of sheer boredom. He looked like one more tribute to Douglas Fairbanks, but fans apparently considered him something of a lightweight, and he lasted for only four stories. Still, he managed to get away from Batman in the first three of them and was caught at last only after he kidnapped a whale and held it for ransom. The Cavalier may have been killed in prison, since—unlike so many colleagues—he apparently never got out.

Of all the rogues that didn't seem to make the grade, none looks more obviously promising in retrospect than the Riddler. His debut in *Detective Comics* #140 (October 1948) represented a superb example of story breakdown and page design by Dick Sprang, while the Riddler as delineated by Bill Finger was the quintessential Batman foe.

Above: *Real Fact Comics* #5 (November–December 1946) presented this fanciful version of Batman's creation. Pencils and inks by Win Mortimer.

Opposite: Alfred is all tied up in his work in Jerry Robinson's splash panel from *Batman* #31 (October–November 1945).

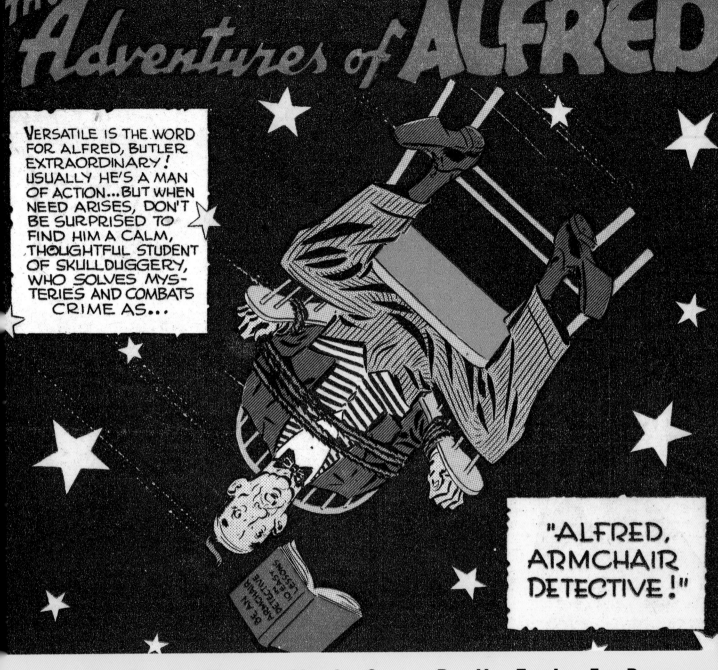

# THE Adventures of ALFRED

VERSATILE IS THE WORD FOR ALFRED, BUTLER EXTRAORDINARY! USUALLY HE'S A MAN OF ACTION...BUT WHEN NEED ARISES, DON'T BE SURPRISED TO FIND HIM A CALM, THOUGHTFUL STUDENT OF SKULLDUGGERY, WHO SOLVES MYSTERIES AND COMBATS CRIME AS...

"ALFRED, ARMCHAIR DETECTIVE!"

# B A T M A N ' S   B U T L E R

Being Bruce Wayne by day and Batman by night must have made it tough for a hero to find time to sleep, much less keep up the mansion he had inherited. That seems to have been the rationale behind the emergence of Alfred Pennyworth, the gentleman's gentleman who became Batman's manservant in 1943. He arrived unannounced and unexpected in *Batman #16* (April–May 1943), a rotund British butler whose father had once worked for Bruce Wayne's. Before Wayne and Dick Grayson could figure out what to do with him, he had stumbled onto their secret identities, and thus became part of their team. Originally intended as comedy relief, he eventually became a resourceful and intelligent figure, and at times more vital to Batman's well-being than even Robin was.

Evidence suggests that Alfred was created by the writers of the 1943 *Batman* serial (Victor McLeod, Leslie Swabacker, and Harry Fraser), and that DC Comics asked Don Cameron to write the first Alfred story to conform to Hollywood's version of the Wayne household. Cameron couldn't have known, however, that the forthcoming movie Alfred (William Austin) was decidedly slender. The chubby comic book version promptly went on a diet, and grew a mustache too. The initial joke was that Alfred imagined he could become a detective himself, but this wore thin in a few years—if not before Alfred had acquired his own series of humorous short stories, "The Adventures of Alfred," in the back pages of *Batman*. It ran for years and included some of Jerry Robinson's last drawings of the denizens of Wayne Manor.

Others might leave clues for their detective nemesis because their obsessions were out of control, but Edward Nigma was obsessed with clues themselves and could not commit a crime without producing a puzzle to help Batman solve it. His costume covered with question marks, the Riddler followed the classic pattern that had become Finger's narrative trademark. Batman would encounter his opponent three times: losing the first fight, earning a draw in the second, and finally triumphing in the third. It was formula, no doubt, but also an innately satisfying story structure that embodied elements of myth and folklore. Another fine Riddler tale appeared

two months after the first, and then E. Nigma disappeared. He lay dormant until 1965—only then would he begin to gain recognition as one of Gotham City's master malefactors.

During the decade when these imaginary madmen were striving to achieve a taste of comics immortality, the United States was engaged in a terrible war against an enemy that was all too real. Many super heroes got their start experiencing World War II adventures, and indeed, it has been theorized that such characters owed their great popularity to emotions engendered by the conflict. Batman could be seen battling the enemy or at least selling bonds on many a comic book cover, but actual stories in which he fought the Axis were comparatively few. His was a hermetically sealed fantasy world, one where references to Alice in Wonderland were not too far off the mark, and his one significant World War II epic was his first motion picture, the Columbia serial *Batman* (1943).

In the days before television, movie serials were the equivalent of a TV series, with weekly chapters of less than a half hour in length being shown at local cinemas. They were intended for children and were generally not well made, especially by Columbia, which somehow ended up with the rights to both Batman and Superman. *Batman* isn't very good, but it's interesting as a cultural artifact. The villain is a Japanese spy named Daka (played by Caucasian actor J. Carroll Naish), whose hobby is turning Americans into mind-controlled "zombies," while his actual job is stealing radium for a device he calls an atom disintegrator. Considering that the war ended when the United States dropped an atom bomb on Japan, it's perhaps lucky that Batman and Robin were around, but there's something unpleasant about the film's attitude toward Japanese-Americans, and the narrator's smug announcement that "a wise government rounded up the shifty-eyed Japs."

Well, there was a war on, but there's no excuse at all for Lewis Wilson's portrayal of Batman as an

Above: Original cover art for *Batman* #30 (August–September 1945), pencilled and inked by Dick Sprang.

upper-class twit, or for Douglas Croft's smug performance that turns Robin into a kid you have to hate. These two can hardly be bothered to fight crime, and respond to a plea from Bruce Wayne's girlfriend, Linda Page (Shirley Patterson), by saying they'll attempt a rescue the next morning, when they've had time to pack. After a leisurely drive to the scene of the crime in a convertible that also serves as the Batmobile, and which has a little trailer in tow, the pair take a long pause to discuss the advisability of suiting up and going into action. Most of the serial is maddening in this manner, but it did provide a name and new emphasis for the Batcave, which the comics would then expand into the greatest hideout a kid could imagine. Apparently the writers were cave-crazy, since they also came up with a Cave of Horrors for Dr. Daka and a third cave that served as a radium mine. The serial was directed by Lambert Hillyer, who did much better by bats with his 1936 feature *Dracula's Daughter.*

Columbia waited until 1949 to release a second serial, *Batman and Robin,* but it wasn't much of an improvement. Many people think it's worse, and it was almost certainly cheaper, but it had a sturdier

Batman in actor Robert Lowery, and at least this time there was no propaganda about inferior races. Instead there was a hooded villain called the Wizard, a serial stereotype but nonetheless not too different from several scofflaws who had shown up in the comics. This time the leading lady was

Left: Matt Crowley, radio's Batman. Below: Batman appeared on radio in the comics, when Dick Sprang drew him as a contestant on real-life quizmaster Kay Kyser's *College of Musical Knowledge,* for *Detective Comics #144* (February 1949). Script: Edmond Hamilton. Inks: Charles Paris.

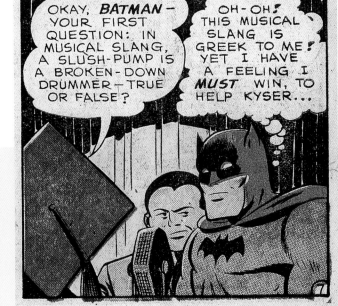

# BATMAN'S BACKSTAGE BROADCASTS

Batman spent years as Superman's radio guest star, and if he never got a show of his own, it wasn't for lack of trying. Two serious attempts were made to get the Caped Crusader on the air, the first in World War II. All that remains is a script, but it's believed that it was recorded, with Scott Douglas in the starring role. The opening wasn't as snappy as Superman's famous "faster than a speeding bullet" introduction, but it did inform listeners curious about Batman that "his keen brain and athlete's body, combined with almost unbelievable acrobatic skill, have made the horned black mask and the flapping black cape the symbol of law and decency." Since Batman's ears are described as horns, it's possible that someone watched the 1943 serial, which could have made Batman seem more commercial, but the pilot didn't sell. The story, called "The Case of the Drowning Seal," was a variant on Robin's origin, with the boy's parents, now F.B.I. agents as well as circus stars, killed by Nazi spies. The seal of the title was trained to flap his flippers in code, and when Bruce Wayne switched to Batman, he used an English accent to protect his identity.

Batman's second try came in 1950, with a fifteen-minute recording, recently rediscovered, for a proposed show called *The Batman Mystery Club.* The script was by Don Cameron, an accomplished contributor to the comics, and his story, "The Monster of Dumphrey's Hall," was intriguing. Good enough, in fact, that it's frustrating never to hear the solution to the mystery of a haunted room whose tenants are said to die at the hour of midnight. It would have been hard to sell the program in 1950, when radio drama was giving way to TV, but what probably killed it was the format. *The Batman Mystery Club* was a group of kids being lectured by the Caped Crusader (John Emery), using strict parliamentary procedure, and apparently every episode was intended, in Batman's words, "to prove that ghosts and apparitions are only figments of man's imagination." The oddly narrow focus was apparently Cameron's idea: he was writing a book on the occult when he died in 1954, at the age of forty-eight.

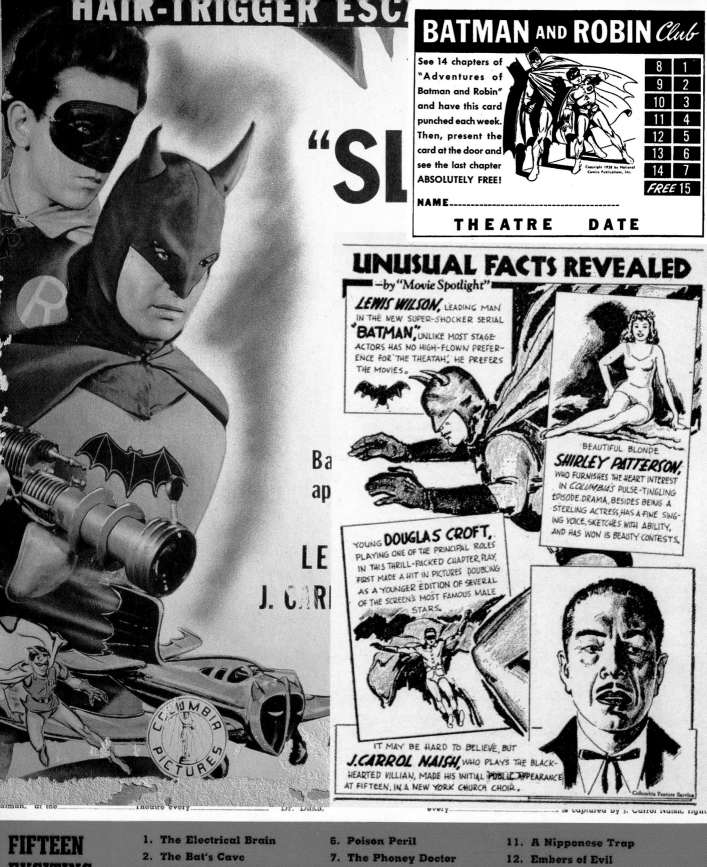

HAIR-TRIGGER ESCA...

"SL...

## UNUSUAL FACTS REVEALED
— by "Movie Spotlight"

LEWIS WILSON, LEADING MAN IN THE NEW SUPER-SHOCKER SERIAL "BATMAN," UNLIKE MOST STAGE ACTORS HAS NO HIGH-FLOWN PREFERENCE FOR 'THE THEATAH,' HE PREFERS THE MOVIES.

BEAUTIFUL BLONDE SHIRLEY PATTERSON, WHO FURNISHES THE HEART INTEREST IN COLUMBIA'S PULSE-TINGLING EPISODE-DRAMA, BESIDES BEING A STERLING ACTRESS, HAS A FINE SINGING VOICE, SKETCHES WITH ABILITY, AND HAS WON 15 BEAUTY CONTESTS.

YOUNG DOUGLAS CROFT, PLAYING ONE OF THE PRINCIPAL ROLES IN THIS THRILL-PACKED CHAPTER PLAY, FIRST MADE A HIT IN PICTURES DOUBLING AS A YOUNGER EDITION OF SEVERAL OF THE SCREEN'S MOST FAMOUS MALE STARS.

IT MAY BE HARD TO BELIEVE, BUT J. CARROL NAISH, WHO PLAYS THE BLACK-HEARTED VILLIAN, MADE HIS INITIAL PUBLIC APPEARANCE AT FIFTEEN, IN A NEW YORK CHURCH CHOIR.

Columbia Feature Service

COLUMBIA PICTURES

Ba...
ap...
LE...
J. CAR...

Batman, at the ............... Theatre every ............... Dr. Daka. ............... every ............... is captured by J. Carrol Naish, right.

# FIFTEEN EXCITING CHAPTERS

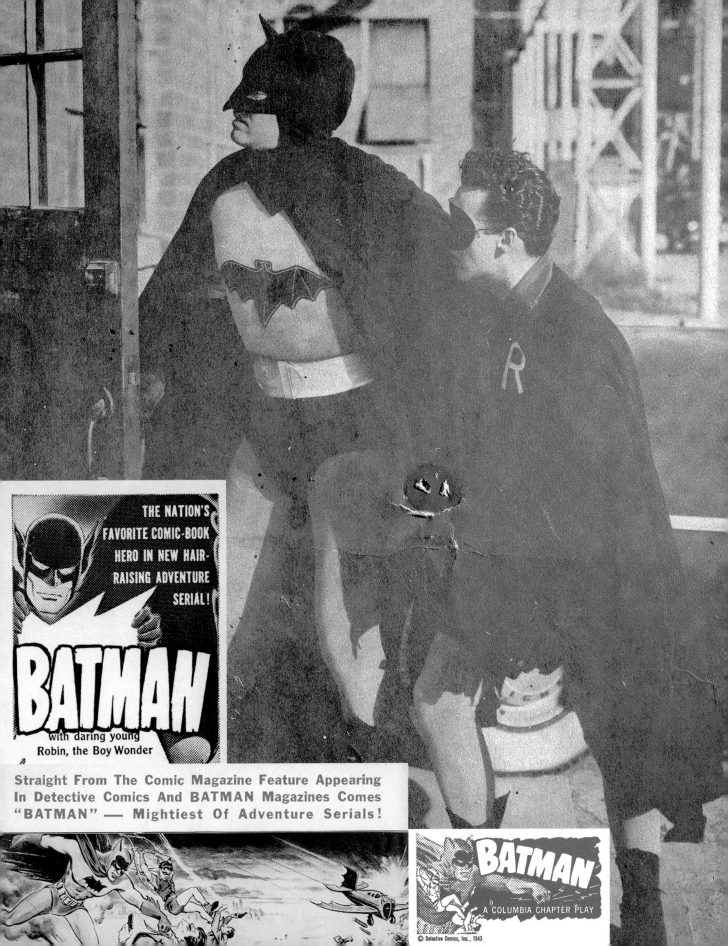

THE NATION'S
FAVORITE COMIC-BOOK
HERO IN NEW HAIR-
RAISING ADVENTURE
SERIAL!

# BATMAN

with daring young
Robin, the Boy Wonder

Straight From The Comic Magazine Feature Appearing
In Detective Comics And BATMAN Magazines Comes
"BATMAN" — Mightiest Of Adventure Serials!

**BATMAN**

A COLUMBIA CHAPTER PLAY

© Detective Comics, Inc., 1943

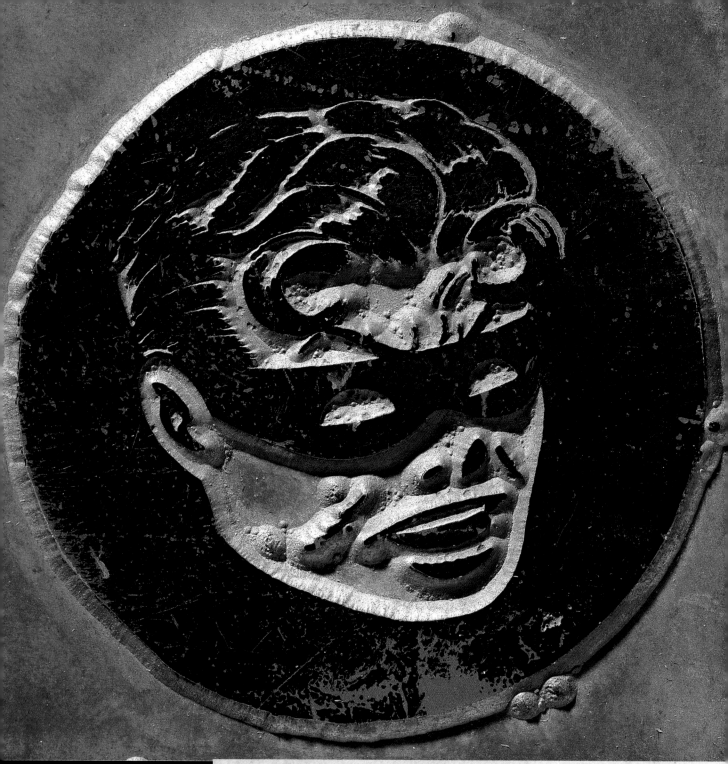

Above: This object of lead and wood was used to print Robin's image on comic books in the 1940s and 1950s.

Right: A portion of Bob Kane's snappy stationery, circa 1940s.

Opposite: This solo Robin story from *Star Spangled Comics* #111 (December 1950) reinforced the relationship between the Batman characters and fictional detectives of the past. Pencils by Jim Mooney. Inks by Charles Paris.

*Bob Kane* CARTOONIST
CREATOR OF
**BATMAN AND ROBIN**
▼
DETECTIVE COMICS, INC.
480 LEXINGTON AVENUE
NEW YORK 17, N. Y.

MARGIE

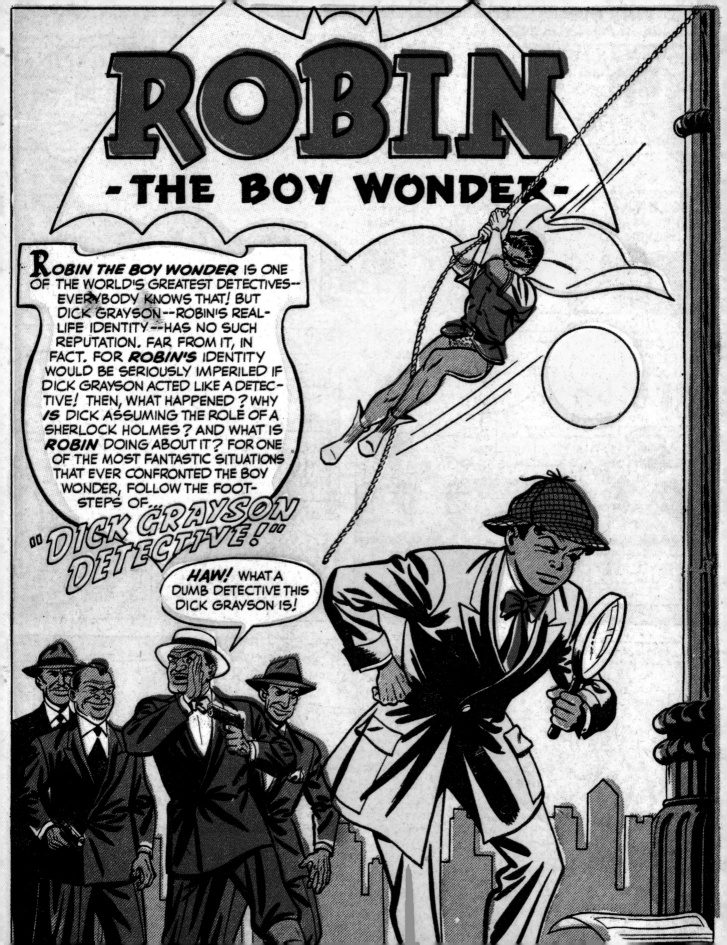

Batman's latest flame in the comics, Vicki Vale (Jane Adams). Her brother, a bad apple named Jimmy, fell to his death wearing Batman's costume, which didn't seem to upset her much and at least was a fairly ingenious way of explaining how the Caped Crusader eluded doom at the end of one chapter. Spencer Bennet was the director, and the producer, famous for cutting corners, was Sam Katzman. The serials may have been "knocked out in about ten days," as Bob Kane lamented, but they reached millions and almost certainly increased sales of the Batman comics.

The largest audience of this era, however, was the one listening to radio. Before TV, radio's comedy and drama shows made this medium the biggest thing in home entertainment, and Batman was there. However, as in the case of newspaper comic strips, Superman got there first. As a result, Batman ended up playing guest star to his predecessor and never got a program of his own. *The Adventures of Superman* started in 1940, but Batman didn't show up until 1945, by which time the actor playing Superman, Bud Collyer, felt he had earned some time off. Conventional wisdom states that Batman and Robin were introduced only so Collyer could go on vacation, but the three characters worked together in their first adventure. Actually Robin showed up first, soliciting Superman's help to rescue his partner from the evil Zoltan's wax

museum, where Batman was trapped in a state of suspended animation. Ultimately released, Batman bitterly declared, "No one is going to make a dummy out of me." More often it was Superman who needed rescuing, falling into comas after exposure to the alien element kryptonite, and thus obliging Batman and Robin to carry on without him. On one occasion a blast from the green stuff gave the Man of Steel amnesia, and he wandered off to become an amazing baseball player. Most plots made Batman a subsidiary character, but once, when Superman's girlfriend Lois Lane was charged with murder, it was the star of *Detective Comics* who dug up the evidence that freed her. There were a few radio Batmans over the years, but Matt Crowley usually played the role, with Ronald Liss as Robin.

Throughout the 1940s Batman appeared in newspapers, movies, and radio; the exposure helped make him a household name for millions who never bought a comic book. Still, DC was providing by far the best view of this hero who was slowly becoming an American icon. The end of World War II hurt sales figures for several super heroes, including those who had been appearing in DC's flag-waving *Star Spangled Comics*. To keep the title afloat, Robin was given his own stories, featured on the cover, beginning with *Star Spangled Comics* #65 (February 1947). Batman made a number of guest appearances with the Boy Wonder, which meant that the Caped Crusader was now showing up in four different comic books.

A year later, Batman achieved some sort of epiphany in *Batman* #47 (June–July 1948), when he finally tracked down the murderer of his parents. The killer was Joe Chill, now a white-haired racketeer and head of a trucking company. Confronted by Batman, who wouldn't kill him and couldn't get the proof to convict him, Chill rushed to tell his cohorts just whose lives he'd snuffed out, and they immediately gunned him down for inspiring their worst enemy's crusade against crime. "I guess you

Above: Vicki Vale was Batman's longest-lasting girlfriend (1948 to 1963), but Commissioner Gordon has been his ally since 1939. Art by Dick Sprang and Charles Paris from *Batman* #81 (February 1954).

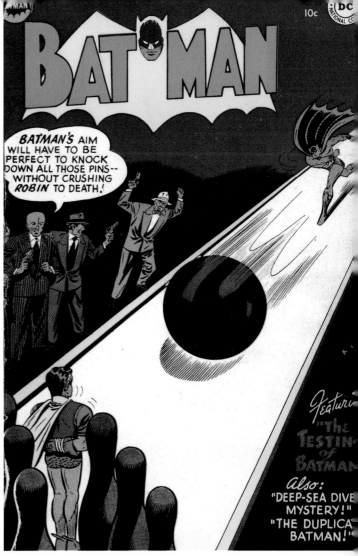

got me," groaned Chill as he died in Batman's arms. The story could have been the end of the series and the beginning of a new life for Bruce Wayne, but nobody even thought of such a thing. Readers who missed that issue not only missed Joe Chill, but could be forgiven for never even knowing about the trauma that had created Batman in the first place.

The Joker's big moment of truth came in *Detective Comics* #168 (February 1951). In "The Man Behind the Red Hood," an origin for the Ace of Knaves emerged. The Joker was a lab worker exposed to a pool of chemical wastes while robbing the Monarch Playing Card Company, and he dyed for his sins, turning red, white, and green. This was a watershed story, although its impact did not register for years. Heretofore the Joker had been the Clown at Midnight, the Acolyte of Absurdity, a fantastic figure from a nightmare whose rictus grin of death had denigrated all human endeavor. Batman had been the control freak, and the Joker had been chaos. Now, for the sake of rationality, the spirit of anarchy was squeezed down into the body of an embittered employee who took the wrong kind of dive. In years to come, literal-minded writers would embrace this concept, despite its chemical improbability, and the Joker would be perhaps a bit diminished. It would not be humor that would do him in—this was his stock-in-trade, after all—but rather the attempt to turn the mythic into the mundane.

Meanwhile, the scripts of Bill Finger, interpreted by the pencils of Dick Sprang and the inks of Charles Paris, reached new heights of ingenuity and inspiration. "Writing for comics is a difficult job," Finger said. "You have to describe a scene so completely that the artist knows exactly or as nearly as possible what to draw." In his determination to make things clear, Finger became known for providing artists with clippings culled from papers and magazines, so they could see exactly what he was talking about. "I once found an article on a giant typewriter used for an exhibition at a trade show and used it as a prop in a script," he recalled. Such oversize objects, built by big businesses to advertise their wares, became crime scenes in countless Batman stories. Spectacular in themselves, these huge props also served to dwarf Batman and Robin, giving them the same perspective as the small children who eagerly embraced the tales. The inflated images also constituted a sly satire on what many Americans held dear, yet passed without notice in a medium nobody took too seriously. In *Batman* #34 (April–May 1946), Dick Sprang drew Batman and Robin capering across the monumental faces of past American presidents carved into Mount Rushmore. More than a decade passed before director Alfred Hitchcock finally got the chance to stage a similar audacious scene in his film *North by Northwest* (1959). He said he had been wanting to do it "for years."

Overleaf: In "The Brain That Ruled Gotham City," from *Detective Comics* #210 (September 1954), Dick Sprang stages a grim melodrama on death row. Charles Paris did the inks, and Walter Gibson probably wrote the script.

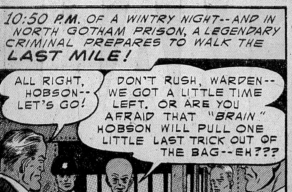

10:50 P.M. OF A WINTRY NIGHT--AND IN NORTH GOTHAM PRISON, A LEGENDARY CRIMINAL PREPARES TO WALK THE LAST MILE!

ALL RIGHT, HOBSON-- LET'S GO!

DON'T RUSH, WARDEN-- WE GOT A LITTLE TIME LEFT. OR ARE YOU AFRAID THAT "BRAIN" HOBSON WILL PULL ONE LITTLE LAST TRICK OUT OF THE BAG--EH???

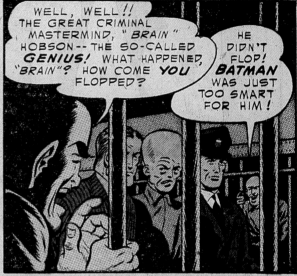

WELL, WELL!! THE GREAT CRIMINAL MASTERMIND, "BRAIN" HOBSON--THE SO-CALLED GENIUS! WHAT HAPPENED, "BRAIN"? HOW COME YOU FLOPPED?

HE DIDN'T FLOP! BATMAN WAS JUST TOO SMART FOR HIM!

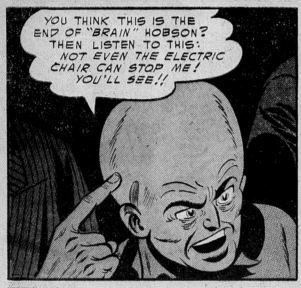

YOU THINK THIS IS THE END OF "BRAIN" HOBSON? THEN LISTEN TO THIS: NOT EVEN THE ELECTRIC CHAIR CAN STOP ME! YOU'LL SEE!!

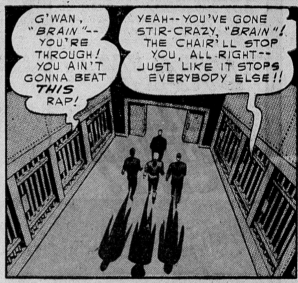

G'WAN, "BRAIN"-- YOU'RE THROUGH! YOU AIN'T GONNA BEAT THIS RAP!

YEAH--YOU'VE GONE STIR-CRAZY, "BRAIN"! THE CHAIR'LL STOP YOU, ALL-RIGHT-- JUST LIKE IT STOPS EVERYBODY ELSE!!

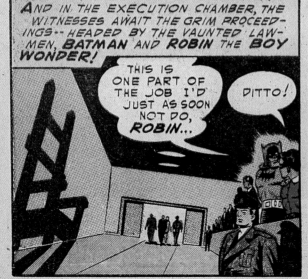

AND IN THE EXECUTION CHAMBER, THE WITNESSES AWAIT THE GRIM PROCEEDINGS--HEADED BY THE VAUNTED LAWMEN, BATMAN AND ROBIN THE BOY WONDER!

THIS IS ONE PART OF THE JOB I'D JUST AS SOON NOT DO, ROBIN...

DITTO!

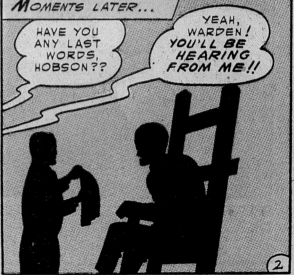

MOMENTS LATER...

HAVE YOU ANY LAST WORDS, HOBSON??

YEAH, WARDEN! YOU'LL BE HEARING FROM ME!!

2

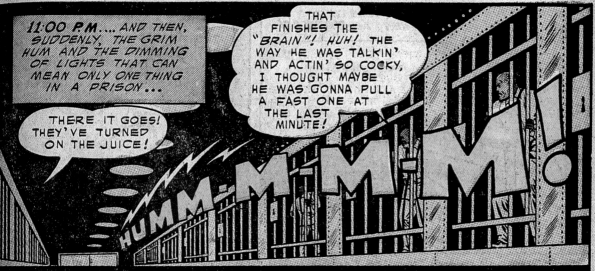

11:00 P.M.... AND THEN, SUDDENLY, THE GRIM HUM AND THE DIMMING OF LIGHTS THAT CAN MEAN ONLY ONE THING IN A PRISON...

THERE IT GOES! THEY'VE TURNED ON THE JUICE!

THAT FINISHES THE "BRAIN"! HUH! THE WAY HE WAS TALKIN' AND ACTIN' SO COCKY, I THOUGHT MAYBE HE WAS GONNA PULL A FAST ONE AT THE LAST MINUTE!

HUMM-M-M-M!

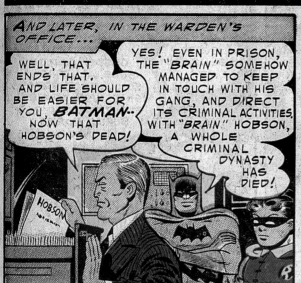

AND LATER, IN THE WARDEN'S OFFICE...

WELL, THAT ENDS THAT. AND LIFE SHOULD BE EASIER FOR YOU, BATMAN-- NOW THAT HOBSON'S DEAD!

YES! EVEN IN PRISON, THE "BRAIN" SOMEHOW MANAGED TO KEEP IN TOUCH WITH HIS GANG, AND DIRECT ITS CRIMINAL ACTIVITIES, WITH "BRAIN" HOBSON, A WHOLE CRIMINAL DYNASTY HAS DIED!

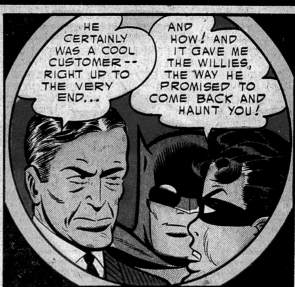

HE CERTAINLY WAS A COOL CUSTOMER-- RIGHT UP TO THE VERY END...

AND HOW! AND IT GAVE ME THE WILLIES, THE WAY HE PROMISED TO COME BACK AND HAUNT YOU!

ALL AT ONCE...

WARDEN! WARDEN! THERE'S BEEN A BREAK!

A BREAK? BUT I HEARD NO ALARM! WHO ESCAPED?

"BRAIN" HOBSON!! HIS BODY HAS DISAPPEARED FROM THE PRISON MORGUE! IT'S GONE!!

WHAT?

3

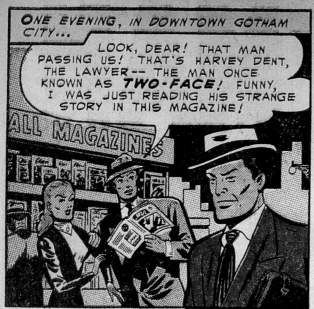

ONE EVENING, IN DOWNTOWN GOTHAM CITY...

LOOK, DEAR! THAT MAN PASSING US! THAT'S HARVEY DENT, THE LAWYER-- THE MAN ONCE KNOWN AS *TWO-FACE*! FUNNY, I WAS JUST READING HIS STRANGE STORY IN THIS MAGAZINE!

HOW'S THAT FOR COINCIDENCE! I BUY A MAGAZINE WITH *TWO-FACE'S* STORY IN IT-- AND A MOMENT LATER, HE COMES WALKING BY IN THE FLESH!

**THE STRANGE CAREER OF TWO-FACE**

HARVEY DENT WITH HIS FACE RESTORED BY PLASTIC SURGERY

HARVEY DENT AS HE LOOKED AFTER THE ACCIDENT WHICH TURNED HIM INTO *TWO-FACE*, THE DESPERATE CRIMINAL

By

YES, HARVEY DENT IN THE FLESH---AND COMPLETELY UNAWARE OF THE TWIST OF FATE THAT LIES WAITING FOR HIM JUST MINUTES AWAY!

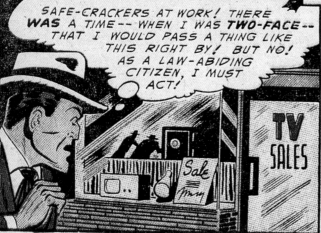

SAFE-CRACKERS AT WORK! THERE *WAS* A TIME-- WHEN I WAS *TWO-FACE*-- THAT I WOULD PASS A THING LIKE THIS RIGHT BY! BUT NO! AS A LAW-ABIDING CITIZEN, I MUST ACT!

TV SALES

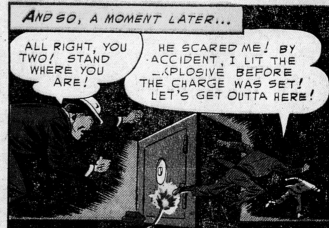

AND SO, A MOMENT LATER...

ALL RIGHT, YOU TWO! STAND WHERE YOU ARE!

HE SCARED ME! BY ACCIDENT, I LIT THE EXPLOSIVE BEFORE THE CHARGE WAS SET! LET'S GET OUTTA HERE!

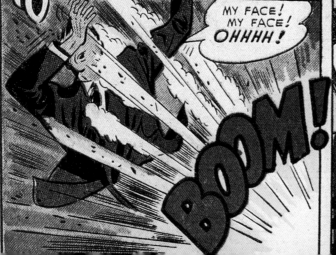

SO INTENT IS HE ON CAPTURING THE CROOKS, DENT FAILS TO HEED THE DANGER-SIGNS! ALL AT ONCE...

MY FACE! MY FACE! OHHHH!

BOOM!

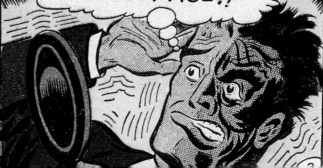

RUSHING BLINDLY OUT OF THE STORE, HIS FACE SEARED WITH PAIN, DENT HAILS A CAB WHICH TAKES HIM HOME. THEN, IN THE PRIVACY OF HIS BEDROOM...

LOOK AT ME! THE EXPLOSION HAS UNDONE ALL MY PLASTIC SURGERY-- I HAVE BECOME *TWO-FACE*!! *TWO-FACE* *TWO-FACE*!!

Bill Finger came up with such colorful concepts by dint of constant research. His son Fred recalled how, after Finger's divorce, father and son would spend weekends visiting museums, zoos, planetariums, and any other site that might provide a springboard for a Batman story. "Sometimes I'd be working all night on a script, depending on how an idea hit," Bill Finger once confessed in an interview, but in fact he was always battling against deadlines and usually lost. The good work didn't come easily for him. Dick Sprang, who loved the West, had moved to Arizona after the war, and was working through the mail. Sometimes he would receive only part of a script, but would have to draw completed pages and send them on to DC without knowing how the story would end. "If Bill had created some outlandish machine or character that I knew would come up later in the story, I had to make a tracing of my concept in the pages I was turning loose, and this required some careful figuring," he admitted. Yet Finger, a frustrated fantasist whose son remembered him as always "lying on his back, dreaming," was, in Sprang's words, "the best comics writer I ever encountered."

As the 1950s unfolded, the Batman comics featured funny stories about a frantic, frustrated Joker acting like a fugitive from Looney Tunes, and sinister stories like the one about a condemned criminal whose disembodied brain survived his electrocution to become the leader of his gang. Crime and horror comics were crowding the super heroes off the shelves, and the Batman chroniclers responded with "Two-Face Strikes Again" in *Batman* #81 (February 1954). This eruption of evil, one of the most frequently reprinted stories in the Batman canon, brought Batman's most frightening foe back into the spotlight, even though he'd been killed in the newspaper strips and also cured and redeemed in DC's comic books back in 1943. Two-Face was like a scab that had to be scratched, however, and three improbable stories had already appeared in which miscreants had disguised themselves as Two-Face, so that the character could show up in the comics without compromising his reformation. It wasn't enough, however, so in *Batman* #81 the innocent attorney now known as Harvey Dent attempted to prevent a burglary and had his patched-up face blown off again for his trouble. There was no justice in it, any more than there had been when Bruce Wayne's parents died, but Two-Face had been set loose again.

He wouldn't be back for seventeen years, because 1954 had also seen the publication of something far more frightening: a book by Fredric Wertham called *Seduction of the Innocent*. This lengthy tirade, the culmination of Dr. Wertham's campaign against comic books, was a surprisingly successful attempt to persuade Americans that comics were corrupting their children, luring them into acts of sex and violence. The effect on the industry was devastating, and Batman was very nearly destroyed.

1,000,000 GOTHAM CITY BANK NOTE 1,000,000

EVEN THE FIENDISH MIND OF THAT ARCH PRANKSTER, THE **JOKER**, COULD NEVER HAVE CONCEIVED A SITUATION AS BIZARRE AS THE ONE WHICH YOU ARE ABOUT TO DISCOVER! FOR NOW, THROUGH A FANTASTIC CIRCUMSTANCE, THE UNDERWORLD'S JESTER DOFFS HIS COMIC ROLE TO EMERGE AS ONE OF THE WORLD'S RICHEST MEN-- A VERITABLE MODERN-DAY MIDAS! AND STARTLING AS IT SEEMS-- EVEN THE DARING DUO, **BATMAN** AND **ROBIN**, MUST NOW KEEP "HANDS OFF" THE CRIMINAL ENEMY! HERE IS A STORY OF GOLDEN GAGS AND WHACKY WEALTH WHEN THE CRIME CLOWN STARTS SPENDING...

"THE JOKER'S MILLIONS!"

1,000,000 ONE MILLION DOLLARS 1,000,000

HERE, BOY! DUST OFF THIS PLUSH CARPET BEFORE I MAKE MY ENTRANCE! HERE'S A $100 TIP FOR YOUR TROUBLE!

BOB KANE

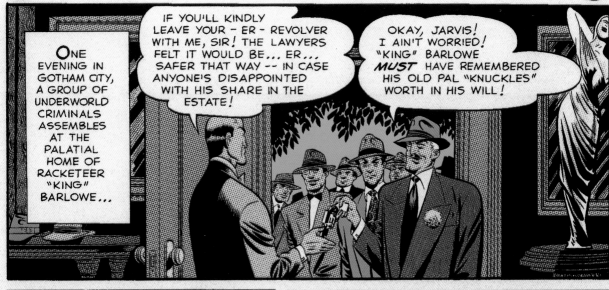

ONE evening in GOTHAM CITY, A GROUP OF UNDERWORLD CRIMINALS ASSEMBLES AT THE PALATIAL HOME OF RACKETEER "KING" BARLOWE...

IF YOU'LL KINDLY LEAVE YOUR - ER - REVOLVER WITH ME, SIR! THE LAWYERS FELT IT WOULD BE... ER... SAFER THAT WAY -- IN CASE ANYONE'S DISAPPOINTED WITH HIS SHARE IN THE ESTATE!

OKAY, JARVIS! I AIN'T WORRIED! "KING" BARLOWE *MUST* HAVE REMEMBERED HIS OLD PAL "KNUCKLES" WORTH IN HIS WILL!

BUT EVEN AMONG THIS BIZARRE CREW, ONE FIGURE STANDS OUT AS THE STRANGEST OF THE LOT -- IT IS THAT CLOWN PRINCE OF CRIME, THE *JOKER!*

HEY, JOKER! WHAT ARE *YOU* DOIN' HERE? YOU WERE THE LATE "KING" BARLOWE'S *ENEMY!* WHAT DO YOU THINK HE LEFT YOU IN HIS WILL, HIS PARKING TICKETS? HA, HA!

THE LAWYERS ASKED ME TO COME AND THE JOKER NEVER TURNS DOWN AN INVITATION!

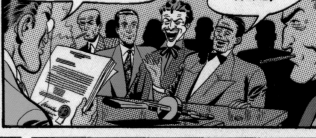

AND PRESENTLY, AS THE CRIMINAL ASSEMBLAGE GATHERS TO LEARN HOW EACH WILL SHARE IN THE FORTUNE OF THE DECEASED UNDERWORLD CZAR...

THIS IS THE LAST WILL AND TESTAMENT WRITTEN BY WILLIAM "KING" BARLOWE SIX MONTHS BEFORE HIS... ER... UNFORTUNATE DEATH BY SHOOTING WHILE TRYING TO ESCAPE FROM PRISON. "FIRST, TO MY TRUSTED FRIEND 'WAXEY' GATES..."

GOOD OLD KING! I KNEW HE'D REMEMBER ME! WHAT A PAL!

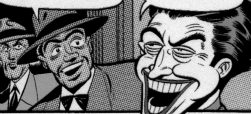

"...I LEAVE THE BLACKJACK I TOOK AWAY FROM HIM AFTER HE TRIED TO BRAIN ME WITH IT WHEN WE WERE KIDS JUST OUT OF REFORM SCHOOL!"

WHAT? WHY THAT CHEAP, NO GOOD... AH...AH... *CROOK!* WITH HIS MILLIONS IN LOOT ALL HE LEAVES ME IS...!

HA, HA! YOUR OLD *PAL!* HA, HA!

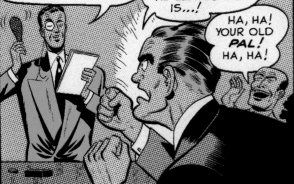

AND AS THE READING OF THE WILL CONTINUES...

"...TO MAKE SURE HE KNOWS HOW MUCH I THOUGHT OF HIM -- I BEQUEATH TO *BATMAN* -- ONE PENNY!"

HA HA!

HA, HA!

HA, HA!

2

AND FINALLY...

WHAT ABOUT THE KING'S **BIG** DOUGH? HE HAD OVER FIVE MILLION BUCKS WORTH OF LOOT STASHED AWAY!

YEAH! WHO'S GONNA GET THAT?

NOW, NOW, GENTLEMEN! I'M COMING TO THAT! "THE REMAINDER OF MY ESTATE, A MILLION DOLLARS IN CASH PLUS A FORTUNE IN JEWELS, GOLD, PLATINUM AND OTHER VALUABLES GOES TO..."

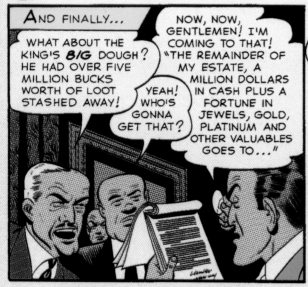

"...THE JOKER!"

WHAT? BUT THE JOKER WAS KING'S ENEMY! I WAS HIS PAL AND ALL I GOT WAS A BROKEN DOWN TOMMY-GUN! THIS AIN'T FAIR!

AS USUAL, BOYS, I HAVE THE LAST LAUGH! HA, HA, HA, HA, HA, HA!

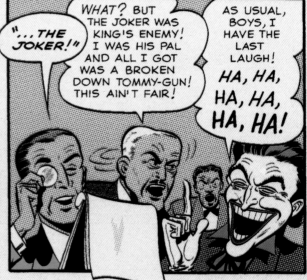

AND SO, IN THE DAYS WHICH FOLLOW, TO THE HOME OF THE CRIME CLOWN COMES A FORTUNE WORTHY OF A MIDAS...

AH, YES! THE PACKAGES OF 100 DOLLAR BILLS! THEY GO IN THE BASEMENT, BOYS, NEXT TO THE THOUSANDS!

BUT NOW THE JOKER DECIDES TO LIVE IN A STYLE TO WHICH HE IS NOT ACCUSTOMED...

I CAN'T STAY IN THE DUMP I'VE BEEN LIVING IN SINCE I WAS RELEASED FROM PRISON-- MUST FIND SOMETHING SUITABLE FOR A **MILLIONAIRE**!

BUT...BUT, SIR! THIS MANSION HAS 87 ROOMS!

NO, NO! THIS HOUSE IS MUCH TOO SMALL! I SAID A **BIG** HOUSE!

AND WITH HIS NEW-FOUND WEALTH, THE JOKER GOES ON A SUPER-SPENDING SPREE...

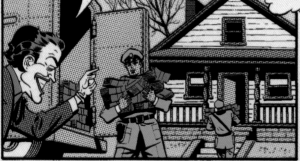

THERE YOU ARE, BOY! A $100 TIP FOR YOUR TROUBLE!

THERE'S BRUCE WAYNE, THE WEALTHY PLAYBOY! TO THINK THAT I'M NOW DINING AT THE SAME CLUB HE VISITS!

(WHISPER) GET A LOOK AT THE JOKER, BRUCE! HE SURE HAS HIT IT RICH SINCE HE GOT OUT OF PRISON!

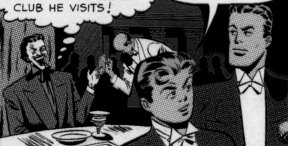

AND LATER, IN THE SECRET **BAT-CAVE** WHERE BRUCE WAYNE AND HIS YOUNG WARD DICK GRAYSON HAVE SWITCHED TO THEIR MORE FAMOUS IDENTITIES OF **BATMAN** AND **ROBIN**...

THE JOKER IS OPENLY BOASTING THAT HE INHERITED KING BARLOWE'S FORTUNE, **ROBIN**! UNFORTUNATELY, WE CAN'T PROVE THAT BARLOWE'S WEALTH IS **STOLEN PROPERTY**!

THEN THE JOKER CAN LEGALLY KEEP IT, **BATMAN**! I WONDER WHAT THE JOKER WILL DO NOW THAT HE DOESN'T HAVE TO ROB TO GET WEALTH?

3

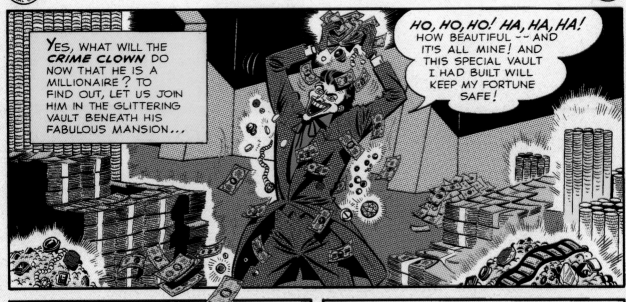

YES, WHAT WILL THE **CRIME CLOWN** DO NOW THAT HE IS A MILLIONAIRE? TO FIND OUT, LET US JOIN HIM IN THE GLITTERING VAULT BENEATH HIS FABULOUS MANSION...

HO, HO, HO! HA, HA, HA! HOW BEAUTIFUL -- AND IT'S ALL MINE! AND THIS SPECIAL VAULT I HAD BUILT WILL KEEP MY FORTUNE SAFE!

AND LATER, IN ONE OF THE MANSION'S MANY ROOMS...

TAKE THIS COAT AWAY, TAILOR! I WANT THE SAME STYLE AND COLOR AS MY REGULAR JACKET OVER THERE!

BUT, SIR! THOSE PADDED SHOULDERS! AND... AND THE COLOR... (GULP)... **LAVENDER!** IT'S SIMPLY NOT DONE, SIR!

HEY, BOSS! WE JUST LINED UP SOMETHIN' SENSATIONAL! COME OUT TO THE OCEANSIDE AMUSEMENT PARK AND WE'LL SHOW YA!

SOON AFTER, A SLEEK CONVERTIBLE STOPS BEFORE ONE OF THE CONCESSIONS ALONG THE BOARDWALK AT OCEANSIDE PARK...

The LAUGH HOUSE

THAT'S THE PLACE WE BEEN TELLIN' YA ABOUT, BOSS! WE LEARNED THAT THE PAYROLL FOR THE WHOLE PARK IS KEPT THERE BEFORE BEIN' HANDED OUT! THE JOB'S A NATURAL FOR YOU, JOKER -- ROBBING THE **LAUGH HOUSE!**

HO, HO! THAT WOULD BE SENSATIONAL! WAIT A MINUTE! WHAT AM I SAYING? I **DON'T** HAVE TO ROB ANY MORE! ALL I'D GAIN IS **MONEY** -- AND I'VE GOT PLENTY OF THAT ALREADY! HA! WITH BARLOWE'S LEGACY, **MY CRIME CAREER IS OVER!**

BUT ONE DAY SOON AFTER, IN THE VAST VAULT BENEATH THE JOKER'S MANSION...

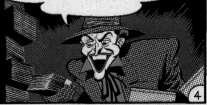

I'VE BEEN SPENDING A LOT LATELY, BUT THERE'S PLENTY MORE WHERE THAT CAME FROM! I'LL JUST GET ANOTHER SUITCASE-FULL FOR POCKET MONEY... SAY! WHAT'S THIS? THIS PACK OF TENS LOOKS STRANGE!

4

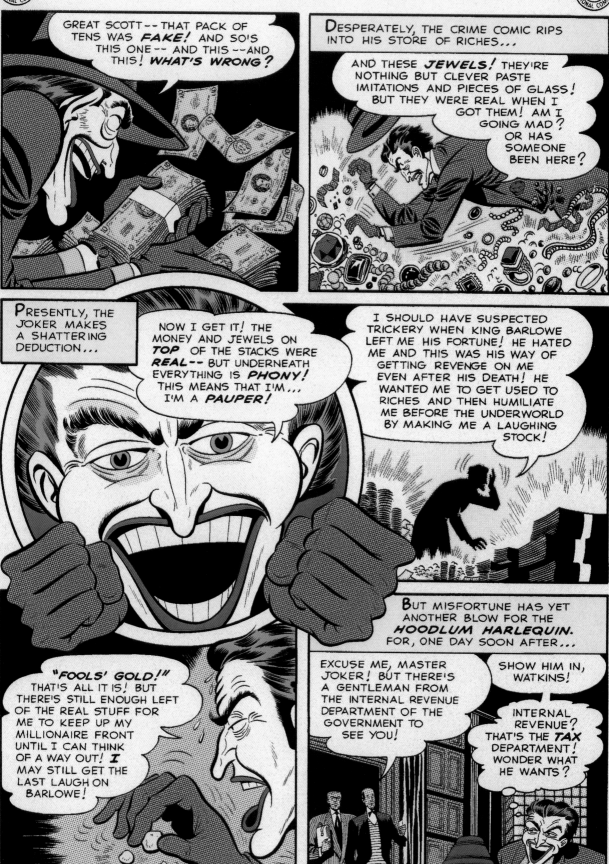

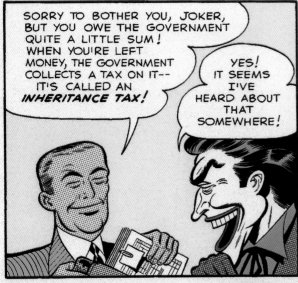

SORRY TO BOTHER YOU, JOKER, BUT YOU OWE THE GOVERNMENT QUITE A LITTLE SUM! WHEN YOU'RE LEFT MONEY, THE GOVERNMENT COLLECTS A TAX ON IT-- IT'S CALLED AN *INHERITANCE TAX!*

YES! IT SEEMS I'VE HEARD ABOUT THAT SOMEWHERE!

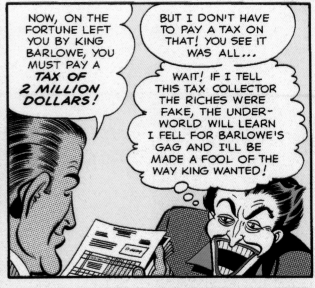

NOW, ON THE FORTUNE LEFT YOU BY KING BARLOWE, YOU MUST PAY A *TAX OF 2 MILLION DOLLARS!*

BUT I DON'T HAVE TO PAY A TAX ON THAT! YOU SEE IT WAS ALL...

WAIT! IF I TELL THIS TAX COLLECTOR THE RICHES WERE FAKE, THE UNDERWORLD WILL LEARN I FELL FOR BARLOWE'S GAG AND I'LL BE MADE A FOOL OF THE WAY KING WANTED!

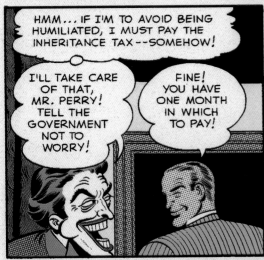

HMM... IF I'M TO AVOID BEING HUMILIATED, I MUST PAY THE INHERITANCE TAX --SOMEHOW!

I'LL TAKE CARE OF THAT, MR. PERRY! TELL THE GOVERNMENT NOT TO WORRY!

FINE! YOU HAVE ONE MONTH IN WHICH TO PAY!

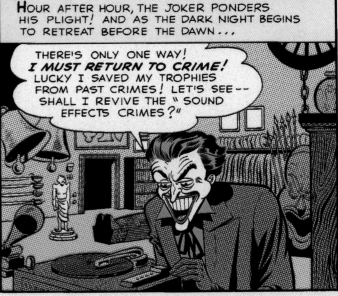

HOUR AFTER HOUR, THE JOKER PONDERS HIS PLIGHT! AND AS THE DARK NIGHT BEGINS TO RETREAT BEFORE THE DAWN...

THERE'S ONLY ONE WAY! *I MUST RETURN TO CRIME!* LUCKY I SAVED MY TROPHIES FROM PAST CRIMES! LET'S SEE-- SHALL I REVIVE THE " SOUND EFFECTS CRIMES?"

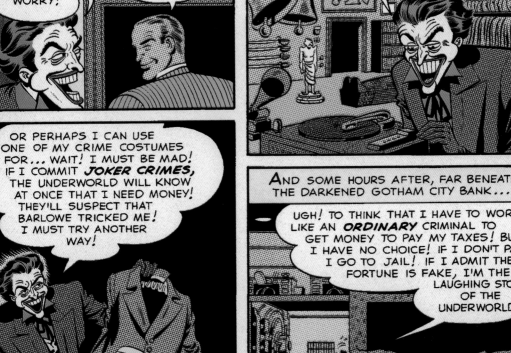

OR PERHAPS I CAN USE ONE OF MY CRIME COSTUMES FOR... WAIT! I MUST BE MAD! IF I COMMIT *JOKER CRIMES,* THE UNDERWORLD WILL KNOW AT ONCE THAT I NEED MONEY! THEY'LL SUSPECT THAT BARLOWE TRICKED ME! I MUST TRY ANOTHER WAY!

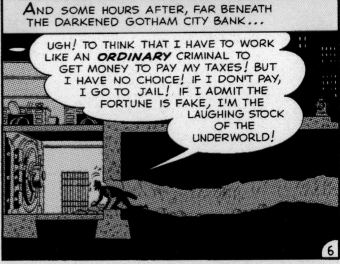

AND SOME HOURS AFTER, FAR BENEATH THE DARKENED GOTHAM CITY BANK...

UGH! TO THINK THAT I HAVE TO WORK LIKE AN *ORDINARY* CRIMINAL TO GET MONEY TO PAY MY TAXES! BUT I HAVE NO CHOICE! IF I DON'T PAY, I GO TO JAIL! IF I ADMIT THE FORTUNE IS FAKE, I'M THE LAUGHING STOCK OF THE UNDERWORLD!

6

DC
SUPERMAN
NATIONAL
COMICS

Detective Comics

DC
SUPERMAN
NATIONAL
COMICS

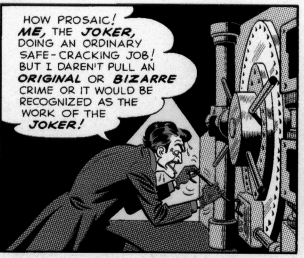

HOW PROSAIC! *ME*, THE *JOKER*, DOING AN ORDINARY SAFE-CRACKING JOB! BUT I DAREN'T PULL AN *ORIGINAL* OR *BIZARRE* CRIME OR IT WOULD BE RECOGNIZED AS THE WORK OF THE *JOKER!*

BUT FATE'S INVISIBLE HAND PLAYS STRANGE TRICKS WITH THE JOKER'S CAREFUL PLAN. FOR SOON AFTER HE LEAVES THE BANK...

AND PRESENTLY...

HELLO, *BATMAN!* THIS LOOKS LIKE A ROUTINE SAFE-CRACKING JOB! THE YEGG GOT AWAY WITH $200,000! WE'LL CHECK UP ON ALL KNOWN SAFE-CRACKERS WHO ARE AT LARGE!

I WONDER HOW "ROUTINE" THIS IS, COMMISSIONER GORDON! TAKE A LOOK AT THAT SIGN!

THAT SIGN FROM A MOVING PICTURE THEATRE! IT SEEMS TO HAVE BEEN PUT THERE ON PURPOSE!

I GET YOU *BATMAN!* IT'S JUST THE SORT OF THING THE *JOKER* WOULD DO IF HE WERE ROBBING A BANK! HUMOROUS LARCENY IS HIS TRADEMARK!

AND LATER...

WHAT A TERRIBLE BREAK! I PLAN AN *ORDINARY* CRIME AND IT TURNS INTO A *LAUGH* CRIME--NATURALLY, I'M SUSPECTED! HMM... I MUST CONTINUE TO LIVE LIKE A MILLIONAIRE TO PUT THEM OFF THE TRACK!

INVITATION TO TAKE MONEY ON BANK WHICH WAS ROBBED!

COME AND GET IT, SAYS SIGN ON BANK-SUSPECT JOKER DID!

BANK NITE ROBBERY POINTS TO JOKER!

THAT NIGHT, AT THE SWANKY PANDA CLUB...

CHAMPAGNE FOR EVERYONE! ON ME, OF COURSE! HERE YOU ARE, WAITER! 100 DOLLARS FOR YOUR TROUBLE!

GOLLY, BRUCE! THE WAD OF MONEY THE JOKER'S CARRYING IS BIG ENOUGH TO CHOKE A HORSE!

UH, OH! HE JUST DROPPED IT, DICK!

HERE! YOU DROPPED THIS...

DON'T TOUCH THAT ROLL OF BILLS! I MEAN... ER...I'LL PICK THEM UP MYSELF!

HMM...THE JOKER CERTAINLY SEEMS UPSET OVER DROPPING THAT MONEY! BRUCE HARDLY HAD HIS FINGERS ON IT WHEN HE GRABBED IT FROM HIM!

7

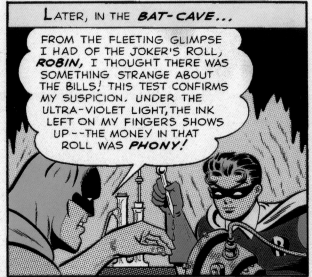

LATER, IN THE *BAT-CAVE*...

FROM THE FLEETING GLIMPSE I HAD OF THE JOKER'S ROLL, *ROBIN*, I THOUGHT THERE WAS SOMETHING STRANGE ABOUT THE BILLS! THIS TEST CONFIRMS MY SUSPICION. UNDER THE ULTRA-VIOLET LIGHT, THE INK LEFT ON MY FINGERS SHOWS UP--THE MONEY IN THAT ROLL WAS *PHONY!*

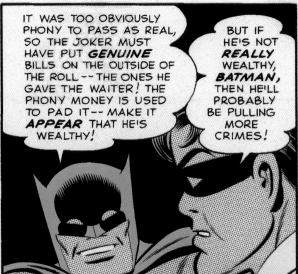

IT WAS TOO OBVIOUSLY PHONY TO PASS AS REAL, SO THE JOKER MUST HAVE PUT *GENUINE* BILLS ON THE OUTSIDE OF THE ROLL -- THE ONES HE GAVE THE WAITER! THE PHONY MONEY IS USED TO PAD IT -- MAKE IT *APPEAR* THAT HE'S WEALTHY!

BUT IF HE'S NOT *REALLY* WEALTHY, *BATMAN,* THEN HE'LL PROBABLY BE PULLING MORE CRIMES!

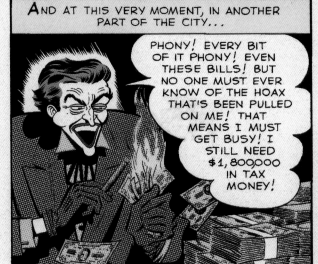

AND AT THIS VERY MOMENT, IN ANOTHER PART OF THE CITY...

PHONY! EVERY BIT OF IT PHONY! EVEN THESE BILLS! BUT NO ONE MUST EVER KNOW OF THE HOAX THAT'S BEEN PULLED ON ME! THAT MEANS I MUST GET BUSY! I STILL NEED $1,800,000 IN TAX MONEY!

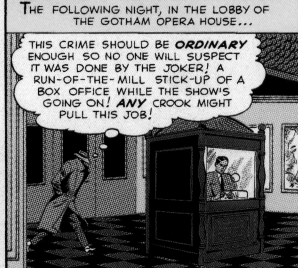

THE FOLLOWING NIGHT, IN THE LOBBY OF THE GOTHAM OPERA HOUSE...

THIS CRIME SHOULD BE *ORDINARY* ENOUGH SO NO ONE WILL SUSPECT IT WAS DONE BY THE JOKER! A RUN-OF-THE-MILL STICK-UP OF A BOX OFFICE WHILE THE SHOW'S GOING ON! *ANY* CROOK MIGHT PULL THIS JOB!

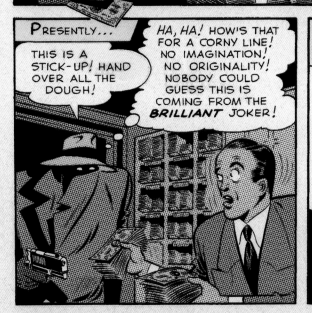

PRESENTLY...

THIS IS A STICK-UP! HAND OVER ALL THE DOUGH!

HA, HA! HOW'S THAT FOR A CORNY LINE! NO IMAGINATION! NO ORIGINALITY! NOBODY COULD GUESS THIS IS COMING FROM THE *BRILLIANT* JOKER!

AND SHORTLY AFTER THE POLICE RADIO HAS ANNOUNCED A ROBBERY AT THE OPERA HOUSE...

THE BOX OFFICE MAN SAID THE ROBBER HAD HIS HAT PULLED WAY DOWN TO COVER ALL HIS HAIR! I WONDER IF THAT COULD HAVE BEEN BECAUSE HIS HAIR WAS *GREEN!* HMM... I'LL JUST TAKE THESE TICKETS AND DESTROY THEM! THEY CAN EASILY BE REPLACED!

BUT THOSE ARE THE TICKETS FOR THE OPERA *I PAGLIACCI!* WHY ARE YOU TAKING THEM, *BATMAN?*

8

THE FOLLOWING EVENING, IN A PLUSH NIGHT CLUB FREQUENTED BY UNDERWORLD BIG SHOTS...

HEY, JOKER! THIS IS DUKE GORMAN! HE JUST BLEW IN FROM THE COAST WITH AN INTRODUCTION FROM THE BIG BOY IN FRISCO! HE'S QUITE A FAN OF YOURS!

YEAH, JOKER! WE'VE HEARD PLENTY ABOUT YOU ON THE COAST! I GOT A BIG KICK OUT OF THE JOB YOU PULLED AT THE OPERA HOUSE LAST NIGHT!

JOB? LAST NIGHT? WHAT ARE YOU TALKING ABOUT?

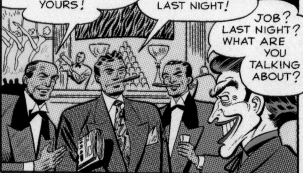

HA, HA! WHO ELSE BUT THE JOKER WOULD TAKE EVERY TICKET FOR PAGLIACCI, THE FAMOUS OPERA ABOUT A CLOWN! IT'S LITTLE TOUCHES LIKE THAT THAT MAKE YOU A GREAT CRIMINAL, JOKER!

WHY...I...ER... I HAD NOTHING TO DO WITH IT! NOTHING!

I CAN'T UNDERSTAND HOW THIS HAPPENED, BUT I MUSTN'T LET ON THAT I PULLED THAT HOLD-UP!

**Gotham Gazette** — ALL PAGLIACCI TICKETS TAKEN FROM OPERA HOUSE... SUSPECT WORK OF THE JOKER!

SOON AFTER...

AT LEAST THIS FAKE MONEY OF KING BARLOWE'S IS OF SOME USE! THIS MANSION I BOUGHT IS COLD AS AN IGLOO AND I CAN'T SPEND ANY OF THE GENUINE MONEY FROM MY LAST TWO JOBS TO BUY FUEL TO HEAT IT-- EVERY PENNY'S NEEDED FOR THE INHERITANCE TAX!

ONLY TWO MORE WEEKS BEFORE THE TAX IS DUE! I MUST PULL SOME MORE JOBS! BUT WHY DO THESE CRIMES, NO MATTER HOW ORDINARY WHEN I EXECUTE THEM, ALWAYS TURN OUT TO HAVE A PRANKISH TWIST WHICH POINTS TO ME? IS IT FATE-- OR IS SOMEONE CAUSING THIS TO HAPPEN?

JANUARY

| S | M | T | W | T | F | S |
|---|---|---|---|---|---|---|
| | | 1 | 2 | 3 | 4 | 5 | 6 |
| 7 | 8 | 9 | 10 | 11 | 12 | 13 |
| 14 | 15 | 16 | 17 | 18 | 19 | 20 |
| 21 | 2 | | | 25 | 26 | 27 |
| 28 | | | | | | |

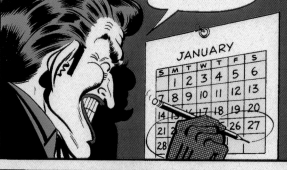

MEANWHILE, IN THE BAT-CAVE...

OH, YOU'RE BACK, BATMAN! TAKING THOSE PAGLIACCI TICKETS SURE MADE THAT BOX-OFFICE ROBBERY LOOK LIKE A JOKER CRIME-- THE PAPERS ARE EATING IT UP! BUT WHAT'S THE POINT?

I'M CERTAIN THE JOKER'S COMMITTING CRIMES, BUT OF THE MOST ORDINARY KIND! I CAN'T PROVE THIS BUT I HAVE A PLAN WHICH MAY MAKE THE JOKER CONFESS!

ATTENTION CAR 72! HOLD-UP CORNER OF ELM AND OTTER STREETS! MAN CARRYING...

I'LL EXPLAIN IT LATER, ROBIN! MEANWHILE, WE MUST FOLLOW UP EVERY ROUTINE POLICE CALL! ANY ONE OF THESE RUN-OF-THE-MILL CRIMES MAY LEAD US TO THE JOKER!

9

BUT AS THE *CRIME-CRUSHERS* SCOUR THE CITY, THE OBJECT OF THEIR SEARCH IS HIMSELF SEARCHING...

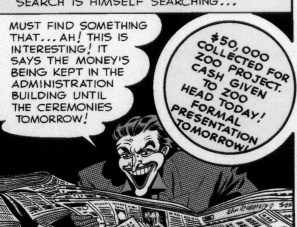

MUST FIND SOMETHING THAT... AH! THIS IS INTERESTING! IT SAYS THE MONEY'S BEING KEPT IN THE ADMINISTRATION BUILDING UNTIL THE CEREMONIES TOMORROW!

$50,000 COLLECTED FOR ZOO PROJECT. CASH GIVEN TO ZOO HEAD TODAY! FORMAL PRESENTATION TOMORROW!

THAT NIGHT, OUTSIDE THE ADMINISTRATION BUILDING AT THE GOTHAM ZOO...

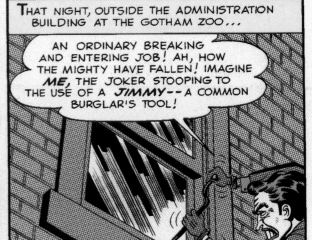

AN ORDINARY BREAKING AND ENTERING JOB! AH, HOW THE MIGHTY HAVE FALLEN! IMAGINE *ME*, THE JOKER STOOPING TO THE USE OF A *JIMMY* -- A COMMON BURGLAR'S TOOL!

AND MOMENTS AFTER, IN THE CRUISING *BATMOBILE*...

ATTENTION CAR 24! THIEF SPOTTED BREAKING AND ENTERING ADMINISTRATION BUILDING AT GOTHAM ZOO! PROCEED AT ONCE!

PROBABLY JUST ANOTHER ROUTINE CRIME, *ROBIN!* BUT WE CAN'T AFFORD TO PASS ANY OF THEM UP! WE NEVER KNOW WHEN WE'LL RUN ACROSS THE JOKER!

SWIFTLY, THE PAIR RACES TO THE CRIME SCENE! AND THERE...

SEEMS LIKE AN ORDINARY JOB! WINDOW JIMMIED OPEN, SAFE BROKEN INTO -- COULD HAVE BEEN ANY ONE OF A DOZEN CRIMINALS WHO HAVE RECORDS FOR THIS SORT OF THING!

GUESS THERE'S NO WAY OF TELLING IF THIS WAS THE JOKER'S WORK OR NOT! OH, GOSH, *BATMAN!* I GOT GREEN PAINT ON MY HANDS! MUST HAVE HAPPENED WHEN WE PASSED THE AVIARY THEY'RE PAINTING!

I SPOTTED SOMEONE RUNNIN' TOWARD THE MONKEY HOUSE! WHEN I PUT MY FLASHLIGHT ON HIM, HE PUT HIS HANDS OVER HIS FACE AND DROPPED THE BOX WITH $50,000 IN IT! THEN HE GOT AWAY BEFORE I COULD STOP HIM!

A CROOK SO ANXIOUS TO HIDE HIS FACE HE LET GO OF HIS LOOT! SOUNDS INTERESTING! I'M HAVING A LOOK AROUND THE ZOO!

BATMAN! WHERE ARE YOU GOING? WAIT FOR ME!

WAIT FOR ME AT THE *BAT-CAVE*, ROBIN! THIS MAY BE MY CHANCE TO PUT MY PLAN INTO ACTION!

AVIARY

10

THE NIGHT PASSES SLOWLY FOR THE BOY IN THE *BAT-CAVE* AND, NEXT MORNING...

GOSH! MORNING AND STILL NO *BATMAN!* WONDER WHAT COULD HAVE DETAINED HIM? I'M GOING BACK TO THE ZOO!

AND SOON AFTER...

THERE'S A CROWD ON HAND FOR THE PRESENTATION OF THE MONEY FROM THE ANIMAL LOVERS TO THE ZOO! BUT WHAT IN THE WORLD IS EVERYONE LAUGHING AT?

HA, HA! HA, HA! HAW, HAW, HAW!

OHHHAHAHA HO, HO, HO! HEE, HEE, HEE!

AVIARY

*ROBIN'S* QUESTION IS QUICKLY ANSWERED FOR, A MOMENT LATER, INSIDE THE AVIARY WITH ITS CAGES OF FABULOUS BIRDS, THE BOY WONDER IS STUNNED BY A FANTASTIC SIGHT...

≥GASP≤ *BATMAN!* WHAT'S HAPPENED TO HIM?

HA, HA! THE JOKER SURE FOOLED *BATMAN!* HE LOCKED HIM IN THE *BAT CAGE!* HA, HA! INSTEAD OF A BAT-*CAVE* HE GOT A BAT-*CAGE!*

BATS (CHEIROPTERA)

THE JOKER MUST HAVE PAINTED THAT *WHITE-FACED MONKEY'S* HEAD *GREEN* AND PUT HIM IN THIS CAGE! IN THE DARK, *BATMAN* THOUGHT THE *WHITE FACE* AND *GREEN HAIR* BELONGED TO THE *JOKER!* WHEN HE RUSHED IN, THE JOKER LOCKED THE CAGE! HA, HA!

YOU *COULDN'T* HAVE FALLEN FOR A GAG LIKE THAT! WHY DON'T YOU TELL THEM IT ISN'T SO?

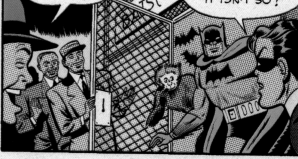

LATER, IN A PLUSH CRIMINAL HANG-OUT...

HA, HA! WHAT A LAUGH! YOU REALLY MADE A FOOL OUT OF *BATMAN* THIS TIME, JOKER! AFTER THIS, YOUR REPUTATION WILL BE *WORLD WIDE!*

THAT MONKEY PROBABLY ESCAPED AND GOT PAINT ON HIM BY ACCIDENT! STILL, IT WAS A GOOD LAUGH ON *BATMAN!*

ME! I HAD NOTHING TO DO WITH IT, DUKE!

JOKER MAKES MONKEY OUT OF BATMAN! CRIME CRUSHER'S NIGHT IN A BAT CAGE!

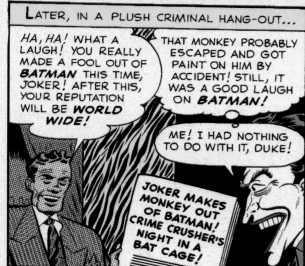

THEN WHAT *BATMAN* SAYS ABOUT IT BEING AN ACCIDENT-- THAT YOU HAD NOTHING TO DO WITH IT-- IS RIGHT, JOKER? AND I WAS SURE IT WAS YOU!

I LOST THE LOOT ON THAT JOB-- MIGHT AS WELL GET *SOMETHING* OUT OF IT! AND DUKE SAID THIS WOULD MAKE ME WORLD-FAMOUS!

WELL, IF YOU MUST KNOW THE TRUTH, *I DID IT!*

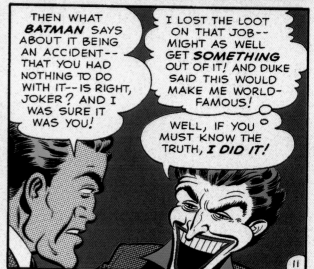

11

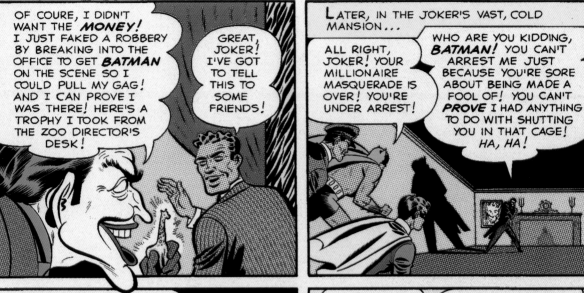

OF COURE, I DIDN'T WANT THE *MONEY!* I JUST FAKED A ROBBERY BY BREAKING INTO THE OFFICE TO GET *BATMAN* ON THE SCENE SO I COULD PULL MY GAG! AND I CAN PROVE I WAS THERE! HERE'S A TROPHY I TOOK FROM THE ZOO DIRECTOR'S DESK!

GREAT, JOKER! I'VE GOT TO TELL THIS TO SOME FRIENDS!

LATER, IN THE JOKER'S VAST, COLD MANSION...

ALL RIGHT, JOKER! YOUR MILLIONAIRE MASQUERADE IS OVER! YOU'RE UNDER ARREST!

WHO ARE YOU KIDDING, *BATMAN!* YOU CAN'T ARREST ME JUST BECAUSE YOU'RE SORE ABOUT BEING MADE A FOOL OF! YOU CAN'T *PROVE* I HAD ANYTHING TO DO WITH SHUTTING YOU IN THAT CAGE! HA, HA!

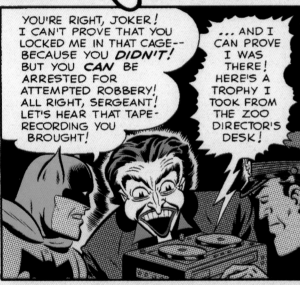

YOU'RE RIGHT, JOKER! I CAN'T PROVE THAT YOU LOCKED ME IN THAT CAGE-- BECAUSE YOU *DIDN'T!* BUT YOU *CAN* BE ARRESTED FOR ATTEMPTED ROBBERY! ALL RIGHT, SERGEANT! LET'S HEAR THAT TAPE-RECORDING YOU BROUGHT!

...AND I CAN PROVE I WAS THERE! HERE'S A TROPHY I TOOK FROM THE ZOO DIRECTOR'S DESK!

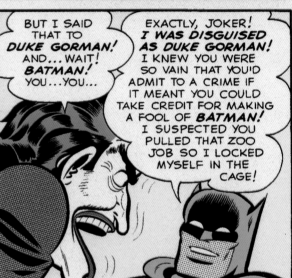

BUT I SAID THAT TO *DUKE GORMAN!* AND...WAIT! *BATMAN!* YOU...YOU...

EXACTLY, JOKER! *I WAS DISGUISED AS DUKE GORMAN!* I KNEW YOU WERE SO VAIN THAT YOU'D ADMIT TO A CRIME IF IT MEANT YOU COULD TAKE CREDIT FOR MAKING A FOOL OF *BATMAN!* I SUSPECTED YOU PULLED THAT ZOO JOB SO I LOCKED MYSELF IN THE CAGE!

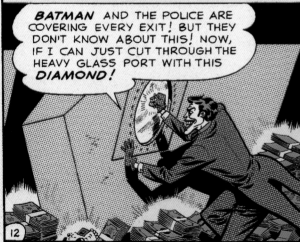

MADLY, THE FIGURE WITH THE GARISH GREEN HAIR FLEES DOWN THE MANSION'S LONG CORRIDORS UNTIL...

*BATMAN* AND THE POLICE ARE COVERING EVERY EXIT! BUT THEY DON'T KNOW ABOUT THIS! NOW, IF I CAN JUST CUT THROUGH THE HEAVY GLASS PORT WITH THIS *DIAMOND!*

12

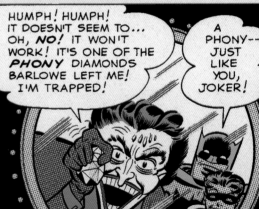

BUT THE LAST LAUGH IS ON THE CRIME CLOWN!

HUMPH! HUMPH! IT DOESN'T SEEM TO... OH, *NO!* IT WON'T WORK! IT'S ONE OF THE *PHONY* DIAMONDS BARLOWE LEFT ME! I'M TRAPPED!

A PHONY-- JUST LIKE YOU, JOKER!

The End

3

# MASKS

screen
stories®

"Duel At Diabl

JUNE 35c

the stars'
warning to

BATMAN

BEWARE OF WOMEN!"

The Group"
THE MOST DARING

Fredric Wertham, author of *Seduction of the Innocent,* never thought Batman would "fall for a girl" either. Pencils by Dick Sprang and inks by Charles Paris for *Batman* #79 (October–November 1953).

For fifteen years, Batman had needed only a few pages to overcome the malevolent machinations of the most vindictive villain, yet he seemed almost helpless against attacks launched in 1954 by Dr. Fredric Wertham. The elderly psychiatrist's high-pitched tirades against comic books created a national furor that culminated in congressional hearings. Before the smoke cleared the medium was nearly destroyed. Comic book sales dropped disastrously, distribution dried up, and the majority

of publishers were driven out of business. The handful that hung on, including DC, adopted stringent industry self-regulation in the form of the Comics Code and managed to survive until the clamor died down.

Wertham's general assertion was that readers would imitate the crimes committed in the comics, but in what remains the most notorious passage from his book *Seduction of the Innocent,* he leveled a special charge against Batman. Launching his longest attack on any comic book character, Wertham devoted four pages of his polemic to persuading his repressed 1950s audience that Batman and Robin were gay and that exposure to their adventures would send young readers down the same path to perdition. "They live in sumptuous

quarters, with beautiful flowers in large vases, and have a butler," Wertham wrote. "It is like a wish dream of two homosexuals living together." What was more, Wertham asserted, "the Batman type of story may stimulate children to homosexual fantasies." His only evidence for these claims came from "overt homosexuals" treated at the sinister-sounding Readjustment Center (Wertham's clinic devoted to the psychotherapy of sexual difficulties), where some individuals occasionally imagined trading places with Batman. Despite the lack of any concrete cause-and-effect link between reading comics and "deviance," such suggestions were dynamite in an era intolerant of nonconformity, especially in sexual matters.

Of course it is inherently absurd to speculate

Above left: Inker Charles Paris was dismayed when he saw Dick Sprang's pencils for this page from *Batman* #84 (June 1954), not because of the outré imagery, but because of all those tiny lines.

Above right: By the time Ace was making friends with aliens, the original impulse behind Batman was a thing of the past. Pencils: Dick Dillin. Inks: Sheldon Moldoff. For *Batman* #143 (October 1961).

on what Batman and Robin might have been doing behind closed doors for the simple fact that, unlike Wertham's patients, they had no lives off the printed page. Batman's creators were evidently heterosexuals, and it would never have occurred to them that homosexual undertones could have been read into the stories they created. It's highly probable that they were focused instead on the objections that would have been raised if Bruce Wayne were living with an adolescent girl, and that they were bending over backward to avoid even the suggestion of sex. In the process, they fell into the trap of

depicting an all-male household that could be subject to Wertham's lurid interpretation. Still, what did it matter? Some say homosexuality is genetic, and some say it's a matter of environment, but only Wertham would claim it was caused by comic books. Yet for most of the next decade, Batman's writers, artists, editors, and publishers would struggle to prove that their comics were not inspiring a generation to become gay or juvenile delinquents, and by overcompensating so strenuously they produced some of the strangest Batman stories ever seen. Their strategies included a proliferation of new Bat-characters designed to create a faux family atmosphere, the introduction of science-fiction villains whose cosmic crimes could not be imitated, and incessant distortions of the image of Batman himself, as if he were obliged to wear a disguise while appearing in his own adventures.

Editor Jack Schiff's initial effort to restore Batman to respectability involved providing the hero with a friend who would never let him down: a dog. The result was the debut of "Ace, the Bat-Hound" in *Batman* #92 (June 1955). A lost dog who ultimately helped Batman and Robin rescue his kidnapped owner, Ace hid his distinctive

In the spirit of time travel, Dick Sprang's Babylonian chariot from *Batman* #102 (September 1956) was a copy of a cover he drew twelve years earlier.

# JUST A MATTER OF TIME

Science fiction did not become a major influence on the Batman comics until the late 1950s, but one special type of speculative story got its start much earlier. Time travel emerged as a theme in 1944, and in the years that followed, Batman and Robin took enough trips to the past to qualify as frequent fliers. These journeys were provided by a balding, bespectacled scientist named Carter Nichols, whose technique for sending people back through history involved hypnotism rather than the more conventional "time machine" (he did start using a ray in 1956). Nichols had no idea he was serving as time travel agent for the Dynamic Duo, however. His apparent subjects were Bruce Wayne and Dick Grayson, who would not change into their more colorful identities until after they had reached their destination.

In the first of their hikes through history, recounted in *Batman* #24 (August–September 1944), Batman and Robin visited ancient Rome. In the dozens of subsequent stories that appeared periodically until 1963, the heroes made stops in such spots as the Stone Age, ancient Greece, King Arthur's court, colonial America, and the old West. Among the celebrities they encountered were Kubla Khan, Cleopatra, Robin Hood, Leonardo da Vinci, Jules Verne, and Alexander the Great. These well-researched tales, most apparently written by Bill Finger, represent some of the best Batman science fiction, not so much because they could be considered educational but because they entertainingly emphasized the spectacle and color of life in bygone days.

"*BATMAN'S* HOLLOW BOOT HEEL CONTAINED A TINY RADIO THAT TRANSMITTED A SIGNAL WHEN HE FLIPPED THE SWITCH..."

"THE SIGNAL REACHED A TINY RECEIVER CONCEALED INSIDE MY COLLAR--AND IT COULD ONLY BE HEARD BY ME BECAUSE IT WAS ABOVE THE RANGE OF THE HUMAN EAR!"

*BATMAN*--HE'S IN TROUBLE AND NEEDS ME!

"I BOLTED DOWN TO THE *BAT-CAVE*-- AND SLIPPED INTO MY MASK, HELD BY A GADGET *BATMAN* HAD DEVISED..."

I SHOULD GET SOMEONE TO GO WITH ME! ALFRED?--NO, THIS IS HIS NIGHT OUT! WHO CAN I GET? I KNOW...

"I STREAKED TO THE HOUSE OF *BATMAN'S* FRIEND, *KATHY KANE*"...

BAT-HOUND!

GOOD THING I KNOW SHE'S *BATWOMAN!* I HOPE SHE REALIZES ALL MY BARKING MEANS I WANT HER TO FOLLOW ME!

ARRF! ARRRF!

"AFTER A SWIFT CHANGE TO HER COSTUME, SHE ACCOMPANIED ME ON THE TRAIL OF THE RADIO-BEAMED SIGNAL..."

THE SIGNAL'S STRONGER NOW! I'M GOING IN THE RIGHT DIRECTION!

BEEP! BEEP!

markings behind a black mask while he was on the case with his costumed cohorts. The story might have been no more than an amusing novelty in the old days, but in troubled times Schiff seized on the favorable response and turned the Bat-Hound into a regular member of the team. "We wanted to get something other than just the plot," said Schiff. "We wanted to have characters that the kids could talk about, and I'll tell you, they really worked. We used to get letters from the readers, who were just fascinated." So Batman borrowed Ace from his owner again and again, under increasingly improbable pretexts, until in 1959 the pooch finally became a permanent resident of Wayne Manor. According to Sheldon Moldoff, the artist who drew him, the Bat-Hound was intended to look like Rin

Above: Tricks of the trade for a canine super hero were revealed in "The Secret Life of Bat-Hound" in *Batman* #125 (August 1959). Art by Sheldon Moldoff.

Opposite: Wallace Wood showed Batman playing the fool in *MAD* #8 in 1954, not long before the hero embarked on a decade of unusually zany adventures. Script: Harvey Kurtzman.

## BATBOYS TO MEN

Just a few months before *Seduction of the Innocent* appeared, Batman had been the subject of a more affectionate attack in the eighth issue of the *MAD* comic book (December 1953–January 1954). "Batboy and Rubin" depicted the Caped Crusader as a diminutive grouch who is eventually revealed to be the most dangerous killer in "Cosmopolis"—a vampire. This may have been the inspiration for several later stories in which DC toyed with the idea of Batman as bloodsucker, and the goofy little bat who aped Batboy's antics in the *MAD* story might have inspired the DC character Bat-Mite. And who can even guess what the Batman team was thinking when they used the initial issue of the watered-down Comics Code–approved *Batman #90* (March 1955) to show Robin teaming up with a little person called Batboy, who fought crime with a Louisville Slugger and ended up employed by the local baseball team? Batman was barely present in the story at all, and it looked as if his creators were deliberately making a mockery of him before someone else beat them to it.

The debut of Bat-Mite, the most improbable addition to the "Batman Family," drawn by Sheldon Moldoff and Charles Paris for *Detective Comics* #267 (May 1959). Written by Bill Finger.

Tin Tin, the German shepherd whose TV show ran on ABC from 1954 to 1959.

Moldoff, who had served briefly as Bob Kane's assistant in 1939, returned to work for Kane in 1953, and ended up drawing the bulk of the bizarre stories that altered the Batman mystique over the course of the ensuing decade. "It was a job," said Moldoff, whose deal to work as Kane's "ghost" meant keeping his participation a secret, "and I never said a word for fifteen years." Kane had an agreement with DC to produce "365 pages minimum a year," according to Moldoff, who was hired as a subcontractor to provide the pencils. "It was a living for me for a long time," he said. "Bob knew I never missed a deadline, I was dependable, and I was a friend." And Moldoff's pencils reflected the artistic approach pioneered by Kane. "It's a fantasy, and I think the cartoon style helps it," Moldoff said, "by disassociating it from reality." Most of Moldoff's work was inked by Charles Paris, who provided the same service for veteran Dick Sprang, but Moldoff and Paris never met. "The field was very competitive," recalled Moldoff, "and you rarely hobnobbed with people, because there was always somebody waiting for your job."

Yet Moldoff certainly seemed to have the inside track on the Caped Crusader, especially when Dick Sprang cut back on his basic Batman stories to devote time to the Superman-Batman team-ups that became the leading feature of a revamped *World's Finest Comics* in 1954. The number of pages in the publication shrank and so the two heroes, who had each been featured in solo stories, now shared one tale. Alvin Schwartz wrote the first one, but he soon relinquished

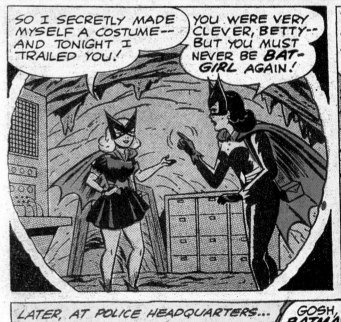

the job to Edmond Hamilton, because, he said, "I wouldn't have felt comfortable having Superman, Batman, and Robin together. They represented such antithetical unities." Certainly Superman tended to dominate the action, putting

Right: Everybody gets into the act as Kathy Kane's niece Betty suits up and becomes Bat-Girl in *Batman* #139 (April 1961). Pencils: Sheldon Moldoff. Inks: Charles Paris. Script: Bill Finger.

Opposite: Batwoman swings into action to rescue Batman from slumping sales, in Sheldon Moldoff's splash page from *Detective Comics* #233 (July 1956). Inks: Charles Paris. Script: Edmond Hamilton.

# THE SILVER AGE

The early days of comic books, when heroes like Superman and Batman were introduced and the medium achieved its first great popularity, are referred to by nostalgic fans as the Golden Age. Disputes exist about when this halcyon period came to an end, but it was certainly over by 1955, when both the art form and the industry were in disarray following widespread attacks on the medium. In 1956 there were signs of new life, most of them sparked in the laboratory of DC editor Julius Schwartz. A polished professional whose work was characterized by meticulous attention to detail, Schwartz brainstormed with artists to create cover ideas that could inspire stories, and conferred with writers to assure precisely crafted tales. "I love to plot," he said. The parade of new super heroes marching out of his office, delineated by writers John Broome and Gardner Fox and drawn by artists Carmine Infantino, Gil Kane, Murphy Anderson, and Mike Sekowsky, marked the start of what fans now call the Silver Age.

The Schwartz specialty was reviving and revising abandoned characters from the Golden Age. Employing test runs in anthology comic books like *Showcase* and *The Brave and the Bold,* Schwartz introduced updated features like the Flash (1956), Green Lantern (1959), the Atom (1961), and Hawkman (1961). Each of them then got his own comic book, and most ended up in the Justice League of America (1960), a team of DC's top attractions that also included Superman and Batman. This was Schwartz's first brush with the Caped Crusader, whose flagging career he would galvanize when he inherited the hero in 1964.

Batman in an awkward position, but the team-up was a financial success in an era when those were few and far between. Strangely enough, Dick Sprang, the quintessential Batman artist, once said he preferred working on *World's Finest Comics* because he viewed the chance to draw Superman's feats as a welcome novelty.

Still, Superman couldn't shake up Batman's world as thoroughly as Batwoman did. This character made her debut in *Detective Comics* #233 ( July 1956), written by Edmond Hamilton and illustrated by Sheldon Moldoff. It seems clear that her introduction was part of a publishing decision to alter the ambience of the series. Memories are vague on this point, but the responsibility may have rested with DC publisher Harry Donenfeld's son Irwin. After Whitney Ellsworth moved to Califor-

nia to produce a Superman television series, Irwin Donenfeld was serving as de facto editor in chief. "He came in and he had a lot of things that he sort of threw at us," recalled Batman editor Jack Schiff. Then again, Schiff himself believed new characters would bump up sales, and everyone seemed eager to provide Batman with some female companionship.

Initially, Batwoman was presented as something of an interloper. She was Kathy Kane, a former circus acrobat who used an inheritance to fulfill her dream of imitating Batman, and began showing up in answer to the Bat-Signal, catching crooks and even rescuing the Dynamic Duo. Even while fighting crime, however, she displayed signs of conventional womanliness. She carried a purse rather than wearing a utility belt, and armed herself with such

Opposite: Batman teamed up with the Justice League, shown in their debut in *The Brave and the Bold* #28 (March 1960). Pencils: Mike Sekowsky. Inks: Bernard Sachs. Batman also got top billing in Ideal's 1966 play set.

Below left: The Batman family gangs up to harass poor Robin, in a strained attempt to create a heterosexual atmosphere from *Batman* #144 (December 1961). Pencils: Sheldon Moldoff. Inks: Charles Paris. Script: Bill Finger.

Below: In a bizarre manifestation, from *Detective Comics* #275 (January 1960), the Dark Knight becomes an electrically charged force field. Cover by Sheldon Moldoff.

"flashing feminine tricks" as a lipstick filled with tear gas and a compact containing sneezing powder. Sheldon Moldoff dressed her in bright yellow tights with little buttons down the front; her oversize mask, extending beyond her face to create the impression of a bat's ears, was ingeniously designed but nonetheless suggested the matronly look of harlequin eyeglasses. Batman protested that by law no man in Gotham City but he could wear a bat costume, and she responded, "I'm a woman!" By the end of the story Batman had uncovered her identity and convinced her that battling bad guys was too dangerous.

Inevitably, however, Batwoman returned again and again over the next few years, even gaining superpowers on one occasion, until her appearances became a regular feature of the series. In another story, when Bruce Wayne was mistakenly jailed, she took over as Robin's boss, and it wasn't much later that Dick Grayson had a story-length nightmare, immortalized on the cover of *Batman* #122 (March 1959), concerning "The Marriage of Batman and Batwoman." The happy couple are depicted leaving the church arm in arm, while Robin stands on the sidelines and worries, "Gosh! What'll become of me now?" Whether or not the creators were attempting to reassure everyone that Batman was heterosexual, this story may have succeeded in creating anxieties in boys about females being the enemies of friendship and loyalty. By *Batman* #153 (February 1963), Batwoman responded to an apparently impending doom by pledging her love to Batman, and he reciprocated, only to declare his comments a white lie once the danger was past. Readers looking for mystery and adventure were beginning to wonder why they should put up with such soap opera, and why Batman wasn't out at night wrestling with Catwoman instead.

Meanwhile, there were further additions to what the comics were starting to call "the Batman Family." Mogo "the Bat-Ape" arrived in *Batman* #114 (March 1958) but never really went any-

Artist Sheldon Moldoff.

This pinup by Sheldon Moldoff, reprinted in several comics, looked like a souvenir from a family picnic, with only the shadow in the background suggesting the Batman that used to be.

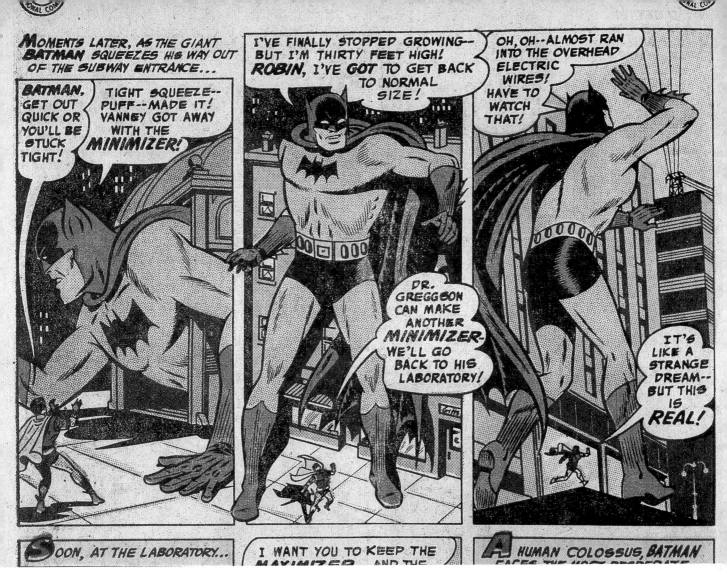

MOMENTS LATER, AS THE GIANT BATMAN SQUEEZES HIS WAY OUT OF THE SUBWAY ENTRANCE...

BATMAN, GET OUT QUICK OR YOU'LL BE STUCK TIGHT!

TIGHT SQUEEZE-- PUFF--MADE IT! VANNEY GOT AWAY WITH THE MINIMIZER!

I'VE FINALLY STOPPED GROWING-- BUT I'M THIRTY FEET HIGH! ROBIN, I'VE GOT TO GET BACK TO NORMAL SIZE!

DR. GREGGSON CAN MAKE ANOTHER MINIMIZER-- WE'LL GO BACK TO HIS LABORATORY!

OH, OH--ALMOST RAN INTO THE OVERHEAD ELECTRIC WIRES! HAVE TO WATCH THAT!

IT'S LIKE A STRANGE DREAM-- BUT THIS IS REAL!

SOON, AT THE LABORATORY...

I WANT YOU TO KEEP THE MAXIMIZER AND THE

A HUMAN COLOSSUS, BATMAN FACES THE MOST DESPERATE

where. The Bat-Mite, on the other hand, was hard to lose. "Is he an elf? A gremlin? An imp or a pixie?" readers were asked when Bat-Mite first appeared in *Detective Comics* #267 (May 1959). Actually he claimed to be a visitor from another dimension, although Moldoff, the artist who introduced him, called him "a little alien from outer space." Either way, a lot of fans suspected that he really came from the Superman comics, where a similar sprite named Mr. Mxyzptlk had been distressing the Man of Steel for years. Like Batwoman, Bat-Mite was an admirer of Batman who set out to emulate his idol, costume and all, but his magical powers caused nothing but headaches. He also served to dissipate whatever ominous atmosphere still lingered in Gotham City. Before long he was

ganging up on Batman by riding around on the back of the Bat-Hound while serving as "Batwoman's Publicity Agent" in *Batman* #133 (August 1960). Things were getting silly, but there was more to come.

In *Batman* #139 (April 1961), Bat-Girl arrived. She was Batwoman's niece, Betty Kane, who was such a big fan that she made her own costume and set out to emulate . . . well, the pattern was pretty clear by then. Although some time elapsed between each character's debut, it's apparent that nobody was expending much effort on originality. Still, a female companion for Robin had been introduced, and there were scenes of Bat-Girl kissing him while he blushed and sweated with embarrassment. Of course while all this heterosexuality was being

Editorial insistence on novelty led to oddities like this oversize Batman, drawn by Dick Sprang and Charles Paris for *Detective Comics* #243 (May 1957).

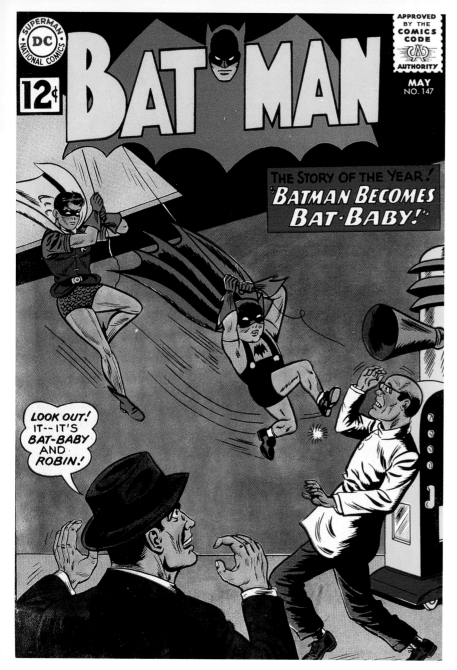

therefore be obliged to endure Bat-Girl's unwelcome advances while the adults look on approvingly. If a comic book could actually turn people gay as Dr. Wertham had suggested seven years earlier, this one might have had the power to do it.

The 1961 *Batman Annual* featured a pinup, drawn by Sheldon Moldoff, of the entire smiling "Batman Family." It looked like Batman and Batwoman were the parents, with Robin and Bat-Girl as the kids and Bat-Mite as the baby. Ace doubled as the family dog, with Alfred and Police Commissioner Gordon on hand as a couple of elderly uncles. Someone capable of taking this picture seriously might have concluded the vengeful Batman of yore had at last been healed and made whole, but the less fanciful fact was that the series had somehow taken a wrong turn, switching from super heroes to situation comedy.

Another innovation of the era was the introduction of science fiction into the *Batman* saga. Traces of the genre had always been around in super hero comics, but in the late 1950s Batman was virtually overwhelmed by visitors from other worlds. The idea had worked for several other DC characters, and Batman was carried along with the tide. This trend is usually attributed to the influence of editorial director Irwin Donenfeld, who years later couldn't recall exactly what had taken place. "I like to take credit for everything," he said, "but truthfully I just don't know."

Stories like "The Mystery Seeds from Space" and "The Interplanetary Batman" and "Manhunt in Outer Space" began to proliferate, and Sheldon

established, things couldn't be allowed to get too passionate, and attempts to reach the proper compromise attained new heights of absurdity in "Bat-Mite Meets Bat-Girl" from *Batman* #144 (December 1961). Here the extradimensional elf plays Cupid on behalf of Bat-Girl but Robin resists, citing the example of Batman, who had renounced "romance" while he was a crime fighter. Then Batman and Batwoman show up to announce that Robin is too young to make such a decision and will

Sheldon Moldoff's cover for *Batman* #147 (May 1962) shows a hero at pretty much the end of his rope, but the image is difficult to dislodge from the mind.

Moldoff found the challenge of drawing aliens a welcome change of pace from the criminals of Gotham City. In fact, the genre eventually inspired one of Moldoff's most fondly remembered stories, the nightmarish "Robin Dies at Dawn," from *Batman* #156 (June 1963). In this case, however, the interplanetary adventures were hallucinations inspired by sensory deprivation experiments for which Batman had volunteered. Yet if individual stories worked, the overall atmosphere of rocket ships and gigantic, garishly colored monsters seemed antithetical to the mood that had been originally established for the Caped Crusader. And when, inevitably, members of the "Batman family" were added to the mix, the effect was completely outlandish. Yet the attempt to boost sales by providing novelty proved irresistible.

"It was important to make each cover look completely different," Moldoff explained. As a result, when Martian monsters or new Bat-characters weren't on view, the editorial policy was to present grotesque distortions of the hero himself. Almost every month, it seemed, drastic modifications were made in Batman's size, shape, age, or attributes, all designed to startle the newsstand browser into parting with a dime or, by the end of 1961, twelve cents. The most common cause of the changes was some mad scientist's experimental ray. Readers were treated to "The Giant Batman" and "The Phantom Batman," then "The Armored Batman" and "The Zebra Batman," then "The Merman Batman" and "The Negative Batman." Bruce Wayne might become hideous, in "The Batman Creature," or magical, in the redundantly titled "The Bizarre Batman Genie." He might be transformed into a colleague, in "Batman–The Superman of Planet X," or end up wrapped in bandages in "Batman and Robin–The Mummy Crimefighters." He might end up old and feeble, in "Rip Van Batman," but perhaps the most distressing metamorphosis took place in Moldoff's "Batman Becomes Bat-Baby." In short, Batman might be almost anybody but himself. "One of those things must have worked, so they kept

trying," theorized Moldoff, who soldiered on, illustrating the increasingly outrageous scripts that editor Jack Schiff sent to Bob Kane.

By 1964, Batman was in big trouble. Today's fans often look back with affection at the sheer zaniness of the stories from the late 1950s and early 1960s, but the seemingly endless array of stunts designed to prop up the hero had nearly done him in. There was no core character left, just a hollow man being battered from place to place by whatever gimmick could be concocted, and sales were dropping drastically. Things looked bad. Although it seems almost inconceivable in retrospect, Bob Kane has said, "They were planning to kill Batman off altogether."

Selected to engineer a rescue attempt was editor Julius Schwartz. "I took over *Batman,* which I

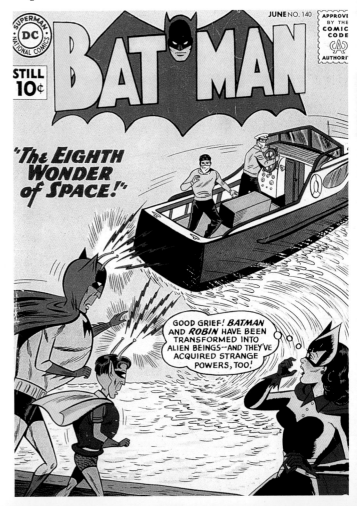

The Dynamic Duo became antenna-twitching aliens with the power to create tidal waves in *Batman* #140 (June 1961). Pencils by Sheldon Moldoff and inks by Charles Paris.

Below: Carmine Infantino's cover for *Batman #164* (June 1964) was the first one for this title to feature the "New Look," which included a modified costume and an updated art style. Inks: Joe Giella.

Right: The Dynamic Duo try not to stay idol, but nonetheless fall victim to pyramid power in this original art for *Batman #167* (November 1964), pencilled by Carmine Infantino and inked by Murphy Anderson.

Far right: Poison Ivy, whose plants turned her toxic, may have been inspired by Nathaniel Hawthorne's nineteenth-century story "Rappaccini's Daughter." Cover for *Batman #181* (June 1966): Carmine Infantino and Murphy Anderson. Script: Robert Kanigher.

didn't want to do, but they said I had to because the magazine was doing badly," Schwartz recalled. "I wouldn't say they were going to kill it, but it certainly was being discussed." Schwartz, with more than two decades of experience, had recently enjoyed a string of successes by introducing new versions of old heroes like the Flash and Green Lantern, so he seemed like the logical choice to revamp Batman. He has frequently discussed his strategy but rarely mentions three of his most crucial decisions: he abandoned the policy of putting Batman through freakish transformations, he jettisoned all references to aliens and outer space, and he unceremoniously banished the dependent members of the "Batman family," including Bat-Hound, Bat-Mite, Bat-Girl, and Batwoman. It was as if they had

never existed, although Batwoman was briefly revived fifteen years later, only to be rather gratuitously stabbed to death in *Detective Comics* #485 (August–September 1979). The new Schwartz version of Batman was unveiled in *Detective Comics* #327 (May 1964), which announced on its cover that it was introducing a "New Look" for the character. The alteration was most immediately apparent in the artwork, featuring pencils by

Editor Julius Schwartz.

Carmine Infantino and inks by Joe Giella. For the first time, the standard Batman art style developed over the years had been supplanted by something different. Infantino, an artist known for his innovative layouts and striking cover designs, depicted Batman in a style that was considerably less cartoonish and more realistic than what had gone before, while Giella's detailed renderings served to emphasize the contrast. Bob Kane's stylized signature, which had heretofore appeared on the work of every Batman artist, was no longer in evidence on the Infantino stories. Kane's name still showed up on the pages ghosted for him by Sheldon Moldoff, but those drawings were now also inked by Giella, who influenced them in favor of the new approach. And since Dick Sprang had retired from comics (his last work appeared in 1963), the classic look of the character seemed to have been completely abandoned.

A hallmark of the "New Look" was the yellow oval that Schwartz had placed around the bat emblem on the hero's chest. This new insignia echoed the imagery of the Bat-Signal, and in time would become the hero's trademark, comparable to the red and gold shield that Superman sported. Schwartz also streamlined the bulky Batmobile into a sleek sports car, but his biggest contribution was bringing Batman back to basics, an approach that included reviving some of the best villains of bygone days. "I was a big detective story fan,"

Schwartz said, citing favorites like the ingenious Anglo-American author John Dickson Carr. From that time onward, mystery and detection would be emphasized, but as Schwartz later admitted, "The first story I did, I made two terrible mistakes. One was that the story took place during the day, and the second was that when Batman caught the villain, he pulled a gun on him. That shows how much I knew about Batman."

One thing Schwartz did know about was the lingering influence of Dr. Wertham's witch-hunt. "There was a lot of discussion in those days about three males living in Wayne Manor," he said. "So I had Alfred die in the process of saving Batman's life, and I brought in Aunt Harriet, who was the aunt of Dick Grayson." The script describing Alfred's demise, which appeared in *Detective Comics* #328 (June 1964), was one of the last contributions made to the Batman comics by their

The revival of the Riddler in *Batman* #171 (May 1965) inspired the first episode of the new ABC television series. Pencils: Carmine Infantino. Inks: Murphy Anderson.

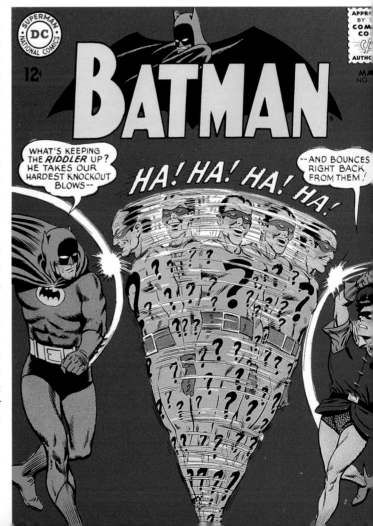

*Official*

# BATMAN
## EQUIPMENT SET

IDEAL

*Official*
### CRIME FIGHTING EQUIPMENT
# HELMET CAPE
# & UTILITY BELT

BAT-A-RANG

BAT RADIO

BAT GRENADE LAUNCHER

BAT. GRENADE

SECRET MESSAGE SENDER

BAT ROPE

BAT FLASH

BAT CUFFS

original writer, Bill Finger. Like so many comic book deaths, however, Alfred's proved to be only temporary. By 1965 a Batman television series was in the works, and the producers were planning to include Alfred, so Schwartz was obliged to follow suit. To accomplish the resurrection, he used a villain called the Outsider (the name was taken from a horror story by H. P. Lovecraft, whom Schwartz had once represented as a literary agent). After a convoluted plot, which stretched over many months, it was revealed in *Detective Comics* #356 (October 1966) that the Outsider was actually Bruce Wayne's faithful butler, traumatized by injuries, amnesia, and a madman's medical experiments, but finally restored to his former self. The story was something of a stretch, but a small price to pay for the advantages of having Batman become a TV star,

which doubled the sales of the comic books. Schwartz's improvements in the comics had already done the hero some good, but having Batman broadcast directly into virtually every American home would turn the character into an icon.

In September 1965, Bob Kane wrote a letter to *Batmania*, an early Batman fan magazine, to announce that "ABC Television and 20th Century–Fox Films are jointly in the process of making an extremely high-budget color pilot of an hour-a-week Batman series that may wind up as two half-hour-a-week shows." Although success in any medium is unpredictable, Kane was extremely optimistic: "This is going to be the 'in' show to watch," he wrote, adding that despite Batman's widespread previous recognition, "the TV series will be the topper to it

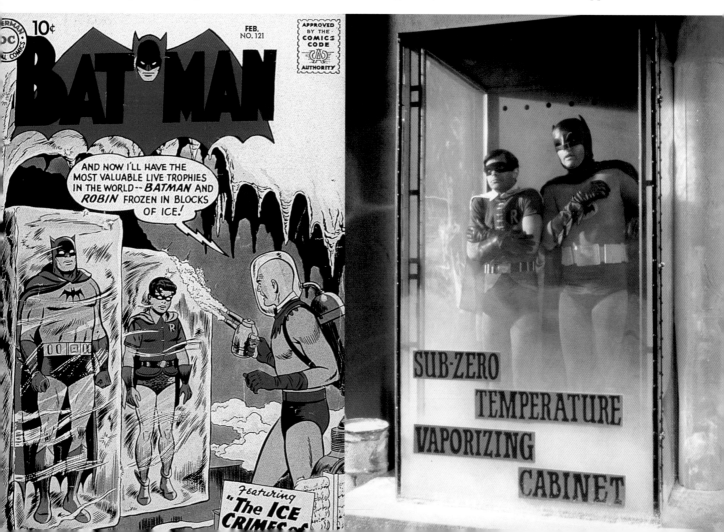

This shot from the 1966 movie *Batman* features the TV show's main menaces: the Penguin (Burgess Meredith), the Riddler (Frank Gorshin), Catwoman (Lee Meriwether, replacing Julie Newmar, who had another film assignment), and the Joker (Cesar Romero).

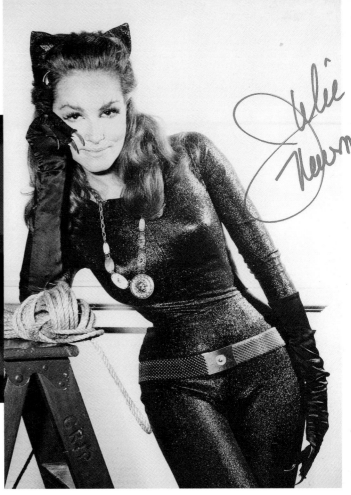

all." As it turned out, the program surpassed everyone's expectations and became an authentic phenomenon. Making its debut in midseason when such starts were rare, the series also broke precedent by appearing in a pair of half-hour segments broadcast on two different nights each week, and it seemed destined for a long run when both episodes placed among the top ten programs in the ratings. A genuine fad, the show faded as fast as it had flared, cutting back to one appearance a week and ultimately lasting a mere twenty-six months before it was canceled. Never before had a television series had such a meteoric rise and fall.

When *Batman* first aired, on January 12, 1966, the episode's villain was the Riddler. This hitherto minor bad guy was promptly vaulted into the pantheon of Batman's most famous foes, and the role turned a comedian and impressionist named Frank Gorshin into a star. The script, by Lorenzo Semple Jr., was based on a story that had appeared in *Batman* #171 (May 1965). In fact, there's a legend that TV producer William Dozier came up with the idea for the series after reading this issue on a transcontinental flight. Dozier, however, remembered that he was reading the comics because ABC had already acquired the rights to the character, and Bob Kane said the network became interested after one of their executives attended a showing of the 1943 *Batman* movie serial at Hugh Hefner's Playboy mansion in Chicago. Kane also recalled talking to Dozier and saying, "Why don't you have a cliffhanger like the Batman serials?" That idea was used, along with a pompous narrator like the one who had opened the serial (Dozier supplied the voice for the show). Another motivation for broadcasting *Batman* may have been the burgeoning Pop Art movement; galleries and museums were featuring works by Andy Warhol and Roy Lichtenstein that employed imagery derived from comics, including DC's. Warhol was a guest at the New York "discothèque frug party," which the network

Left: The Dynamic Duo cool their heels courtesy of Mr. Freeze, in one of the old-fashioned cliffhangers that kept millions of viewers tuning in at the height of Batmania.

Above right: While other guest stars camped it up, Julie Newmar as Catwoman took her role a little more seriously, and remains the favorite villain of many Batfans.

Overleaf: Masses of merchandise arrived in 1966, including a Batman rag doll, Robin with a bobbin' head, and cola from Cott for those who take their heroes internally.

UNA PRODUZIONE DI **WILLIAM DOZIER** / CON **ADAM WEST · BURT WARD**

e la schiera dei nemici pubblici

"LA DONNA GATTO"          "IL JOLLY"          "IL PINGUINO"          "L'ENIGMISTA"
**LEE MERIWETHER · CESAR ROMERO · BURGESS MEREDITH · FRANK GORSHIN**

PRODOTTO DA                    REGIA DI                    SCRITTO DA
**WILLIAM DOZIER · LESLIE H. MARTINSON · LORENZO SEMPLE, Jr. · Colore De Luxe**

Top left: Carmine Infantino's couch potato Caped Crusader arrived in August 1966.
Above right: This Italian poster for the *Batman* movie shows that the Caped Crusader was conquering the world.

The original costumes for a trio of heroes—Batman (right), Robin (page 109), and Batgirl (page 110)—were designed for the ABC-TV series by Patricia Barto and Jan Kemp.

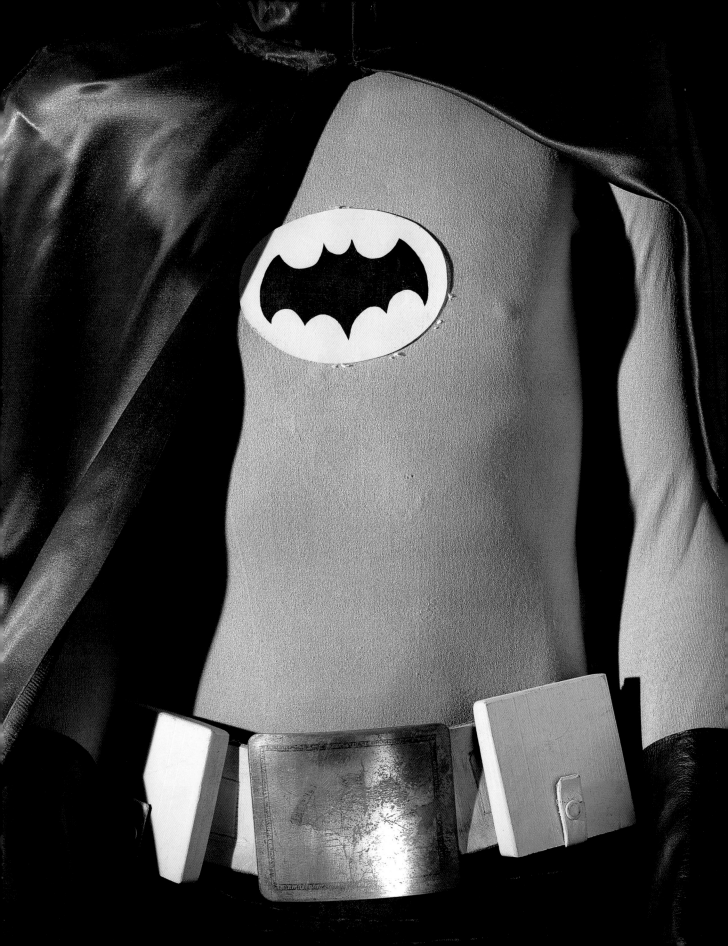

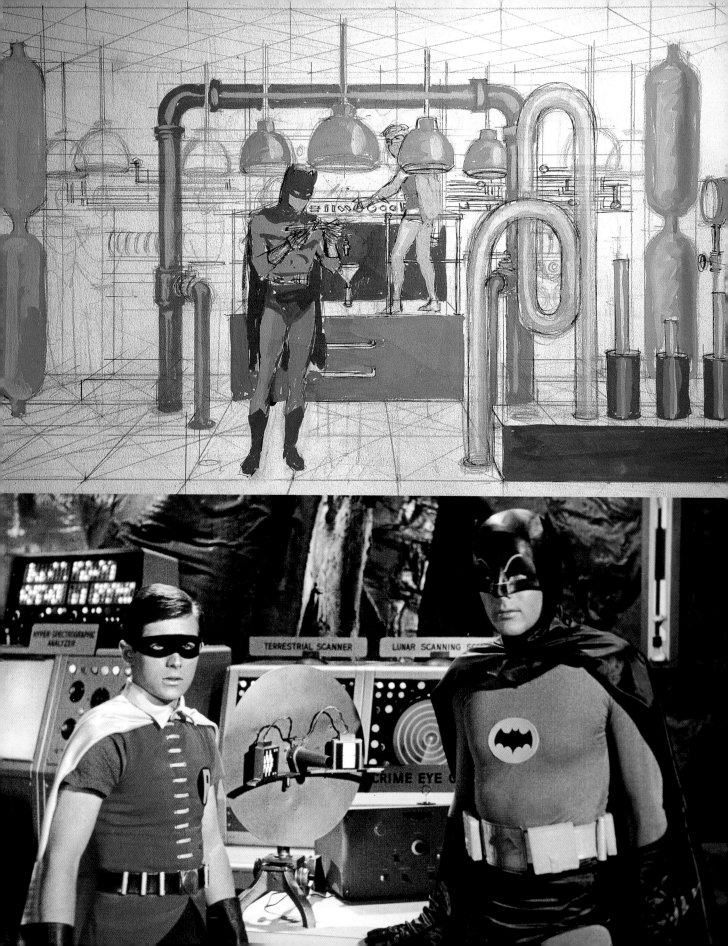

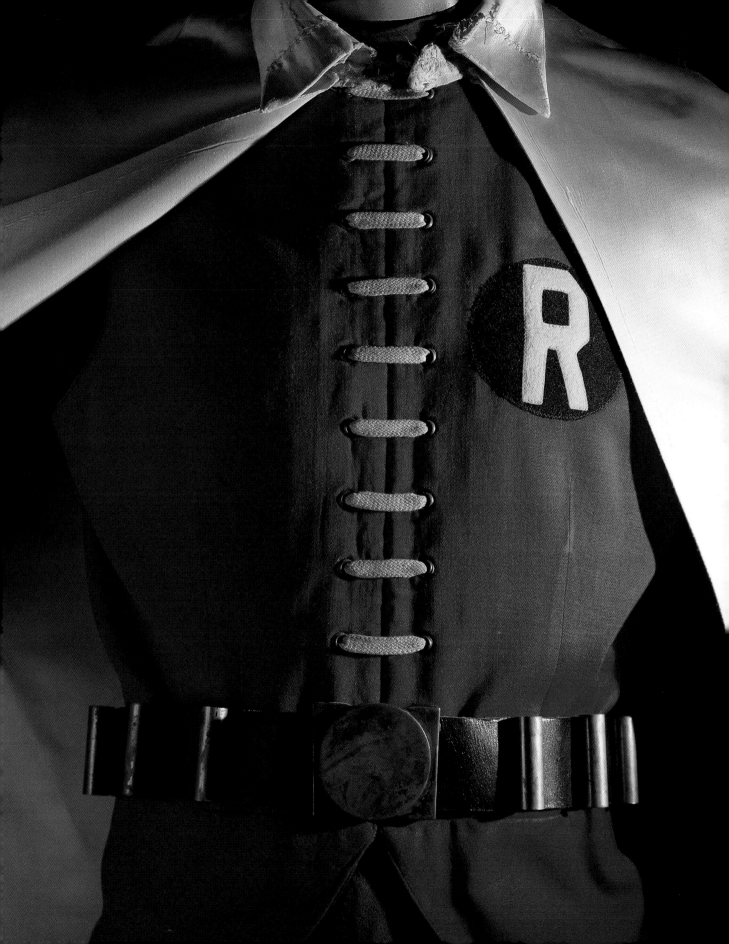

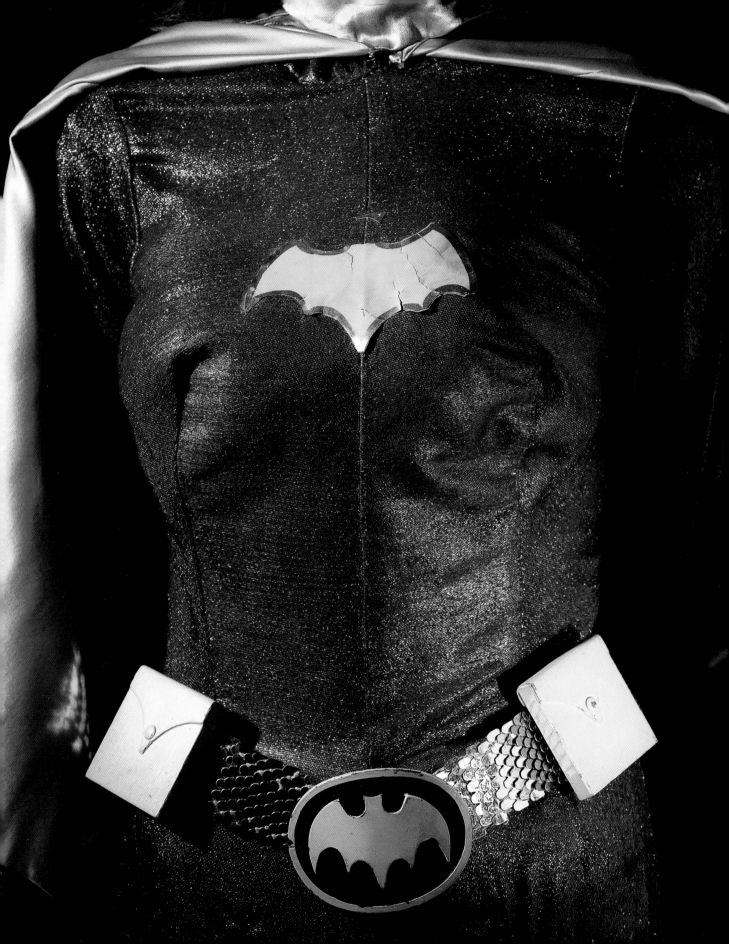

threw to celebrate the show's debut; also present was a fan dressed as Batman, who was uninvited but evidently too entertaining to eject.

The idea that something could be amusing because it was corny or ridiculous was essential to Pop and its allied aesthetic, camp; this was also the approach employed in producing the program. Some fans of the comic books were annoyed, but they were a minority compared with millions of adults who enjoyed feeling sophisticated, and millions of kids who didn't know or care that they were watching a spoof. And there was plenty to entertain them: the show had expensive sets, brightly colored costumes, a rocking theme song (by Neal Hefti), and lots of gaudy gadgets. Of these, the most memorable was the Batmobile, created for the show by car customizer George Barris.

Still, it was the characters that made *Batman* a success, and actor Cesar Romero recalls being told by the producer that "the important characters were the villains." Romero was a hit as the Joker, even if his white clown makeup had to be slathered over the mustache he refused to shave. The bad guy who appeared most often during the show's 120 episodes was Burgess Meredith as the Penguin. "It was kind of a trendy thing to do at the time," he said, but in fact he and Romero were among the first to battle Batman, and the show became fashionable only after their trend-setting performances. "I love the original crew of villains," said Bob Kane, including among their number Julie Newmar, who as Catwoman invested her role with an inimitable

Page 108 (top): Sketch artist Leslie Thomas did this drawing of the television Batcave for the show's art director, Serge Krizman.

Page 108 (bottom): Down in the Batcave, Robin and Batman pose in sets that were among the first to take advantage of color television.

Above: Yvonne Craig as Batgirl arrived on the scene for Batman's third television season, but she didn't succeed in saving the sagging show.

# BATGIRL STRIKES BACK

Comic books may have been the original inspiration for the *Batman* TV series, but by 1967 the tail was wagging the dog. The program was such an unprecedented hit that the comics were now imitating it, so when the quest for demographics caused ABC executives to demand a new character on the tube, DC was obliged to introduce her too. "When the ratings slipped on the TV show, they wanted a female interest," said editor Julius Schwartz. "I don't remember the exact details, but I was asked to create a Batgirl. I called Carmine in, and he drew the costume and did the cover. I worked out the story and called it 'The Million Dollar Debut of Batgirl.'"

The Batgirl who got her start in *Detective Comics* #359 (January 1967) was very different from the younger Bat-Girl of 1961, and not just because she didn't have a hyphen. The new version was fully grown, a librarian, and the daughter of Police Commissioner Gordon. Gardner Fox's script showed the redhead becoming a costumed crime fighter almost by accident, when she ran into a robbery while wearing a Halloween outfit and couldn't resist the temptation to go into action. By coincidence the robbery victim was Bruce Wayne, and Barbara Gordon as Batgirl soon became Batman's ally. The TV Batgirl lasted only a few months, but her counterpart in the comics was around for years, and at one point even had her own solo stories in the back of *Detective Comics*. An injury eventually put an end to her career in uniform, but she has continued to combat criminals as a computer expert.

ironic eroticism. She was persuaded to take the part by her younger brother, a student at Harvard, and she credits some of her success to a Lurex costume that "had a kind of elasticity to it, so it gave where it was supposed to."

The Riddler, the Joker, the Penguin, and Catwoman (all characters originally created for the comics) proved to be the mainstays of the program's first and most successful season, so they were teamed together for a 1966 feature film, shot after the season's shows were completed. This movie's expanded budget paid for a Batcopter and Batboat, but it was generally less incisive than a single episode of the TV series. Director Leslie H. Martinson did come up with one inspired slapstick sequence, in which Batman desperately attempts to dispose of a bomb but can't toss it away because he keeps running into innocent bystanders, from nuns to baby ducks, no matter which way he turns.

As Batman, Adam West had a role that defined his career. His Robin, Burt Ward, was an unknown chosen for his appearance and a certain raw enthusiasm, but West had worked extensively in film and television and realized the danger of being typecast. He took the role anyway, he said, because "I felt I had such an opportunity to create a character that would become a part of pop culture." Initially intending to play Batman broadly, he soon realized that a certain amount of restraint would be more effective. "The trick is to let the costume work for you," according to West, even though he found it restricting and uncomfortable. "The tights were itchy," he said. "If you'll notice, my Batman was always moving."

When new television episodes were aired in the fall of 1966, ratings were down. Some commentators feel that the show had become too self-consciously campy, or that new villains created to accommodate visiting stars were somehow substandard (although Victor Buono as King Tut and Vincent Price as Egghead were certainly up to snuff). Perhaps the novelty of a show that was

Official Batman milk mugs were the perfect accessories for lunches consisting of Batman milk, Batman peanut butter, and Batman bread. For dessert: Batman bubble gum.

Above: The comics introduced a new Batgirl, Commissioner Gordon's daughter Barbara, in *Detective Comics* #359 (January 1967). Pencils: Carmine Infantino. Inks: Sid Greene.

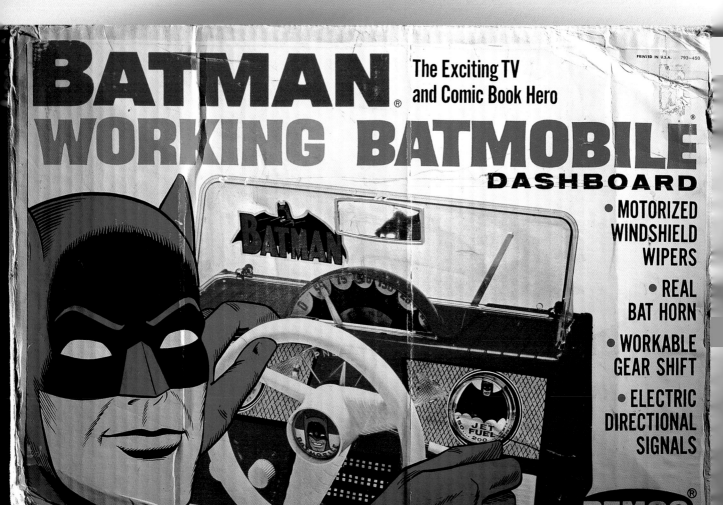

Left: A tin toy at a time when plastic was becoming more common, this Japanese Batmobile hit the road in (you guessed it) 1966.

Bottom left and below: Kids could get behind the wheel of the Batmobile with Remco's 1966 dashboard, shown here with the original box.

admittedly silly had simply worn off. By the start of the third season in September 1967, audiences were disappearing dramatically, and ABC responded with two strategies: cutting back to one show a week (thus eliminating the popular cliffhangers), and bringing in a new character called Batgirl. This was not the kid of the comic books but a curvaceous adult, played by dancer Yvonne Craig. The plan was to attract new audience members, especially idealistic young girls and less high-minded older men. "I used to think the reason they hired me was because they knew I could ride my own motor-cycle," said Craig, but years later, she claimed, "I realized they hired me because I had a cartoon voice." Either way, Batgirl didn't really work. There wasn't room for her in stories that had been cut back to half an hour, and in any case a third hero in Batman stories has always been something like a third wheel on a bike.

The last new *Batman* program, featuring Zsa Zsa Gabor as a wicked beautician who reads minds with her hair dryers, was shown on March 14, 1968. The series has been in reruns ever since, and it has had a lasting effect. It moved millions of dollars' worth of Bat-merchandise, from plastic models to peanut butter, and set up a naïve concept of comic books that has remained lodged in American minds for decades. It also caused some changes in the Bat-man comics themselves. "I don't know if I was pleased with it, but it was the thing to do," said editor Julius Schwartz. "When the television show was a success, I was asked to be campy, and of course when the show faded, so did the comic books." The temporary surge in sales had certainly been welcome, but in the long run the camp craze had undone the conscientious effort to restore Bat-man to his roots.

Carmine Infantino, the artist whose work on Batman's "New Look" represented only one of his contributions to DC Comics, was named the

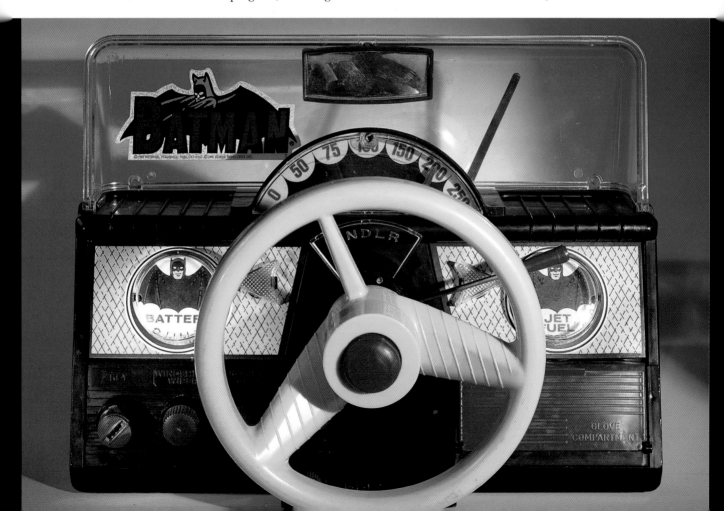

company's art director by Irwin Donenfeld in 1966. The next year, at the height of Batman's popularity, DC was acquired by Kinney National Services, which then bought Warner Bros. Also in 1967, Infantino became editorial director of DC, and he favored the more modern look for Batman that he had pioneered. "When I brought in my work, he used to go over it with a blue pencil," said Bob Kane. "And we had a real feud after that, because I broke it in half and threw it on his desk." Infantino and Kane eventually agreed to disagree, and Kane retired from active participation in the comics that same year, although he said the timing was a coincidence. "I wanted to kind of be an entrepreneur, just take a vacation, travel, and get away from the routine."

Sheldon Moldoff, who had been ghosting Kane's artwork for the past fifteen years, suddenly learned that he was out of the Batman business as well. He knew that negotiations had been in progress, but his agreement was with Kane rather than the publisher. "Finally Bob told me that DC was going to handle everything." He recalls being given his last script and just handing it back. "That's the way our relationship ended," said Moldoff, who has begun only recently to receive recognition for his years drawing Batman. "I didn't think I had any fans," he said, "or that anyone knew who I was."

Without Kane or Moldoff, whose associations with *Detective Comics* went back to 1939, the last links to the past were broken. It would remain for Julius Schwartz and a new generation of talent to bring Batman back from the brink once more.

Pages 118–33: Coming out of the camp craze, the Batman of the 1970s acquired a new aura of drama and realism through the innovative art style of Neal Adams. "Challenge of the Man-Bat," from *Detective Comics* #400 (June 1970), marks the debut of an ambiguous antagonist. Inks: Dick Giordano. Script: Frank Robbins.

BAM! ZOWIE POW! BIFF!

BATMAN

CARTOON KIT BY COLORFOR IS HERE...NOW!

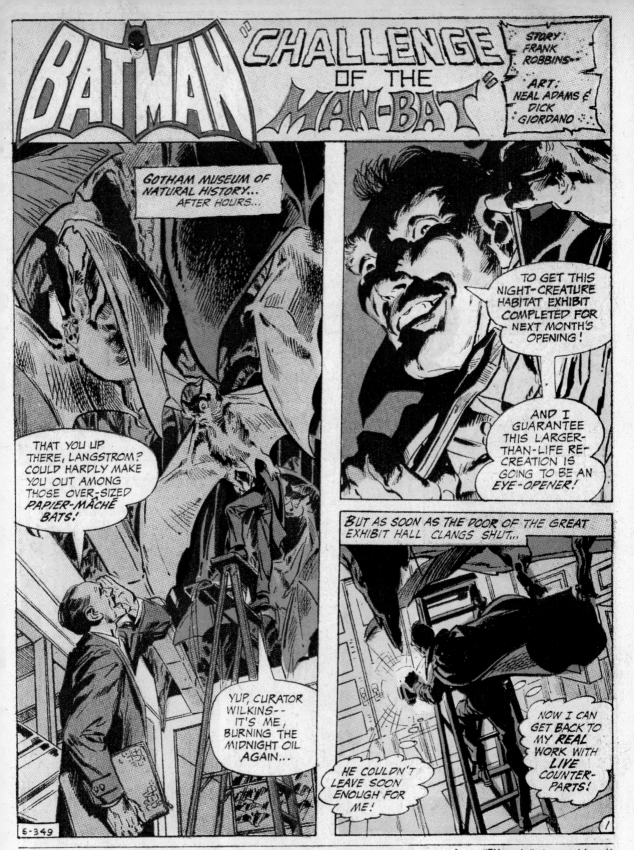

DETECTIVE COMICS, No. 400, June, 1970. Published monthly by NATIONAL PERIODICAL PUBLICATIONS, INC., 2nd & Dickey Sts., Sparta, Ill. 62286. EDITORIAL, EXECUTIVE OFFICES, 909 THIRD AVENUE, NEW YORK, N.Y. 10022. Julius Schwartz, Editor. Carmine Infantino, Editorial Director. Second Class Postage Paid at Sparta, Ill. under the act of March 3, 1879. No subscriptions. For advertising rates address Richard A. Feldon & Co., 41 E. 42nd St., New York, N.Y. 10017. Copyright © National Periodical Publications, Inc., 1970. All rights reserved under International and Pan-American Copyright Conventions. The stories, characters and incidents mentioned in this magazine are entirely fictional. No actual persons, living or dead, are intended or should be inferred.

THE BRIGHT LIGHT HURTS YOUR WEAK EYES, DOES IT? SOON YOU'LL SLEEP, LITTLE FURRED FRIEND...

AND SOON I WILL HAVE A NATURAL ABILITY EVEN THE GREAT *BATMAN* DOESN'T POSSESS!

WHILE UNDERGROUND IN ANOTHER PART OF *GOTHAM CITY*...OTHER MEN HAVE COME UP WITH A WAY TO *COMBAT BATMAN'S* NIGHT-FIGHTING ABILITY!...

FROM NOW ON OUR VAULT-HEISTS WILL BE CARRIED OUT *UNDETECTED!* NO ONE--NOT EVEN THE *MASKED MAN-HUNTER*--WILL BE ABLE TO SPOT US!

BECAUSE UNLIKE US-- *BATMAN* CAN'T *SEE* IN PITCH-BLACKNESS!

WITH OUR "LIGHT-INTENSIFIER" GOGGLES, THE DARKEST OBJECTS LOOK BRIGHT AS DAY!

AND WITH THESE FOAM-SOLED SHOES, NOT EVEN A MOUSE COULD *HEAR* US!

THE WALL TO THE GEM-VAULT ROOM SHOULD BE RIGHT HERE, ACCORDING TO THIS UNDER-GROUND PLAN! READS JUST LIKE I HAD A *SPOTLIGHT* ON IT!

HAND ME THE *ULTRA-SONIC* CUTTING TOOL--NOBODY CAN *HEAR* THAT EITHER!

HERE, BOSS...

WHAT WAS *THAT?* THOUGHT I HEARD SOME-THING...

2

MUST'VE BEEN A SEWER-RAT... HEY! CLUMSY!

SORRY, BOSS... THOUGHT YOU HAD IT!

AND EVEN BEFORE THE ECHOING SOUND DIES OUT...

YOU'VE HAD IT ALL RIGHT!

THE BATMAN?! HE HEARD...

CLANGGGGG

AS THE CAPED CRUSADER LANDS IN THE STYGIAN DARKNESS, A WELL-REHEARSED ESCAPE PLAN GOES INTO SILENT, SMOOTH OPERATION!...

BATMAN WON'T DARE SHINE A LIGHT... OR HE BECOMES THE TARGET!

INSTANTLY USING HIS FINELY ATTUNED HEARING, THE GOTHAM GANGBUSTER SWINGS INTO ACTION...

ONLY THE FAINTEST RUSTLE OF CLOTHING-- BUT THEY'RE EVADING ME LIKE THEY CAN SEE!

AS THE LAST OF THE THUGS FLITS PAST...

BATMAN... BLIND AS A BAT! CAN'T RESIST THE TEMPTATION TO--

BUT, DEFTLY ROLLING WITH THE PUNCH...

ALL I NEEDED... SOME CONTACT TO LATCH ON TO!

3

INSTANTLY REGRETTING HIS RASHNESS, HIS PREY PULLS AWAY... BECOMING A MOVING TARGET!...

DARN! COULDN'T CONNECT SOLID!

BOK

RIP

MOMENTS LATER, LEFT ALONE WITH AN EMPTY SLEEVE...

OUT-MANEUVERED BY... SHADOWS! MUST'VE BEEN USING SOME SOPHISTICATED ELECTRONIC SEEING-AID...

THIS MONKEY HAD TO SEE WHAT HE WAS AIMING AT--ME!

NO RISK NOW IN THROWING LIGHT ON THE SITUATION! MAY FIND SOME CLUE...

THERE'S SOMETHING... PROBABLY WHAT CAUSED THE RACKET THAT ALERTED ME!

AN ULTRA-SONIC CUTTING TOOL! CAN ZIP THROUGH CONCRETE AND METAL LIKE CHEESE...

...WITHOUT EMITTING A SOUND THE HUMAN-EAR CAN DETECT!

ONE STUPID SLIP-UP IN A PERFECT SET-UP ALMOST FINISHED US! FROM NOW ON... ALL TOOLS ARE PADDED, DIG?

TOUGH WE HAD TO LOSE THAT ULTRA-SONIC TOOL!

WHILE EXITING IN A REMOTE, DESERTED AREA...

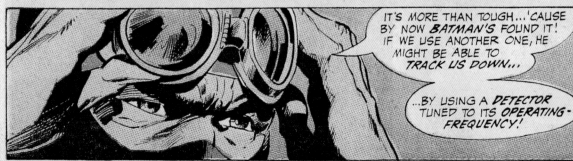

IT'S MORE THAN TOUGH...'CAUSE BY NOW BATMAN'S FOUND IT! IF WE USE ANOTHER ONE, HE MIGHT BE ABLE TO TRACK US DOWN...

...BY USING A DETECTOR TUNED TO ITS OPERATING-FREQUENCY!

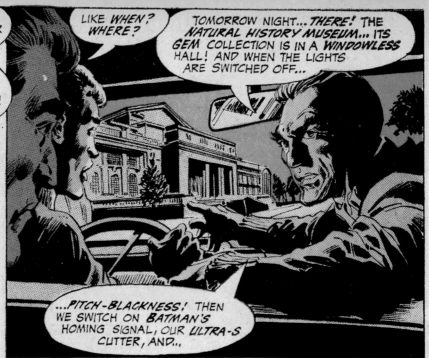

THEN HE'S GOT US STYMIED, BOSS! WE CAN'T PULL ANOTHER "BLACKOUT" JOB WITHOUT THAT *SILENT GIZMO!*

NOT UNLESS WE USE IT AS A *WEAPON* AGAINST THAT SNOOPER! WHICH WE *WILL*...TO *LURE* HIM INTO A *TRAP*...WHERE WE'LL BE READY FOR *ANY* COUNTER-MOVE HE MAKES!

LIKE *WHEN? WHERE?*

TOMORROW NIGHT...*THERE!* THE *NATURAL HISTORY MUSEUM*...ITS *GEM* COLLECTION IS IN A *WINDOWLESS* HALL! AND WHEN THE LIGHTS ARE SWITCHED OFF...

...*PITCH-BLACKNESS!* THEN WE SWITCH ON *BATMAN'S* HOMING SIGNAL, OUR *ULTRA-S* CUTTER, AND...

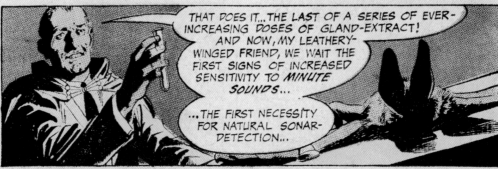

*WHILE IN THE DEPTHS OF THE OUT-WARDLY BLACKED-OUT MUSEUM...*

THAT DOES IT...THE LAST OF A SERIES OF EVER-INCREASING DOSES OF GLAND-EXTRACT! AND NOW, MY LEATHERY-WINGED FRIEND, WE WAIT THE FIRST SIGNS OF INCREASED SENSITIVITY TO *MINUTE SOUNDS*...

...THE FIRST NECESSITY FOR NATURAL *SONAR-DETECTION*...

*ARGHH-H!* THAT NOISE--*UNBEARABLE!*

PLIP PLIP PLIP PLIP PLIP

AND...MY *EYES!* CAN'T STAND THAT *BLAZING LIGHT!*

*SWITCHING OFF THE OFFENDING LIGHT, LANGSTROM HEADS UNERRINGLY ACROSS THE CLUTTERED LAB TO THE CLOSET!...*

SUNGLASSES IN MY JACKET... MUST GET THEM!

6

THEN, A SUDDEN DAWNING REALIZATION...

GOOD LORD! I NAVIGATED IN UTTER **BLACKNESS** WITHOUT BUMPING INTO ANYTHING!

MY VOCAL-CORDS MUST'VE BEEN EMITTING **SUPER-SONIC** SIGNALS!

MY ULTRA-SENSITIVE HEARING PICKED UP THE BOUNCE-BACK ECHOES, GUIDING ME TO MY TARGET LIKE A HOMING MISSILE!

I'VE **DONE** IT! I NOW POSSESS A BAT'S **NATURAL SONAR!**

BUT... **NORMAL** SOUNDS CAN DRIVE ME **CRAZY!** HAVE TO DULL THEM...

THESE WAX EAR-PLUGS WILL DO TILL I CAN GET BETTER ONES!

WHILE IN HIS SECRET LAB ATOP THE **WAYNE FOUNDATION,** BATMAN WORKS FEVERISHLY TO INCREASE HIS HEARING SENSITIVITY...

SINCE I'M A **BAT**MAN IN NAME ONLY, I NEED AN **ARTIFICIAL** AID TO FIND MY TARGETS QUICKLY IN THE DARK!

THESE STEREO-LOCATER EAR-PLUGS SHOULD DO THE JOB, ALFRED!

WORKING DEEP INTO THE NIGHT, THE **CAPED CRUSADER** FINALLY REACHES THE TEST STAGE...

WILL THIS OUTFIT DO, SIR?

FINE! TAKE OFF YOUR SHOES...

AND MOVE AS SILENTLY AS POSSIBLE INTO THE DARK, CARPETED LIVING ROOM!

AND NOW, AS I PLUNGE EVERYTHING INTO DARKNESS... WE PLAY HIDE-AND-SEEK!

6

IN A BRIEF BATTLE OF WITS, BOTH MEN MAKE NO MOVEMENT TO BETRAY THEIR LOCATION... UNTIL LIKE A POUNCING CAT...

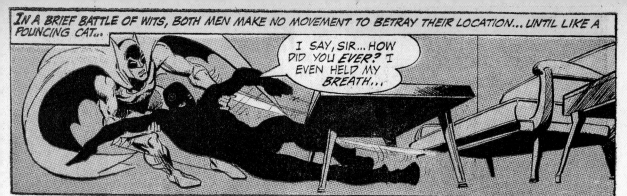

I SAY, SIR... HOW DID YOU *EVER*? I EVEN HELD MY *BREATH*...

AS THE LIGHTS ARE PUT ON AGAIN...

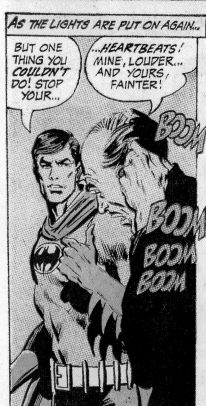

BUT ONE THING YOU *COULDN'T* DO! STOP YOUR...

...*HEARTBEATS*! MINE, LOUDER... AND YOURS, FAINTER!

BOOM

BOOM BOOM BOOM

NOW I'M SET TO COPE WITH THIS "*BLACKOUT*" GANG... SOON AS I ANALYZE THE OPERATING FREQUENCY OF THIS *ULTRA-SONIC* CUTTER, AND RIG UP A LOCATION-FINDER!

WHILE AT THE MUSEUM, A MAN FLUSHED WITH SUCCESS BUT WEARIED BY HIS TRYING BREAK-THROUGH...

ENOUGH FOR NOW! I MUST GET HOME TO BED...

W-WHAT'S-- THIS?!

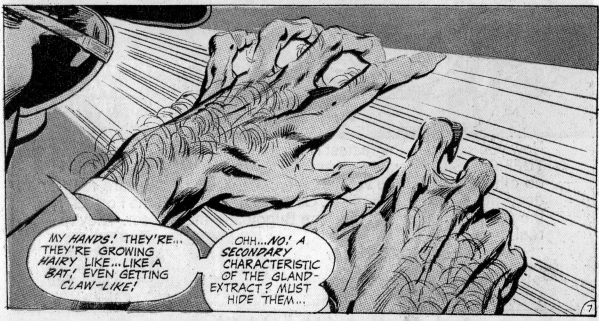

MY *HANDS*! THEY'RE... THEY'RE GROWING HAIRY LIKE... LIKE A *BAT*, EVEN GETTING *CLAW-LIKE*!

OHH...*NO*! A *SECONDARY* CHARACTERISTIC OF THE GLAND-EXTRACT? MUST HIDE THEM...

7

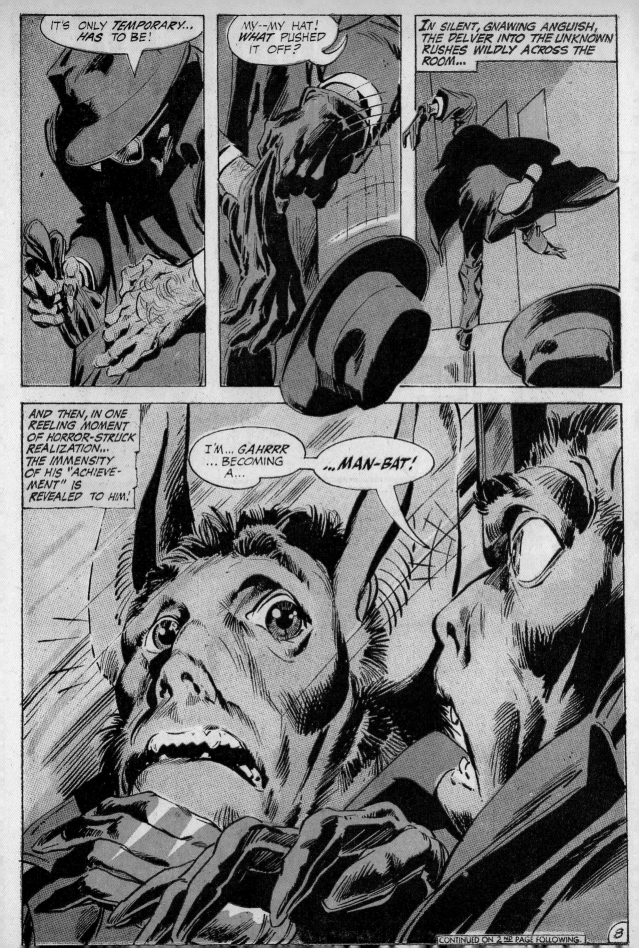

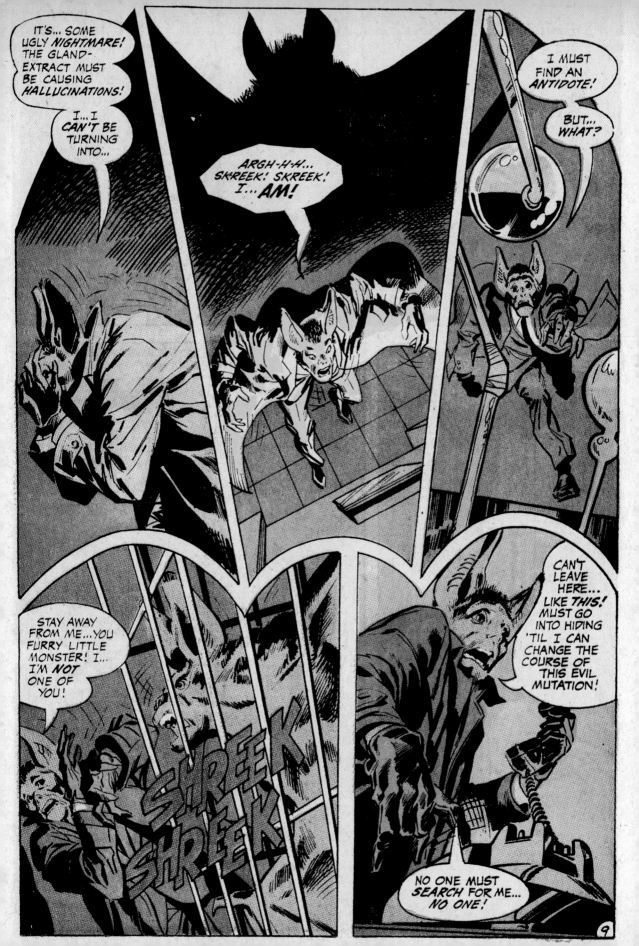

NEXT MORNING, A TELEGRAM DELIVERY TO THE CURATOR OF THE GOTHAM MUSEUM OF NATURAL HISTORY...

"MOTHER SERIOUSLY ILL... STOP... MUST FLY TO CHICAGO...STOP... DON'T WORRY... EXHIBIT WILL BE FINISHED TIME FOR OPENING... LANGSTROM"

DON'T WORRY?

WHO ELSE COULD COMPLETE THIS AUTHENTIC BAT-HABITAT LIKE LANGSTROM?

HE'D BETTER RETURN IN TIME...

WHILE UNNOTICED ABOVE, AMONG NIGHT-CREATURES WHO SLEEP BY DAY... AND HUNT BY NIGHT...

AS THE LONG DAY PASSES AND THE MUSEUM SLEEPS AGAIN, AN EMOTIONALLY EXHAUSTED MAN-BAT WAKES, UNREFRESHED...

SKREEK... YAWN! DREAMED SUCH GRUESOME TORTURED THINGS-- THAT I WAS REALLY A... UGH...BAT! AND SLEEPING HANGING UPSIDE-DOWN...

NO DREAM... GASP...NO DREAM! I AM UP HERE... AMONG THEM! AND...AND THE FANTASTIC STRENGTH MY HANDS NOW POSSESS...!

10

REPEAT... *SURRENDER* BEFORE I...

HA! WANTS TO BAIT US INTO REVEALING OUR POSITIONS BY *ANSWERING!* HE'S BLIND AS A BAT!

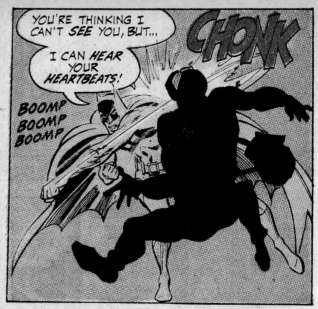

YOU'RE THINKING I CAN'T *SEE* YOU, BUT...

I CAN *HEAR* YOUR *HEARTBEATS!*

CHONK

BOOMP BOOMP BOOMP

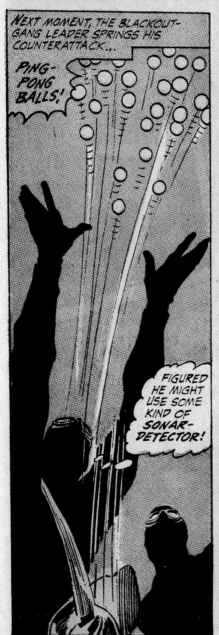

NEXT MOMENT, THE BLACKOUT-GANG LEADER SPRINGS HIS COUNTERATTACK...

PING-PONG BALLS!

FIGURED HE MIGHT USE SOME KIND OF *SONAR-DETECTOR!*

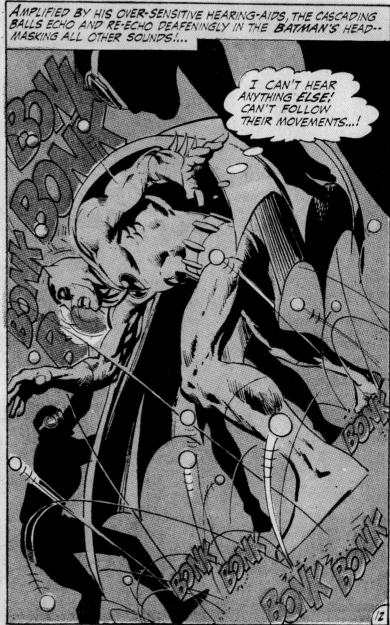

AMPLIFIED BY HIS OVER-SENSITIVE HEARING-AIDS, THE CASCADING BALLS ECHO AND RE-ECHO DEAFENINGLY IN THE *BATMAN'S* HEAD-- MASKING ALL OTHER SOUNDS!...

I CAN'T HEAR ANYTHING *ELSE!* CAN'T FOLLOW THEIR MOVEMENTS...!

BOYK BOYK BOYK BOYK BOYK

12

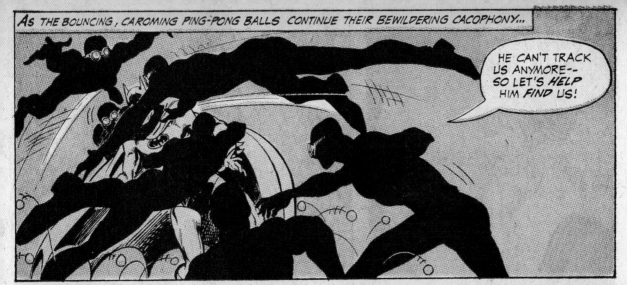

HE CAN'T TRACK US ANYMORE-- SO LET'S *HELP* HIM *FIND* US!

BUT EVEN FOR THE MIGHTY *BATMAN* THESE ODDS PROVE *TOO* GREAT!

I'LL TAKE IT ON THESE BLIND TERMS, ANYTHING THAT HITS ME--*I* CAN HIT!

NOW THAT HE'S HELPLESS...I'LL *FINISH* HIM!

BUT *SUDDENLY,* FROM OUT OF THE BLACKNESS OF THE HUSHED HALL...

SCREEE

SCREEEEE

WHA--? ARGH-H-- IT'S... THE MOST HORRIBLE *THING* I'VE EVER SEEN!

13

14

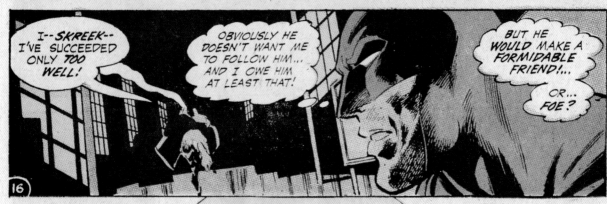

# CLOAKS

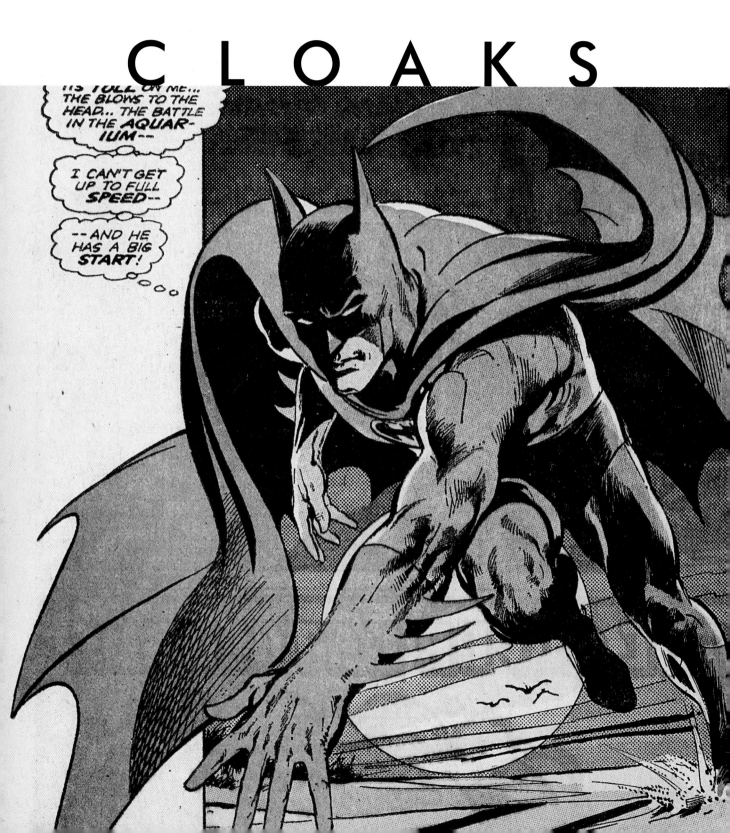

The initial impulse that led to Batman's renaissance came from an unexpected quarter. *The Brave and the Bold,* an anthology comic book that had introduced such successful features as the Justice League of America, had been experiencing a sales slump. Bob Haney, the title's long-time writer, and editors George Kashdan and Murray Boltinoff searched for solutions, including team-up stories featuring various characters. Haney suggested making Batman the lead character, and combining him with a different DC hero in every issue. "We got permission," he said, "and I ran with that book for about thirteen years." Beginning at the height of the Batmania prompted by the TV show, this unusual comic book series was nonetheless comparatively unaffected by the camp craze, and Haney's solidly crafted stories began to attract attention. "I used to sit with Carmine Infantino when he was chief editor," Haney recalled, "and he would read the sales figures to me. If a team hadn't worked, we wouldn't use it again. So I found myself having to rotate pretty much the same heroes, and there were about half a dozen of them, like Flash and Green Arrow. Some minor characters worked well, though."

*The Brave and the Bold* made its most lasting mark on Batman when it provided a showcase for the talent of a young artist named Neal Adams. After unsuccessfully lobbying for work in *Batman* or *Detective Comics,* Adams was still determined to show their editor, Julius Schwartz, what he could do. Editor Murray Boltinoff proved to be more amenable and gave Adams his first chance to draw a Batman story in *The Brave and the Bold* #79 (August–September 1968). Batman was teamed with Deadman, a hero Adams had already been drawing for *Strange Adventures.* Deadman, a character with a cult following, had the uncanny agenda of investigating his own murder, and some of the eerie atmosphere seemed to rub off on his temporary partner. This was a Batman presented with the mystery and menace of bygone days, but portrayed with artistic flourishes by Adams that seemed altogether new.

Born in 1941, Neal Adams had worked in advertising and drawn a newspaper strip based on the TV series *Ben Casey* by the time he got his start at DC. He brought with him approaches that were uncommon in comic books of the day, ranging from complex crosshatching techniques to the use of photographic references for facial expressions. He insisted on contributing to the coloring of his covers and stories (a very unusual procedure at a time when pencillers, inkers, and colorists each had clearly defined tasks) and experimented with unusual page layouts and strange shapes for panels. Most memorably, he delineated a Batman whose face and figure reflected

Self-portrait by Neal Adams.

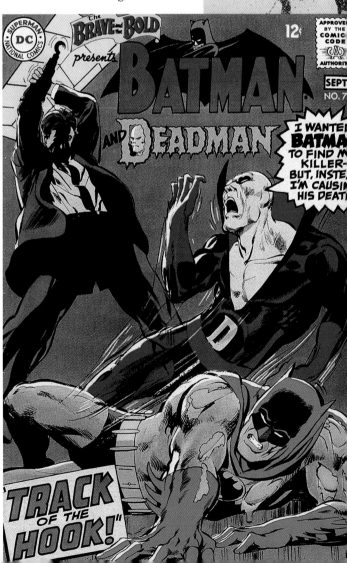

Neal Adams's first Batman story, written by Bob Haney, teamed the Caped Crusader with Deadman in *The Brave and the Bold* #79 (August–September 1968).

the influence of realistic illustration, but whose wildly expressive cloak and melodramatic poses were pure romanticism. As the series progressed over the next few months, Adams increasingly made his presence felt. "If the script called for a daytime scene, I would simply change it in the artwork to a nighttime scene," he said. "I just took a script and tried to make sure that Batman only did things that Batman would do."

His work in *The Brave and the Bold* soon brought Adams to the mainstream Batman books. As if preparing the way, Julius Schwartz had plotted with writer Frank Robbins to send Dick Grayson to college, thus minimizing the participation of Robin. They even shut down Wayne Manor and the Batcave, in effect dropping three decades of accumulated responsibilities and transforming Batman into

a free agent once again. Bruce Wayne moved into a Gotham City penthouse in *Batman* #217 (December 1969). A month later, new talent ushered the hero into a new decade.

"My favorite writer at that time was Denny O'Neil," said Julius Schwartz, "and Neal Adams had done some remarkable work for Murray Boltinoff. I thought they'd make an ideal team." Completing the group was Dick Giordano, a newly recruited editor who was also a skilled draftsman and shared an office with Schwartz. "When I got to DC, Neal and I struck up an immediate friendship," Giordano explained, and when an inker was required for pencils Adams was too busy to finish, "it was natural for Neal to think of me."

Dennis O'Neil, just beginning to hit his stride in comics, had worked with Giordano at a small publisher called Charlton and was part of a group Giordano had brought with him when he was hired by DC. Comics eventually turned out to be the mainstay of O'Neil's career, but that wasn't part of his plan. "It was one of a number of things that I did as a freelance writer," he said. He thought of himself primarily as a journalist, and one of his strengths as a writer was his ability to make his stories seem like significant events and not just entertainments. This talent was especially notable later in 1970, when O'Neil and Neal Adams embarked on a groundbreaking series of stories that forced flagging heroes Green Lantern and Green Arrow to confront topical issues of the day, including racism and drug use.

No attempt was made to send an editorial message when O'Neil started on Batman, however. "It was just pure storytelling," he said, "just melodrama, and it didn't have any pretensions to anything else." O'Neil was born in the same month and year when Batman made his debut, which, he admits, "spooks the hell out of me when I think about it," especially in light of the impact the character eventually had on his life. After taking the Batman assignment, he studied comics that had been published when he was still a baby, in search of clues for creating a modern Batman. "We talked a

15¢ APPROVED BY THE COMICS CODE AUTHORITY
Detective Comics presents NO. 395 JAN.
BATMAN and ROBIN
I OFFER YOU IMMORTALITY-- OR INSTANT DEATH!
CHOOSE, BATMAN-- NOW!

As a new decade dawned, the groundbreaking team of Dennis O'Neil and Neal Adams took its first shot at Batman in *Detective Comics* #395 (January 1970).

# THE DARK KNIGHT ON SATURDAY MORNING

One of the many spin-offs of Batman's success on prime time television sent him careening into the ghetto of Saturday morning cartoons. The hit live-action show had a big budget, but the animated offshoots were filmed on a shoestring, without the money to do much more than fill a time slot. The plan with kidvid was to spend as little as possible on a certain number of shows, then recycle them endlessly for wave upon wave of demographic targets. It worked, and generations of children who grew up with these programs have developed some nostalgia for them, despite the fact that the inexpensive animation was inferior to the theatrical cartoons of earlier years, which were shown simultaneously on TV. Perhaps it was the innate appeal of characters like Batman that made the limited animation acceptable, but still, you could almost see the accountants grinning when Robin shouted, "I can't move! I'm paralyzed!"

The first cycle of Batman cartoons was produced by a studio called Filmation and aired on CBS in *The Batman-Superman Hour* in 1968, packaged with some footage from the previous year featuring the Man of Steel. *The Adventures of Batman* and *The New Adventures of Batman* followed, although apparently only thirty-three episodes were made between 1968 and 1977. In 1973 a new animated series, *The Super Friends,* was released on ABC by the Hanna-Barbera studio, which had made cost-cutting cartoons a science, if not exactly an art. Talented designers like Alex Toth contributed storyboards and model sheets, which gave the show more visual impact. These cartoons, a video version of DC's Justice League, featured heroes like Superman and Wonder Woman along with Batman and Robin. Also involved were two teenagers named Wendy and Marvin, later revamped as "the Wonder Twins," Zan and Janya. *The Super Friends* were repackaged through 1984, but it wasn't until 1992 that a committed new generation of animators rolled up its sleeves and created an outstanding Batman cartoon series.

The unusual coloring techniques of Neal Adams enhance the cover of *Batman* #232 (June 1971), featuring the immortal villain Ra's al Ghūl.

lot, and it just came out that we wanted to go back to the way it used to be," said Julius Schwartz.

"Denny's writing style and my art style seemed to mesh perfectly," recalled Neal Adams. "We agreed on almost every detail of Batman's character. It was in 'The Secret of the Waiting Graves' that we first experimented, set the tone, and pointed the way." This story, for *Detective Comics* #395 (January 1970), presented Batman as a fish out of water, caught up in a Mexican horror tale about a wealthy couple who seek eternal life but end up crumbling into dust. This was a long way from Batgirl and the Batmobile, but, O'Neil said, "I'm sure we didn't give that a second's thought. I just wanted to make it Gothic and spooky. I was being influenced by writers like Lovecraft and Poe, and I didn't think about Gotham City."

Several of the strongest stories created during this innovative period were set far afield from Batman's usual haunts. One of O'Neil's favorites, "A Vow from the Grave," in *Detective Comics* #410 (April 1971), was a carefully clued mystery in a rural environment, with a group of carnival misfits as murder suspects. Even more widely admired was "Night of the Reaper" in *Batman* #237 (December 1971). This tale of a killer dressed as the traditional robed figure of Death had a Halloween setting (recommended by artist Bernie Wrightson) and a background of Nazi atrocities (suggested by writer Harlan Ellison). The enthusiasm that such colleagues felt for this modern version of Batman was a tribute in itself, and Neal Adams responded with some of his most moody and evocative art. The most morbid of Batman's traditional foes, Two-Face, was revived after seventeen years of retirement in *Batman* #234

(August 1971), and the Joker reverted from clown to killer in *Batman* #251 (September 1973).

Almost inevitably, the innovators sought to introduce an original antagonist worthy to stand in the pantheon of his predecessors, and they came up with Rā's al Ghūl, a mysterious figure whose passion was ecology and whose goal was world domination. He possessed the power to bring himself back from death, and he also had a lovely daughter, Talia, with whom Batman became romantically entwined. Batman's initial adventures with Rā's al Ghūl constituted an epic that spanned the globe. "His face had to convey the feeling that he'd lived an extraordinary life long before his features were ever committed to paper," said Adams of this new character. "I created a face not tied to any race at all."

Another new bad guy, Man-Bat, had a simpler

The dead Batman is somebody else wearing a Halloween costume; the atmospheric splash page from *Batman* #237 (December 1971) was pencilled by Neal Adams and inked by Dick Giordano.

IT IS DARK IN THE **VERMONT** WOODS THIS OCTOBER EVENING...DARK EXCEPT FOR THE PALE, COLD GLOW OF A BLOATED MOON SHINING THROUGH BRANCHES WHICH PLUCK AT THE SKY LIKE DEAD FINGERS... AND A LIGHT ATOP A DISTANT MANSION BLINKING LIKE AN EYE OF BLOOD, BLINKING, BLINKING.

AND THERE ARE SOUNDS...SCRAPINGS, RUSTLINGS... THE WHISPER OF BREEZE IN THE BRUSH--OR THE STIRRING OF SHROUDS? NONE IS ALIVE TO HEAR...

ART BY: NEAL ADAMS & DICK GIORDANO. STORY BY: DENNY O'NEIL (FROM AN IDEA BY BERNI WRIGHTSON WITH AN ASSIST FROM HARLAN ELLISON). EDITED BY: JULIUS SCHWARTZ.

...BECAUSE THERE IS ALSO **DEATH** IN THIS PLACE! THE MASKED FIGURE OF **THE BATMAN** LEANS AGAINST A BIRCH, UNMOVING, UNBREATHING, GROWING STIFF AND COLD AS THE DIRT...A VICTIM OF THE...

NIGHT OF the REAPER!

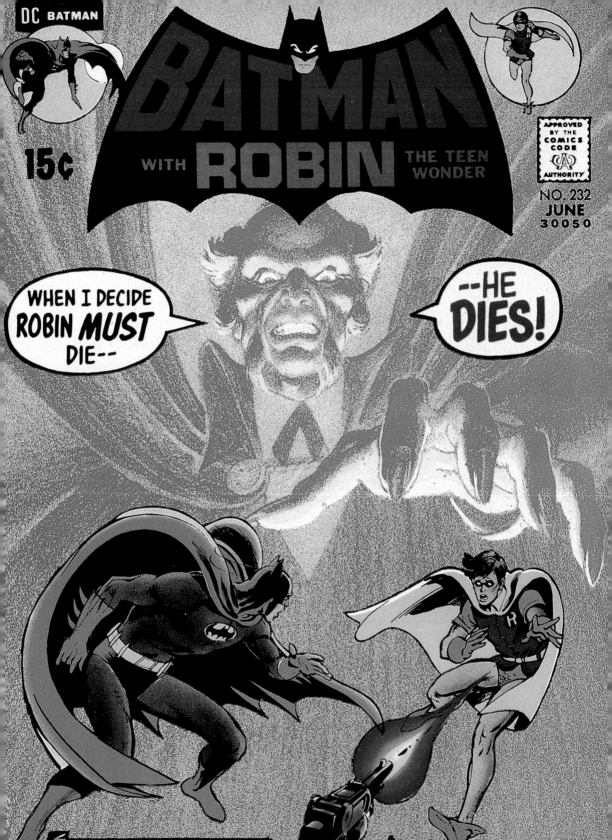

# B A T M A N ' S   S T R I P   T E A S E

Perhaps no other character has shown up in as many American comic strips as Batman. He has made newspaper debuts repeatedly, for various syndicates, but never really caught on despite his popularity in other media. The secret to solid success in a daily strip is one mystery Batman just can't seem to solve. The classic version, prepared by DC using its top artists and writers, was syndicated by McClure and lasted only from 1943 to 1946. In 1953, "Batman and Robin" was part of an experiment called *Arrow, the Family Comic Weekly*. This Sunday supplement failed in a few months, although some of the scripts were written by Walter Gibson, whose hero the Shadow was an early inspiration for Batman. Many of the characters were derived from radio, including Straight Arrow (a white man who disguised himself as a Comanche to outwit outlaws in the old West); coincidentally, his adventures were published in comic books by Vin Sullivan, Batman's original editor.

Batman's longest run, courtesy of the Ledger Syndicate, began in 1966, shortly after the hit TV show took off. Whitney Ellsworth was writer for four years, followed by E. Nelson Bridwell, while artists included Sheldon Moldoff, Carmine Infantino, Joe Giella, and Al Plastino. Despite all this comic book talent, *Batman and Robin the Boy Wonder* seemed almost diametrically opposed to what was happening at DC. In 1970, while O'Neil and Adams turned the comic book version of Green Arrow into a firebrand advocating liberal causes, the newspaper incarnation of the character was teamed with Batman to battle long-haired losers. When a kid took a bullet at a campus protest, Green Arrow cheerfully quipped, "Looks like the shooting took the fight out of those rebels!" Batman slunk out of the strip and abandoned it to some guy named Galexo before it folded in 1974.

Batman was also one of "the World's Greatest Superheroes" for the Chicago Tribune–New York News Syndicate from 1978 to 1985. He even got one more strip in 1989 following the release of his successful feature film, but that strip folded the next year.

story and a more pronounceable name, which may account for his wider public recognition. Making his first appearance in *Detective Comics* #400 (June 1970), Man-Bat was Kirk Langstrom, a scientist and Batman fan who experimented with serums derived from bats and ended up taking on their characteristics. The result was a monstrous, pathetic creature who was nonetheless a genuine menace unless a cure could be found. In retrospect an obvious switch, Man-Bat hadn't occurred to anyone for three decades, but then the idea seemed to have many fathers. "There's a lot of talk about who created Man-Bat," said Julius Schwartz. "The Neal Adams version is not my version." Adams claims he came up with the character, but so does Schwartz.

The late Frank Robbins, who wrote the origin story and also drew some later adventures in his angular style, might have had a third opinion.

Although their influence was tremendous, only a handful of Batman stories were edited by Schwartz, written by O'Neil, pencilled by Adams, and inked by Giordano. These individuals were mixed and matched with various other contributors and were never really partners in the sense that readers might have imagined. "In those days you didn't collaborate," explained O'Neil. "I saw Neal at parties and occasionally ran into him in the halls, but I don't remember any instance where we sat down and talked shop. I was always surprised and delighted to see the final product." Editor Schwartz

Above: Batman and Green Arrow lay down the law to a hospitalized hipster in this politicized strip for December 16, 1970. Script: E. Nelson Bridwell. Art: Al Plastino.

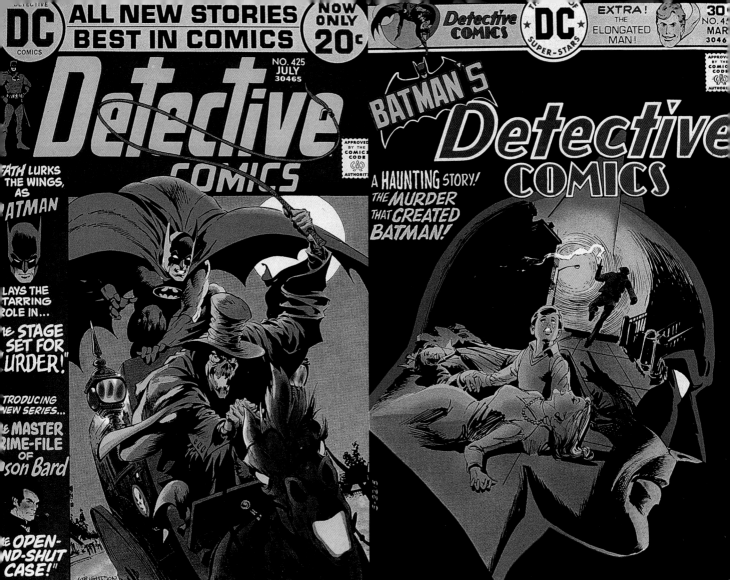

received scripts from writers and handed them out to artists, and perhaps his office mate Dick Giordano, inking and observing, has the most objective view of what was achieved. "We went back to a grimmer, darker Batman, and I think that's why those stories did well," he said. "Even today we're still using Neal's Batman with the long flowing cape and the pointy ears."

Neal Adams left DC after only a few years to create Continuity Studios with Giordano as a partner. After conflicts with Carmine Infantino, Giordano quit as a DC editor but would continue as a Batman artist. O'Neil would write much more, notably

"There Is No Hope in Crime Alley," from *Detective Comics* #457 (March 1976). This story, drawn by Giordano, showed Batman still haunting the side street where his parents were murdered and helped solidify the interpretation of the hero as an obsessive, driven man.

After helping to save Batman's bacon twice, Julius Schwartz took a hiatus from *Detective Comics* when Archie Goodwin took over as editor for seven issues beginning with #437 (October–November 1973). A talented writer who had made his name with scripts for short horror and war tales, Goodwin contributed his share of Batman stories during his tenure, and worked with artist Walter Simonson on the memorable backup series *Manhunter,* designed

Bernie Wrightson, a specialist in macabre subjects like Swamp Thing, drew the masked murderer behind one of Dennis O'Neil's mystery plots for *Detective Comics* #425 (July 1972).

The trauma that created Batman was revisited in Dennis O'Neil's story, "There Is No Hope in Crime Alley," from *Detective Comics* #457 (March 1976). Cover: Dick Giordano.

to begin and end in the space of a year. It was a sign of changing times that most of Goodwin's issues were expanded to one hundred pages, part of an experiment to create an economically viable package in a time of rising prices. Most of each issue was devoted to reprints from previous decades, but this

money-saving measure also suited the purposes of creators and readers who were taking a more serious interest in the medium's past. On his Batman stories, Goodwin worked with striking stylists like Alex Toth and Howard Chaykin, yet it was Schwartz, nearing the end of his long run, who employed the artist who created the biggest stir since Neal Adams. Marshall Rogers didn't draw many stories, but this former architecture student brought with him a sense of design and decoration that made his Batman a benchmark. Working with writer Steve Englehart, Rogers contributed to classics like the Joker opus "The Laughing Fish," in

*Detective Comics* #475 (February 1978).

Meanwhile, Batman-related publications had been proliferating at an uncanny rate. Even though comic books starring villains have rarely been popular, DC released *The Joker* #1 in May 1975 (it lasted nine issues), and *Man-Bat* #1 at the end of the same year (two issues were enough). More successful was *The Batman Family,* launched in September–October 1975. This comic book contained separate stories for the supporting characters and let Batman go his way in peace, thus avoiding the errors of an earlier era that had surrounded Batman with a whole slew of satellites.

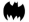

Early in 1979, Julius Schwartz took the assignment to supervise all Superman projects, and Paul Levitz became editor of *Detective Comics* and *Batman,* adding to his work on *The Brave and the Bold. The Batman Family,* which had lasted twenty issues, was folded into the granddaddy of all Batman comics, beginning with *Detective Comics* #482 (February–March 1979). At sixty-eight pages, there was room in *Detective* for individual adventures of Batman, Robin, and Batgirl, plus "you could sneak in something unusual," said Levitz, "and use some interesting choices of artists on odd pieces."

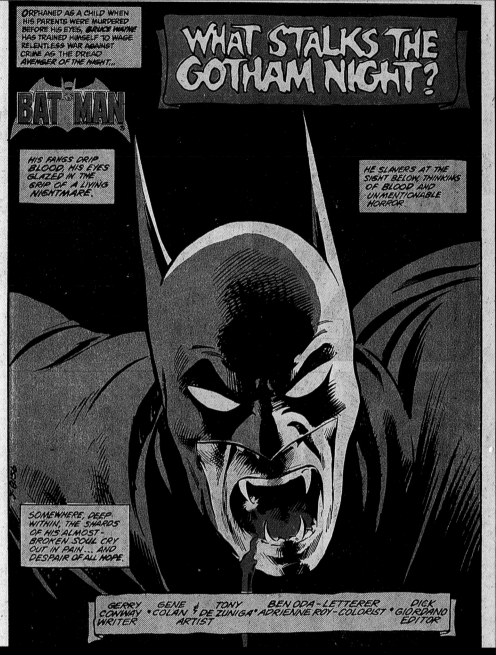

Right: Gene Colan's experience as a delineator of vampires made him a natural to illustrate *Batman* #351 (September 1982). Inks: Tony De Zuniga.

Christopher Lee.

# IN THE VAMPIRE VEIN

There has always been a subliminal association between vampires and Batman; this was a hero who was designed to frighten his foes, and Bob Kane admitted that one of his inspirations was Bela Lugosi's performance in the 1931 movie *Dracula*. So it's not too surprising that another actor's interpretation of Bram Stoker's character could serve as a source for the artist who brought Batman back to his place in the shadows. Neal Adams, whose drawing style is credited with restoring Batman to his roots, cites the films of Christopher Lee as a major influence. In 1968, when Adams began envisioning a new approach to Batman, Lee was making his fourth appearance as Dracula for England's Hammer Films, in *Dracula Has Risen from the Grave*. Noting the swirling, dramatic motion Lee created with his cloak, Adams told himself "that's the way Batman's cape ought to move."

The Transylvanian connection continued to make its mark in years to come. In 1982, writer Gerry Conway concocted a lurid storyline, running through both *Batman* and *Detective Comics,* in which Batman truly (if temporarily) became a vampire. Conway may have been inspired by the chance to work with artist Gene Colan, who had recently completed a seven-year run on a Dracula series for DC's rival, Marvel Comics. "I wanted an opportunity to draw atmosphere," said Colan. "Give me a good horror story, and I'll do that to a fare-thee-well." A decade later, as part of a fanciful *Elseworlds* series, writer Doug Moench and artist Kelley Jones would take this idea to its ultimate conclusion, gruesomely depicting an alternate universe in which Batman completely succumbed to the curse of the undead and ultimately had to be destroyed.

Below: Some of the handsomest Batman art of the decade was provided by Marshall Rogers, here illustrating Steve Englehart's script for *Detective Comics* #473 (November 1977). Inks: Terry Austin.

DC Comics itself was in a considerable state of flux. Jenette Kahn had been appointed as the company's publisher in 1976 and was working to modernize the company and its comics. This meant recognizing that the audience for comic books was growing older, although the talent was growing younger. Levitz, for instance, had been in college studying business when he started at DC and noted that he was the first editor of the Batman line who had grown up on comic books rather than pulps. He was also dealing with a generation of writers and artists who tended to be more independent than their predecessors, perhaps less concerned with job security and more inclined to consider comics an art rather than an industry.

Perhaps the principal contribution that Levitz made during his two-year tenure with the Caped Crusader was to solidify the basic background on which all Batman stories would be built. "What I tried to do was play to a sense of a world and a continuity," he said. "I think it was the first time we did a writer's bible for Batman which established some common things in Gotham City, and some common supporting characters." He also published a

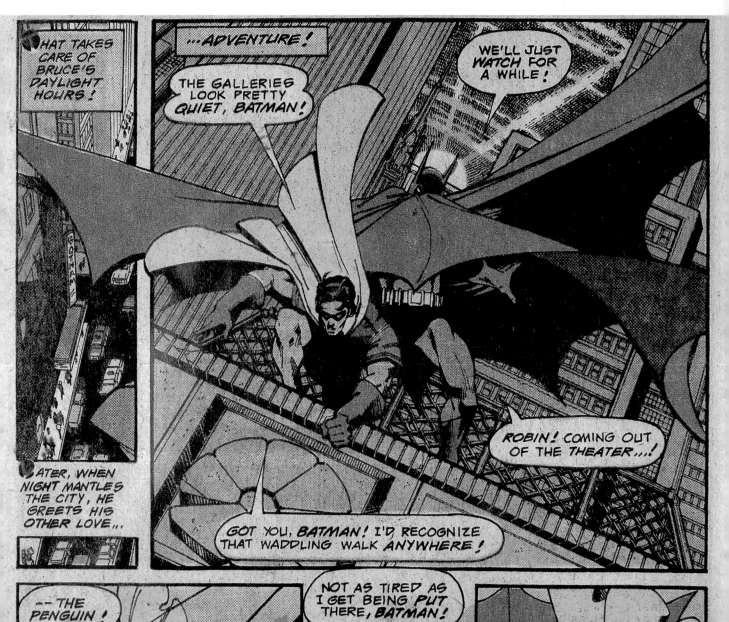

The unlovable second Robin tries on a costume in *Detective Comics* #526 (May 1983). Script: Gerry Conway. Pencils: Don Newton. Inks: Alfredo Alcala.

comparable work for the edification of the fans. "*The Untold Legends of the Batman* is probably one of the things that I'm proudest of editorially. It was the first Batman miniseries and laid out a lot of the character's back story." This 1980 series, condensing years of Batman's history into three issues, was written by Len Wein and drawn by John Byrne and Jim Aparo.

At the end of 1980, comics experienced one of their periodic slumps, and *Detective Comics* was abruptly cut back to the standard thirty-two pages. As Levitz wrote at the time, "the decline in news-stand sales that caused the change was equally sudden, requiring swift action." In retrospect, the move was healthy, demanding that more attention be paid to Batman than to subsidiary heroes. In the summer of 1981, Levitz gave up control over the Caped Crusader and moved to the business side of the company. Dick Giordano, an artist and editor with close ties to Gotham City, was brought in to keep the Batmobile running on all cylinders.

"Batman was and still is my favorite character," Giordano said, "so my approach to any Batman assignment has been a mixture of awe, respect, and responsibility to keep the character's mythos intact, maybe make it a little better if I could." Dennis O'Neil referred to Giordano as a "zen" editor, who could influence writers and artists without seeming to do so. "I always felt the creative process was a delicate thing and it could be disrupted or destroyed by too much editorial control," Giordano explained. "I felt that if I had hired people who could do the job, they should do it instead of me." Although, he stated, "I didn't really have a plan, I was just trying to do good Batman books," Giordano encouraged integrated story lines, like Gerry Conway's idea about a vampire Batman that ran through both *Batman* and *Detective Comics*.

Late in 1982, after a little more than a year on the job, Giordano was promoted to an administrative position, and eventually went on to become editorial director at DC. He was replaced as Batman's editor by Len Wein, one of the character's best

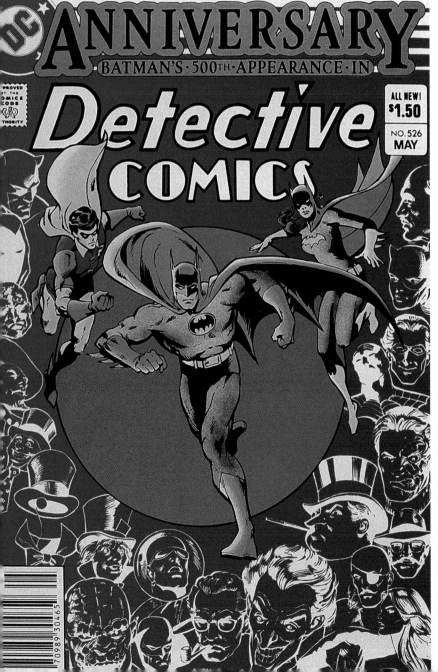

An army of antagonists showed up to help Batman celebrate a golden moment: his 500th appearance in *Detective Comics,* in issue #526 (May 1983). Art by Don Newton and Dick Giordano.

writers of that time. In fact Wein preferred to think of himself as a writer more than an editor and tended to adopt a laissez-faire attitude. "I worked with really talented people," he said. "They made my job easy and they made me look good." The most significant event of his administration was the introduction of a new Robin, Jason Todd, in *Batman* #357 (March 1983). Dick Grayson was pretty much out of the picture by then, working under the name Nightwing as leader of the Teen Titans. Once he was gone for good, however, the disadvantages of having Batman operate without a sidekick to talk to became apparent again. Enter Jason Todd, whose circus performer parents were killed by criminals in a bit of exposition shamelessly reminiscent of 1940. It took a few issues to get him into uniform, and some

readers felt it never really fit.

As an executive, Dick Giordano continued to contribute to the comics, but primarily by "getting people to work for DC who could do the work a little better." In this capacity, he did his bit for Batman by arranging for writer-artist Frank Miller to create one of the seminal works in comic book history, a four issue miniseries called *Batman: The Dark Knight Returns* (1986). "I put the deal together, and Frank and I did a lot of the plotting together in a restaurant downstairs," said Giordano. "The version that was finally done was about his fourth or fifth draft. The basic storyline was the same but there were a lot of detours along the way." Giordano, who dropped out midway after "a difference of opinion" with Frank Miller, credits art director Richard Bruning with facilitating delivery

A murderer introduced to turn the new Robin into an orphan, Killer Croc was created by Gerry Conway. Pencils by Curt Swan and inks by Rodin Rodriguez from *Batman* #358 (April 1983).

A montage of images from the *The Dark Knight Returns* (clockwise from left): TV screens with a talking head; Batman and Commissioner Gordon conferring beneath the Bat-Signal; and a declaration from Batman.

of the work. "Frank wanted to take the time that was needed to get the job done," said Giordano. "That's what our argument was about."

The very idea of ignoring deadlines to give pages some extra polish was antithetical to comic book business as usual, especially when that business meant regular publishing schedules; in this sense at least, Frank Miller was the culmination of the quest toward artistic independence. DC supported Miller's work with a package that included extra pages, square binding, and glossy paper to show off the subtle water colors added by artist Lynn Varley. American comics had never looked like this, but a new generation of discriminating readers, served by a growing network of comic book specialty shops, supported the costly format. *The Dark Knight Returns* racked up impressive sales.

Frank Miller.

Still, it was the content that set this series apart. In previous projects at DC and rival Marvel Comics, Frank Miller had developed a bold and deceptively simple graphic style, which he sums up as "the way I feel the line works across a page when I'm working on it, and what I think gets across the most emotion, or humor, or the most violence." Inked with elegant restraint by Klaus Janson, Miller's art complemented his prose style. "I'm a real believer in brevity," Miller said, "in the writing and the drawing." The apparent transparency of his presentation drew attention to the plot, and many readers failed to realize how artfully they had been manipulated when they began responding emotionally to what was, essentially, a genre story about a masked hero who takes the law into his own hands. This was a

comic book whose implications regarding vigilantism were heatedly debated in the mainstream press, and that was Miller's greatest triumph.

"I felt that super hero comics had really been held back by a misperception that they were just for kids," said Miller. "The comic book world had become so utterly pleasant and safe that the idea of somebody dressing up in tights and fighting crime just seemed beside the point." So Miller set *The*

The final, fatal confrontation between Batman and a dead serious Joker in *The Dark Knight Returns*. Script and pencils: Frank Miller. Inks: Klaus Janson.

Some things apparently never change. In this montage of images from *The Dark Knight Returns,* Robin is in peril, and Batman must come to the rescue.

*Dark Knight Returns* in the future, when a fiftyish Batman had retired. Drinking and despairing, Batman is galvanized back into action by the reappearance of old foes like the Joker and Two-Face and especially by the emergence of roving gangs of mutants who seem to rule the streets of Gotham City. Batman discovers corruption in every level of society, from his colleague Superman (now working as a government agent) to the fatuous talking heads who appear on omnipresent TV screens and debate Batman's every move. By the end of the story the hero is literally a man on horseback, undaunted as chaos devours the urban landscape, and rallying for his troops the very mutants he had once opposed. The series was condemned by some as "fascistic," although Miller insisted it was "never meant to be a political tract." Others denounced it for apparently allowing Batman to commit homicide, although Miller maintained that in the general mayhem "he doesn't actually kill people."

Fans responded enthusiastically to the visceral impact of the series; they called it "dark" and "gritty," though Miller soon grew sick of such labels. He also tried to point out that this savage narrative was ironic, and that some of the big moments were self-consciously "operatic," but few heard the subtler notes of music, even when Batman's last words in the last issue were an officious order for Robin: "Sit up straight." John Byrne, Miller's writer-artist colleague who was simultaneously doing a less drastic face-lift on Superman, suggested that "Robin must be a girl," and Miller complied. In retrospect the imperative seems less than inevitable, perhaps no more than trendy gender bending or possibly just a response to the homophobia inspired by Dr. Wertham more than thirty years earlier. In any case, old Batman was safely teamed with an adolescent girl, and the only gay person in sight was a criminal, the Joker, who insisted on

A Frank Miller sketch for *The Dark Knight Returns.*

This 1996 *Dark Knight Returns* statue was designed by Frank Miller and sculpted by William Paquet.

calling Batman "my sweet" and died in a carnival's Tunnel of Love.

Sexual politics aside, Miller succeeded in spectacular fashion with his agenda for super hero comics, "keeping them as preposterous as they are, but also bringing in a world where the odds weren't so heavily weighted in the hero's favor." *The Dark Knight Returns* would help propel Batman into a new phase of international celebrity. In 1986 Dennis O'Neil was selected to keep the momentum going as Batman's next editor. No stranger to the mystery and menace that are at the roots of Batman's appeal, O'Neil was about to embark on a long crusade that would carry the man in the cape into the next century.

# S I G N A L S

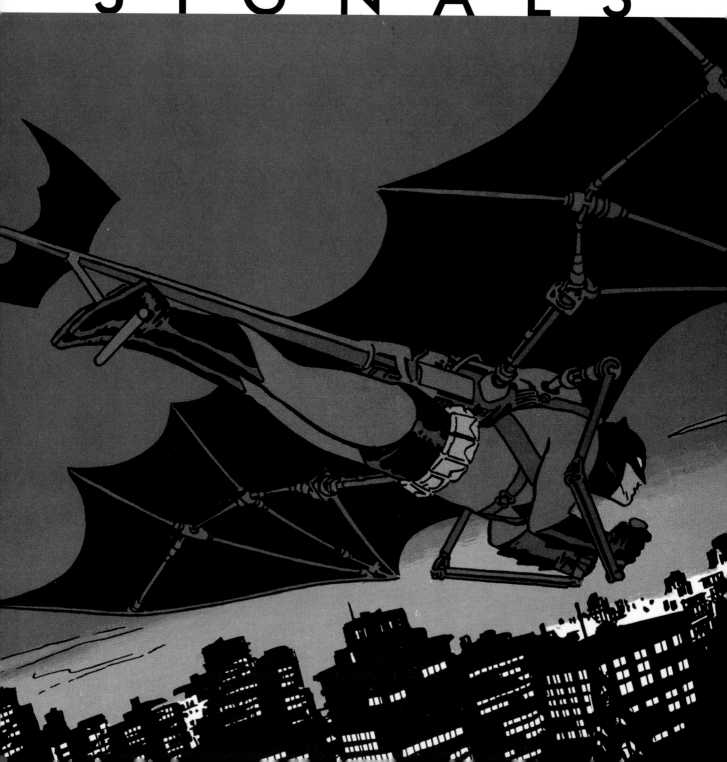

The year 1986 signaled a new start for Batman, as well as every other character published by DC Comics. These heroes had accumulated so much complicated history over the past decades that their backgrounds were becoming burdensome, which inspired the editorial decision to put them all through a comic book time warp called *Crisis on Infinite Earths.* The result of this twelve-issue series was that Batman (along with his colleagues) was given a makeover, one that retained key elements from his original creation but reinterpreted them for modern readers. "I guess I was hired to revamp Batman," said newly arrived editor Dennis O'Neil. "At least, I assumed that was my mission."

To reintroduce the character's origin story, DC called on Frank Miller, who felt he was creating "bookends" since he had just finished depicting a possible future for Batman in *The Dark Knight Returns.* Miller's script for the four-issue miniseries *Batman: Year One* was interpreted by artist David Mazzucchelli, who had a similar taste for a bold, direct art style. "David is an absolute dream to work with," said Miller. "He is able to take a panel description, no matter how complicated, and make it look as if it's the most simple, natural thing in the world."

"In the first thing I did, I got really lucky with Miller and Mazzucchelli," said O'Neil. "Dick Giordano had contracted for them to do *Batman: Year One,* and my only contribution was talking them into letting me publish that in the *Batman* comic books first, before its eventual appearance in hardcover. That was a

"...I CAN ALWAYS FIND MY WAY IN THE *DARK.*"

A wing-gliding Batman soars over Gotham City in the fourth issue of *Batman: Year One,* which was also *Batman* #407 (May 1987) Script: Frank Miller. Art: David Mazzucchelli.

Todd McFarlane's finale to *Batman: Year Two* appeared in *Detective Comics* #578 (September 1987). Mike Barr called the art style "an explosion of black glass."

tremendously effective way to send the message that this was a new beginning, and the style of the writing and the art was going to be quite different from the books that had preceded it."

Acknowledging that Batman is "an American legend," Miller did not meddle with the myth excessively. His principal change was one of tone. Less of a playground for colorful psychotics than before, Miller's Gotham City is a bleak site colored by corruption: cops, criminals, and even high society are all part of the pattern. Bruce Wayne (accompanied since childhood by the faithful butler Alfred) seems to be the only honest citizen around, but a newly arrived policeman named James Gordon exhibits similar ideals, and the key to the story

is the development of a relationship between Wayne and Gordon that enables both of them to survive. Miller's most radical innovation was revamping Catwoman as an oppressed prostitute taking revenge on the establishment. This idea would be downplayed in later comics, and the original concept of an adventuress with expensive tastes would reemerge.

A sequel, *Batman: Year Two*, made its initial appearance in four issues of *Detective Comics* in 1987. The writer was Mike Barr, who had been exchanging Batman ideas with Frank Miller for years, and the artist for most of the run was a newcomer named Todd McFarlane. For this series Barr created a grim new costumed villain called the Reaper,

Left: David Mazzucchelli's strong line creates a bold Batman in this original art for a *Batman: Year One* advertisement.

Above: The Caped Crusader confronts Commissioner Gordon in another piece drawn by David Mazzucchelli.

a vigilante in leather armor with two giant scythes for hands. The Reaper's murderous techniques helped define Batman's more humane approach to fighting crime, but McFarlane's revolutionary drawing style may have made more of a mark on the Dark Knight. "If I drew like everybody else, that would be stupid," McFarlane explained. "If you've seen it before, why do it again?" Where Mazzucchelli was simple and understated, McFar-lane was baroque and melodramatic. In his hands Batman's cape was a living entity, and grew to impractically extravagant size whenever that would make for a more impressive picture. "The last part of the Batman series was the first ink job I ever did," said McFarlane, who wanted more influence over the presentation of his pencils. Readers found the effect sensational, and McFarlane's subsequent insistence on control over all aspects of his work has

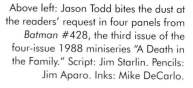

Above left: Jason Todd bites the dust at the readers' request in four panels from *Batman* #428, the third issue of the four-issue 1988 miniseries "A Death in the Family." Script: Jim Starlin. Pencils: Jim Aparo. Inks: Mike DeCarlo.

Above: This unpublished art by Jim Aparo was prepared in case Batman fans voted for Jason Todd to survive the Joker's time bomb, but they didn't. Inks: Mike DeCarlo.

Left: The tale of Robin's death was retold by writer James Robinson and artist Lee Weeks in *Batman: Legends of the Dark Knight* #100 (November 1997).

Right: In this handsome panel drawn by Brian Bolland for *The Killing Joke* (1988), the Batmobile carries Batman through an abandoned carnival to a climactic confrontation with the Joker.

made him one of the key comic book creators of the past decade.

The vivid contrast between the work of McFarlane and Mazzucchelli demonstrated the stylistic range that Batman could encompass, and it also showed an editorial policy of accommodation to artistic vision. For the first twenty-five years Batman was drawn in the style pioneered by Kane, Robinson, and Sprang; then, after a period of experimentation, the Neal Adams approach became a powerful influence for fifteen years. By the 1980s, however, all molds seemed to be broken. "We now say that Batman has two hundred suits hanging in the Batcave," explained editor O'Neil, "so they don't have to look the same. What this allows me to do is to give good artists maximum flexibility when dealing with this archetype. Everybody loves to draw Batman, and everybody wants

to put their own spin on it." Amid infinite variations, the repeated visual motif of points or triangles has made Batman among the most instantly identifiable of comic book characters, yet O'Neil suspects that Batman reminds readers of someone else, that the ears on the hero's cowl are suspiciously similar to a devil's horns. "That's the archetypal image of evil, and therefore it is fascinating to us, but he's on our side," O'Neil said. "It's like having your cake and eating it too."

The fans were evidently feeling a bit devilish themselves. In 1988 they were given the chance to influence the outcome of a storyline and voted to kill off a major character. Dennis O'Neil set the wheels in motion when he suggested that an audience might be attracted by an opportunity to participate in the creation of comics. "I saw it as a logical extension of stuff that's been happening in live theater for years and was increasingly happening in the electronic media," he said. "We decided that maybe the best way to do this was with a 900 phone number." Discussions with DC president Jenette Kahn determined that the telephone vote shouldn't be wasted on something insignificant, so O'Neil decided he would use it to solve his "Robin problem." Jason Todd, the second kid to wear the Robin uniform, had been introduced in 1983, but his increasingly brash personality had alienated a lot of readers, and O'Neil knew he would have to alter Jason's attitude or else eliminate him from the series. "I hadn't made up my mind which one," he said, so he decided to let the readers decide. At the end of *Batman* #427, Robin was caught in an explosion set by the Joker, and the inside back cover displayed a pair of phone numbers that would determine the Boy Wonder's fate.

This loathsome, leering Joker played tour guide to Batman as he took a trip through a chamber of horrors in *Arkham Asylum* (1989). Art: Dave McKean. Script: Grant Morrison.

"Robin will die because the Joker wants revenge, but you can prevent it with a telephone call," the ad read.

O'Neil and editorial director Dick Giordano were at odds in anticipating the outcome. "I expected it to be overwhelmingly in favor of letting the kid die," said O'Neil, but the final tally ultimately went against Jason Todd by a margin of only twenty-eight votes. "I heard it was one guy, who programmed his computer to dial the thumbs down number every ninety seconds for eight hours, who made the difference." Although he would later regret the whole business, O'Neil went ahead and printed the ending the fans had demanded in *Batman* #428. "We did the deed, and we got a blast of hate mail and a blast of negative commentary in the press," he said. On the bright side, the way was paved for a third and more popular Robin, while the Batman comic books received publicity that would soon be snowballing into the biggest blizzard of Batmania the world had ever known.

Batman stories became even more unpredictable with the introduction of graphic novels.

These expensively produced one-shot books, usually three or four times the length of a regular comic, told their tales outside the regular continuity of the monthly titles. The paperback book collections of limited series like *Batman: The Dark Knight Returns* and *Batman: Year One* had paved the way, and like them, the early graphic novels were presented as special events. Such was the case with the pioneering *Batman: The Killing Joke* (1988). The

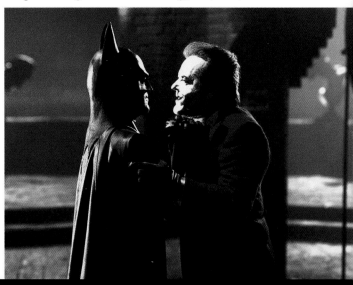

A TALE OF THE BATMAN

GOTHAM
by GASLIGHT

$3.95
U.S.
$4.95
CAN.

# ENTERING ELSEWORLDS

Not long after the Batman graphic novels had established themselves as an ongoing aspect of the character's career, a new subgenre with a unique twist emerged. In 1989, writer Brian Augustyn conceived the idea of a Batman who had fought crime in the Gotham City of a hundred years earlier, and the result was the graphic novel *Gotham by Gaslight*, subtitled *An Alternative History of the Batman*. Strong artwork by Mike Mignola and P. Craig Russell enhanced the tale of Batman battling a Jack the Ripper who had fled across the Atlantic, and the concept that there might have been a bevy of Batmen, confronting evil across the ages, caught on. Other writers and artists were inspired to create a series of graphic novels that quickly acquired their own *Elseworlds* imprint. Jacket copy promised tales wherein "heroes are taken from their usual settings and put into strange times and places—some that have existed, or might have existed, and others that can't, couldn't, or shouldn't exist."

Before long, various versions of Batman were showing up in Elseworlds environments including the Civil War (*The Blue, the Grey, and the Bat*, 1992), a medieval fairyland (*Batman: Dark Joker—The Wild*, 1993), Gothic Germany (*Castle of the Bat*, 1994), a post-apocalyptic future (*Brotherhood of the Bat*, 1995), a Nazi-infested Great Depression (*Dark Allegiances*, 1996), Al Capone's Chicago (*Scar of the Bat*, 1996), and King Arthur's Camelot (*Dark Knight of the Round Table*, 1998). Creators were afforded the opportunity to create variations on Batman more extreme than ever before, which paradoxically served to rein-

villain was the Joker (who would be a favorite in many such works to follow), and the script was by Alan Moore. This English writer had achieved acclaim with his twelve-issue DC series *Watchmen* (1986), which he called "that strange take on super heroes." It was designed to probe the psychology of such costumed characters, and in *The Killing Joke* Moore provided the same service for the Joker, juxtaposing flashbacks of his early life with his present misdeeds. Building on the old Joker origin story, Moore piled on the pathos by depicting the character as a failed comedian who turns to crime to support his family, only to end up chemically disfigured while his wife is coincidentally killed in a

idea of a madhouse confining Batman's most colorful villains, but Morrison acknowledged that he was treating the characters as symbols, and Arkham Asylum as a state of mind. Employing Jungian archetypes and semiotic signs, the writer trapped Batman in the brooding building to face down all his enemies. This was a multilayered psychodrama that critics found either profound or pretentious, but it was undeniably unique. Adding immeasurably to the effect were the painted panels, rendered with horrific élan by Dave McKean. The artist's own taste for obscurantism may have rendered the story even more mysterious, but his hallucinatory visions of the villains were often unforgettable.

freak accident. In a surprising development the Joker gunned down Batgirl, putting her into a wheelchair and ending her career. Both that crime and the Joker's new back story tended to diminish the relish with which readers could approach the crime clown's antics (perhaps Moore's motive), although eliminating Batgirl also seemed to serve corporate convenience in a period when a brooding, isolated Batman was in vogue. In any case *The Killing Joke* was a hit, enhanced by Moore's craftsmanship and elegantly rendered artwork by Brian Bolland.

An even more impressive success was enjoyed by 1989's *Arkham Asylum,* a graphic novel that became a best-seller, priced at $24.95. Writer Grant Morrison (like Moore, part of a "British invasion" that was revitalizing American comics) used the

Such interesting work inspired many more Batman graphic novels, which in the coming years would multiply until they could fill a bookshelf.

The key event for the Dark Knight in 1989 was the release of the motion picture *Batman*. This third film of the same name was not the cheap children's serial of 1943, or the quickie TV spin-off of 1966, but instead a major movie with established stars, a hot director, and a serious budget. It went on to become the biggest hit of the year, and one of the most popular films of all time. Producers Jon Peters and Peter Guber had been trying to get the project off the ground for years, and they were sparked to renewed effort by the late 1980s renaissance in Batman comics. But according to Peters, "Not until we

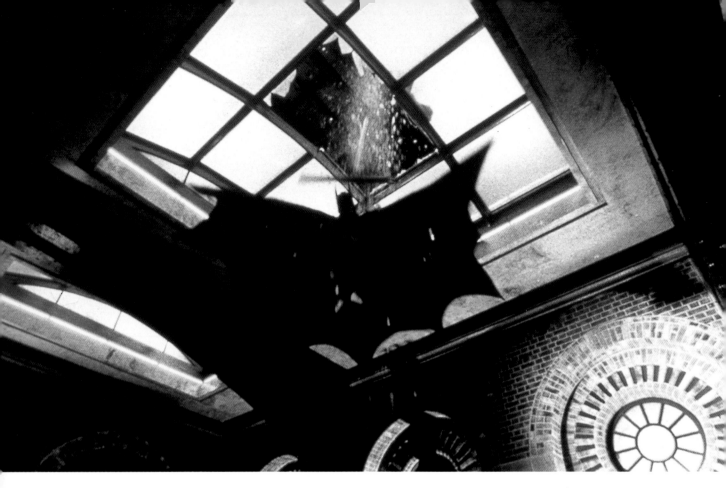

met Tim Burton did we begin to have all the pieces fit." Director Burton had worked on animated films before helming hits like *Pee-Wee's Big Adventure* (1985) and *Beetlejuice* (1988), which made it clear that his cartoonist's sensibility and macabre taste might be just the combination to create a more serious cinematic version of the Caped Crusader.

The *Batman* screenplay, credited to Sam Hamm and Warren Skaaren, begins with a description of Gotham City: "stark angles, creeping shadows, dense, crowded, airless, a random tangle of steel and concrete, as if Hell had erupted through the sidewalk and kept on growing." Common in the comics but unfamiliar to movie audiences, this sort of imagery was brilliantly realized by production designer Anton Furst, whose stunning Gotham sets filled Pinewood Studios outside London. "I don't believe in cinema vérité. You should create your own reality," said Furst. "We ended up with this rather interesting idea of canyons, with structures cantilevered forward and bridges over them. We

even took things like prison architecture and stretched it into skyscrapers."

Perhaps the most unexpected aspect of the film was the casting of Michael Keaton as Batman. Conventional wisdom might have demanded a muscle-bound hero rather than a quick-witted leading man who had at that point most often been seen in comedies. But the producers were intrigued with the idea when they hit upon it, and Tim Burton agreed, citing a certain look in Keaton's eyes as well as his hot temper. The choice proved to be inspired, and Keaton gave a real performance, intelligently worked out and deeply felt, in a role that other actors might have either camped up or walked through. "I wasn't surprised that they would think of me to play Batman, because I assumed at first that they were talking about the TV version or something like that," Keaton recalled. "After I got the script, Tim Burton started to familiarize me with the *Dark Knight Returns* series, and then I began to get a better picture."

Right: Production designer Bo Welch modified the Batmobile for its comeback in *Batman Returns* (1992).

Left: Director Tim Burton's eye for a vivid image helped to make *Batman* a block-buster on the big screen.

165

Checking out the current comics gave the actor an idea of how grim a tale might be told, even though Burton's vision ultimately incorporated the macabre melodrama of the earliest Batman stories along with the grittiness of the new. *Batman* was a duel between two damaged, driven men: a Caped Crusader and a Clown Prince of Crime. Jack Nicholson, an actor with wit and charisma, had been cast as an especially flamboyant Joker. Although Keaton and Nicholson fortuitously shared several traits, including a wicked way with an eyebrow, the problem remained of portraying a hero who wouldn't be overshadowed by his outsized opponent. Before he accepted the role Keaton thought, "Well, I have my interpretation of what this movie is, and I have an idea for what I would do, but I can't imagine that anyone would share that." The director did. "As I was talking to Tim, he just kept nodding, and then I saw his face actually getting more excited, and Tim's a very animated guy. And as we met more and more, I knew that he

and I were headed down the right road."

A key scene for Keaton came well into the movie, when the Joker breaks in on Bruce Wayne and his girlfriend Vicki Vale (Kim Basinger). Wayne responds with a blistering outburst of anger that seems to leap off the screen. "You see, part of Bruce Wayne and Batman was a little crazy, but you hadn't seen it because I decided to play it very contained. But at that point I needed to show another color. I wanted to show you that, with all that flamboyance around me, if need be, I could come up to it. So I actually kind of rewrote some of that scene," said Keaton. The immediate impression is that Wayne is exploding with fury and frustration at being caught without his costume so he can't flatten his foe. It quickly becomes clear, though, that "Bruce Wayne was using a kind of psychological ploy," as Keaton put it, utilizing his real anger to distract the murderous Joker and protect Vicki. It's a strong scene, with layers of irony and introspection shoring up the fireworks, and honest emotion

employed as yet another mask. "What nobody understands is that the key was not Batman. The key was Bruce Wayne," said Keaton. "It's been like my little secret, but that's where the real power comes from."

"The suit had power," admitted Keaton, but it derived from the way he as Bruce Wayne chose to use it. "The icon was so strong that I wanted to maximize this big, beautiful, black image, and if he made really cool, quick, direct turns that were precise, that was one of the ways you saw the difference between Bruce Wayne and Batman." This was also a very logical acting choice, "because I could barely move in that suit. To this day, one hip has not been right because I practiced when I first kicked that guy on the roof, and it was very difficult to get my foot up that high. It was like fifty thousand rubber bands holding you down."

"It was an extremely demanding production," said Keaton, "but there were moments of fun, because I always have fun when I do movies. It was much more smoke and mirrors than movies are today. Now you can do so much with computers, and they're slicker. We had to figure out how to shoot around things and how to disguise things. We were figuring out a lot of this stuff as we went along because there were a lot of obstacles to overcome, because we were making a movie in a way that no one expected it to be made."

Budgeted at $40 million, *Batman* was perceived as an event long before it opened. Its estimated $251 million gross in the United States alone was only part of a bonanza that included hundreds of millions more in worldwide revenues and mer-

chandising. The stylized logo, based on the emblem designed for Batman's costume in 1964, appeared on everything from T-shirts to beach towels, from cereal to sleepwear, and images from the film inspired artifacts ranging from action figures to alarm clocks. Toys included scale model versions of the Batmobile and the Batwing, not to mention a Batman Pez dispenser.

Such success made a sequel virtually mandatory, but director Tim Burton viewed *Batman Returns* (1992) as more of a second chance, an opportunity to create a more personal work now that he had the experience of *Batman* behind him. "Doctors have spent years trying to analyze these characters," he said at the time. "We'll do the best we can in two hours, but there's a lot to explore." Gotham City was certainly more crowded in this outing. Characters selected for the sequel included not only a returning Michael Keaton as Batman, but also three foes: Catwoman (Michelle Pfeiffer) and the Penguin (Danny DeVito), and a new villain who appeared to be manipulating both of them, the tycoon Max Shreck (Christopher Walken).

The movie's Penguin, a depraved, sewer-dwelling monster, was a long way from the dapper little crook of yore. "When I was a kid I read the comic books," said DeVito, "but get that right out of your mind, because this is so totally unique and different." Burton was evidently depending on DeVito to make the character palatable ("I don't think there's anybody better at making the horrible acceptable"), but some observers found this Penguin a bit too chilling.

Michelle Pfeiffer's Catwoman, on the other hand, was devastatingly attractive. Instead of a glamorous thief she was presented as the victim of a shattered psyche, a mousy secretary driven to create a new persona by the malevolence of her employer, Max Shreck. "We're trying to do something more than a two-dimensional comic book character," Pfeiffer said. "It's ironic that Catwoman might be the most difficult role I've ever played." Her transformation from temp to temptress showed remarkable range, and her scenes of leather-clad

Catwoman (Michelle Pfeiffer) and Penguin (Danny DeVito) contemplate a life of crime in *Batman Returns*.

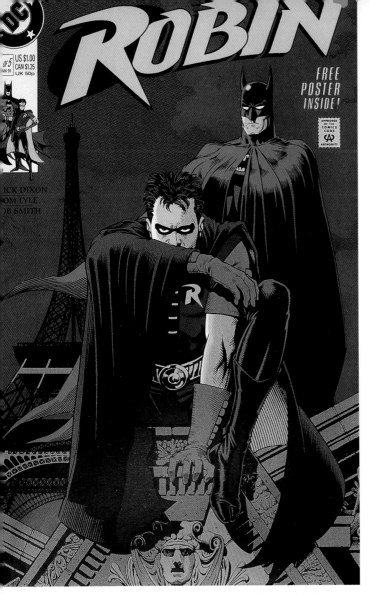

and perverse, especially for a movie bound to attract large numbers of children. The domestic gross was $163 million, enough to make it the biggest hit of 1992, but merchandising was down for *Batman Returns.* This was that rare blockbuster that may have been too much of a personal statement, and when the third in the series was made, neither Tim Burton nor Michael Keaton would be back. "To lighten it up and brighten it up and be a cartoon was of no interest to me," Keaton said. "I like the second one, but I really like the first one because, even though it's imperfect, it stepped out there. It was a bold move, and I was proud of myself for being bold."

A crowd of characters had filled the screen in *Batman Returns,* but Robin was not among them. He was written into the script but then written out again, just as he had been eliminated from the previous film. In the comics, however, DC had established the existence of a new Robin, the third kid to get the gig. His name was Tim Drake, and he had first appeared in *Batman* #436 (August 1989) but didn't get into uniform until *Batman* #442 (December 1989). Bruce Wayne was being very careful about proper training after what had happened to his previous partner, the late if not universally lamented Jason Todd. In fact, Batman might have preferred to do without a sidekick, but his hand was forced when Tim Drake deduced his identity and showed up to apply for the job.

To help establish this modern, computer-literate Robin, editor Dennis O'Neil recruited writer Chuck Dixon to delineate

The third Robin, Tim Drake, wearing a costume designed by Neal Adams, is giving Alfred orders in *Robin II #1* (October 1991). Script: Chuck Dixon. Pencils: Tom Lyle. Inks: Bob Smith.

lust with Batman validated the theory that these two night owls were made for each other. "There was some heat there," observed Michael Keaton, not to mention the hint that the pair might redeem each other. In the final showdown, however, Catwoman's bullet-riddled body was caught in an explosion that should have reduced her to kitty litter. This was satisfyingly tragic, but there was a coda in which Catwoman reappeared, miraculously whole. This final scene looked like a bid for a movie about her; it was in fact announced but never made.

Some critics believe that *Batman Returns,* however uneven, achieved a certain Gothic grandeur and was most true to the spirit of its source in pushing its protagonists to the extreme. Others found it too dark

# NIGHTWING KEEPS ON FLYING

Batman has now had three different Robins working with him, and people who haven't been closely monitoring the DC Universe may well be a little confused by the whole business, especially since various filmed dramatizations of the Batman saga don't always follow the continuity established by the comic books. The third Robin, Tim Drake, is currently active; his predecessor, Jason Todd, was killed in 1988. But what has become of the original Robin, Dick Grayson, the one who made his debut in 1940 and was still going strong during the campy TV show of the 1960s. In a word, he's Nightwing.

Dick Grayson's evolution into Nightwing was a lengthy process, which began in 1964, when he joined forces with some other young sidekicks to form the Teen Titans. They got their own comic book in 1966. Back then, teenagers tended to be viewed as children, but things had changed by the time of the November 1980 revival called *The New Teen Titans*. These characters were independent young adults, and Dick Grayson became their leader. He had been pulling away from Batman for some time, ever since he went to college, and he finally announced his autonomy by donning a midnight blue costume and taking the name Nightwing in 1984. As portrayed by the writer-artist team of Marv Wolfman and George Perez, the new Nightwing and the Titans became the era's most popular characters for DC. Ultimately, in October 1996, the first issue of the monthly *Nightwing* comic book appeared, featuring solo adventures of a character who's become a classic.

$1.95 US $2.75 CAN
OCT '96

CHUCK DIXON · SCOTT McDANIEL · KARL STORY

the latest Boy Wonder's exploits in a 1991 *Robin* miniseries that was so successful that it was soon followed by another and then another. The issues were enhanced by foil, cutouts, and other embellishments, and the investment paid off in unexpected sales. "Robin's a great character, and there was a real reason for inventing him," Chuck Dixon explained. "You need Robin, you need Alfred, to make Batman work. Otherwise he's just a lone psycho. He needs a human being to bounce off of. This was Denny's theory, that it's a triumvirate." In November 1993, Dixon began scripting a new monthly *Robin* comic book which became a solid success. "Dick Grayson was always so perfect in every way," said Dixon, "and of course Jason Todd was far too imperfect. Tim Drake is sort of in the middle. I feel like he's a real teenager."

More Batman comics soon arrived on the scene, all part of the response to a growing resurgence of public interest. *Batman: Legends of the Dark Knight* #1 (November 1989) launched a series that would stand apart from the ongoing, intertwined narratives in *Batman* and *Detective Comics*. The

Perched above the city, a brooding Batman contemplates the plight of innocent victims in this scene from the 1992 graphic novel *Batman: Night Cries*. Script: Archie Goodwin. Art: Scott Hampton.

THE LIGHTS OF THE CITY. AND BEHIND SOME OF THEM, FROM THE POOREST TENEMENT TO THE MOST ELEGANT APARTMENT TOWER...

...TERRIBLE CRIMES ARE BEING PERPETRATED. CRIMES AGAINST CHILDREN BY THE VERY PEOPLE WHO SHOULD COMFORT AND PROTECT THEM.

CRIMES ALL MY TRAINING, ALL MY METHODS MIGHT NORMALLY NEVER UNCOVER.

BUT SOMEHOW... *HE* KNOWS.

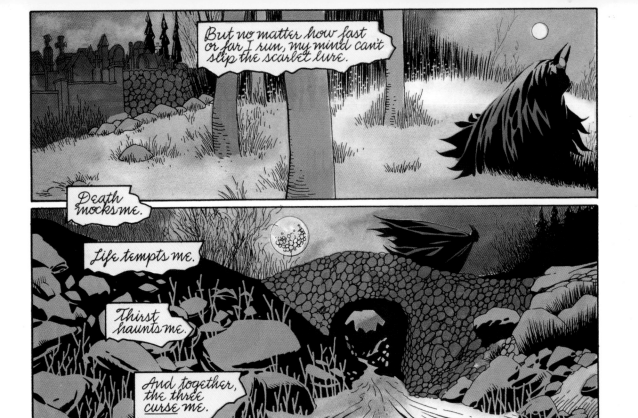

But no matter how fast or far I run, my mind can't slip the scarlet lure.

Death mocks me.

Life tempts me.

Thirst haunts me.

And together, the three curse me.

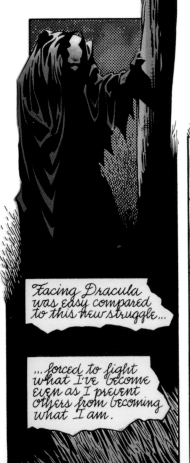

Facing Dracula was easy compared to this new struggle...

...forced to fight what I've become even as I prevent others from becoming what I am.

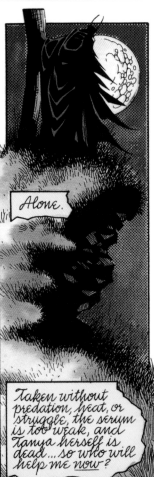

Alone.

Taken without predation, heat, or struggle, the serum is too weak, and Tanya herself is dead...so who will help me now?

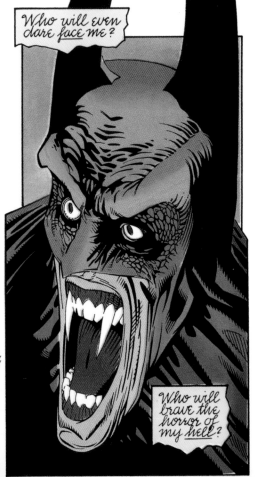

Who will even dare face me?

Who will brave the horror of my hell?

Wandering through Gothic landscapes, Bruce Wayne faces the fact that his disguise has become a devastating reality in the 1994 graphic novel *Bloodstorm*. Pencils: Kelley Jones. Inks: John Beatty. Script: Doug Moench.

Batman batterer Bane, originally created by Chuck Dixon, Doug Moench, and Graham Nolan, was pumped up by the bizarre styling of Kelley Jones for *Detective Comics* #664 (July 1993).

Catwoman may have started her own comic book series (August 1993) with a snarl and a whip, but as portrayed by Jim Balent she remains a fan favorite.

*Legends* comic book was less bound by current storylines, more free to explore interesting plots that perhaps didn't fit into Batman's elaborate history. "It's a legend of Batman, just like the title says," explained Dennis O'Neil, who sometimes wrote scripts for the series; creators changed as each new storyline was introduced. A more mainstream approach was employed in *Batman: Shadow of the Bat,* which came to light in 1993. British writer Alan Grant was the mainstay of this title, which was integrated into the overall Batman storylines. O'Neil found himself using a computer to keep track of the many plot threads while he prepared to launch perhaps the most complex epic ever attempted in comic books.

Meanwhile, Batman graphic novels continued to proliferate, sometimes concerning themselves with social problems. *Seduction of the Gun* (1992) took a stand against the easy availability of firearms and was prompted by a death in the family of a Time Warner executive. Written by John Ostrander and drawn by Vince Giarrano, *Seduction of the Gun* has been credited with helping to influence changes

# A CAT WITHOUT WHISKERS

Catwoman, always one of the most popular Batman villains, got her own regularly published comic book in August 1993. Attempts to make a bad guy the star of a series had been tried before, with characters like the Joker and Man-Bat, but it took a woman to pull it off. The immediate impulse for launching *Catwoman* may have been Michelle Pfeiffer's sensational performance in 1992's *Batman Returns* ("I think Catwoman stole the show," said Bob Kane), but the comic book has now lasted for years on its own merits. Early issues written by Jo Duffy harked back to Frank Miller's revisionist origin in which the lady was a tramp, but the prolific Chuck Dixon arrived with a lighter look at the feline's felonies. "She was a character who seemed to do things just for the fun of it," Dixon said, "which was refreshing to write. Also she's amoral, which seems to open more story possibilities than someone who's virtuous. That's what I stuck with. Comics are overpopulated with angst-driven characters."

Writers have come and gone, but artist Jim Balent has stayed with *Catwoman,* and his detailed, polished renderings are undeniably pleasing to the eye. There's also no point denying that Catwoman's costume seems to have been applied with a spray can of purple paint, or that she sometimes looks like her principal crime is smuggling soccer balls, but complaints are comparatively uncommon. The latest writer, Devin Grayson, has her own interpretation of the character: "This isn't a woman who has studied postmodern feminism or read a lot of Joseph Campbell. This is all very instinctive to her, this dressing up like a cat stuff. And her whole life is set up now to allow her to move through the world like that, accountable to no one, free to act at whim, completely able to ooze sexuality and still keep anyone exactly as far away as she may want."

Bruce Wayne's temporary replacement, the armor-plated Azrael, is featured on a foil-enhanced cover by Kelley Jones for *Detective Comics* #675 (June 1994).

in the laws of Virginia, a state where guns were once more readily obtained. Archie Goodwin authored *Night Cries* (1992), an investigation into child abuse, illustrated with handsome paintings by Scott Hampton. And Dennis O'Neil condemned the use of land mines in *Death of Innocents* (1996), which included striking artwork by the team of Joe Staton and Bill Sienkiewicz.

As Batman crusaded for good causes, he also showed his darker side, which found its ultimate expression in a trilogy of graphic novels published between 1991 and 1998. O'Neil once said, "Look at Dracula, squint a bit, and you see the Batman." DC had toyed with this idea before, but writer Doug Moench and horror artist Kelley Jones grabbed it by the throat and drained all the juice out of it in three increasingly outrageous *Elseworlds* books: *Red Rain* (1991), *Bloodstorm* (1994), and *Crimson Mist* (1998). In the first volume a heroic Batman battles

Dracula successfully but ends up infected by vampirism himself. In the second, when readers might have expected a fortuitous cure, the hero turns predator; in a story full of bloody puncture wounds, both Batman and Catwoman end up impaled and destroyed. This looked like the end of the story, but in the third book Batman was revived as a loathsome, putrescent monster, ravenous to ravage all his old enemies before finally giving up the ghost himself. Conjuring up some of the most disturbing images in Batman comics or any others, Jones provided a graphic demonstration of what Bruce Wayne might have become if he had chosen vengeance rather than justice as his guide. "It's a pretty vicious story," said Jones. "Like a three-act opera, it ends in tragedy."

Kelley Jones, whose work was inspired by old pulp magazine illustrators like Lee Brown Coye of *Weird Tales,* first made his mark at DC drawing the spectral character Deadman. He later became the regular artist on *Batman* and has developed perhaps the most idiosyncratic style of any artist delineating the Dark Knight today. "I always drew it as a super hero book with Gothic overtones," Jones said. "I thought that when Batman started, it was to put fear into the hearts of criminals. He's got to terrify these people." The Jones Batman may be the most grotesque ever, and the key to his imagery became Batman's elongated ears. "It's the one thing everyone would talk about," admitted Jones. "I did make fun of myself with those later on: I had a guy swinging a golf club and it bent the ears, or the Penguin flashed a sword and cut off a tip."

In 1992, editor Dennis O'Neil launched an epic storyline that would eventually run for two years, through seventy-one issues of the various Batman comics and a few others besides. The first part of the saga, titled *Knightfall,* depicted the defeat and apparent destruction of Batman by a monstrously brutal bad guy named Bane.

"We introduced Bane, a very powerful and intelligent villain, in a one-shot comic," explained

406 303     CITY BRIDGE SUNset     SC. 4     J. Calmette

O'Neil. "Then for *Knightfall* we broke him out of prison and put him in Gotham City. Bane realizes that Batman is the baddest guy in this big city, so he picks him out. First he breaks all the criminals out of Arkham Asylum, so poor Gotham City is over-run by a plague of really malevolent people. Batman is kept busy for about six weeks without stopping or sleeping, catching up to these guys and putting them back behind bars. Finally Bane confronts him, they have a tremendous fight, and for the first time in history Batman really loses, no doubt about it." In fact Bruce Wayne's back was broken, as depicted by penciller Jim Aparo in *Batman* #497 (late July 1993), and the Dark Knight seemed to be permanently paralyzed. It was, said O'Neil, a time "to explore a different kind of heroism with Bruce. He's disabled, he's in a wheelchair, he's in pain."

Ty Templeton's cover for *The Batman Adventures* #1 (October 1992) captures the ambience of the animated television show that inspired the comic book.

STOCK

BATMAN #406-51
SC. B-1
INT. BATCAVE DOWNSHOT

406.514 Sc.B-1          INT. BATCAVE DOWNSHOT          STOCK          BATMAN          S.Butz

SCENE.          C 101          BG.

This and preceding spread: Images from the Warner Bros. Animation cartoon series and a Catwoman cookie jar. Following spread: a vivid storyboard drawn by Bruce Timm for writer Paul Dini's 1998 adaptation of the 1952 comic book classic, "The Joker's Millions."

INT. BATCAVE-ELEVATOR.

TVTimes
LOS ANGELES TIMES

TOON

The new season includes an animated
Caped Crusader, a small-screen Ariel
and made-of-flesh Penn and Teller

IN

SCENE A·29 (CONT.) B.G.    SC    B.G.    SC A·30    B.G.

START
PAN W/ BATMAN AS HE PUSHES/
LUNGES W/ BATGIRL TOWARD
MAGAZINE DISPLAY
STOP

CLOSE ON HISSING
MARBLE

SCENE A·30 (CONT.) B.G.    SC A·31    B.G.    SC CONT.    B.G.

ACTION.
·· **BRIGHT FLASH**
AS IT IGNITES ··
(SCREEN GOES WHITE)

BATMAN/BATGIRL LEAP OVER
COUNTER AS BOMB EXPLODES
BEHIND THEM ···

CAM. SHAKE!
BATMAN/GIRL'S
COLORS DX (3X)
QUICKLY TO "HI·CON" COLORS
O.S.
···AS
EXPLOSION
GOES BACK-
LIT W/DIFFUSION

SCENE A·32    B.G.    SC A·33    B.G.

ACTION. DOWN·SHOT ON EXPLOSION
AS IT EXPANDS TO
**FILL FRAME** (CAM. SHAKE)

THE BLAST RIPS PAST
THE MAGAZINE COUNTER
(HI·CON COLORS)
(CAM. SHA

Harley Quinn's dream of domestic bliss with the Joker inspires a one-woman crime wave in the award-winning one-shot *Mad Love* (1994). Script: Paul Dini. Art: Bruce Timm.

on as a new Batman, in an updated and armor-plated costume, and "got nuttier and nuttier month by month," or so O'Neil described him. Ultimately Bruce Wayne recovered, and the long series ended when Batman overwhelmed his replacement in O'Neil's script for *Legends of the Dark Knight* #63 (August 1994). More than a dozen artists worked on the saga, including Norm Breyfogle, Jim Balent, Bret Blevins, Klaus Janson, Mike Manley, and Graham Nolan, but it was the bizarre stylings of Kelley Jones that gave a unifying look to the series when he became chief cover artist.

Another result of the successful story cycle was the welcome return of editor O'Neil to regular scripting, in a new title that began with *Azrael* #1 (February 1995). "*Knightfall* was the neatest job of coordinating we've ever done," said O'Neil. "We didn't have all the mechanics worked out, we didn't have every incident in every issue, but the broad, general story we had to know from the beginning." Chuck Dixon, who along with Doug Moench and Alan Grant was a principal writer on the project, said, "Denny made it easy. It was one of those rare times when all the dramatic high points were there. You had triumph, you had tragedy, you had redemption. It was probably the neatest thing I've ever had an opportunity to work on."

There was yet another sort of heroism to be examined, one that O'Neil intended to challenge with the characterization of the substitute who took Wayne's place as Batman in the sequel *Knightquest*. "We were looking at heroes in other comic books, to say nothing of other media, in which wholesale slaughter seemed to be the primary qualification. They would give some lip service to say this is in a good cause, and then proceed to mow people down." That's a good thumbnail sketch of O'Neil's new character Azrael, first introduced in *Sword of Azrael* #1 (October 1992). He was Jean Paul Valley, inheritor of a secret medieval tradition of merciless martial arts, and he bested Bane while Bruce Wayne nursed his wounds. After that Azrael went

While the groundbreaking *Knightfall* saga was getting its start, Warner Bros. Animation was reinventing Batman in new cartoons created for television. *Batman: The Animated Series* had its premiere in September 1992 and immediately established higher standards for afternoon TV. An exceptionally stylish synthesis of the best elements from generations of comics and films, the show also benefited from striking character design and came as close as any artistic statement has to defining the look of Batman for the 1990s.

When word first came down that Warner Bros. executive producer Jean MacCurdy had proposed an animated Batman series, artist Bruce Timm

Pages 182–85: A plethora of plastic
was pressed by Kenner between 1985
and 1999 to create an array of Batman
action figures. Nobody else has ever
been so thoroughly accessorized.

jumped at the chance. "I was like on fire and I ran back to my cubicle after the meeting and drew a page of Batman drawings in a theoretically animation style. I brought them to show Jean and she loved them," said Timm. "She put me and Eric Radomski in charge of doing a little two-minute pilot film, so we banged the thing together in a couple of weeks. It kind of impressed everybody, and on the basis of that she asked us to produce the show." Radomski had painted brooding views of Gotham City on black backgrounds, an unusual approach that proved especially effective. Against these film-noir settings, Bruce Timm placed characters seemingly inspired by comics creators like Kane, Robinson, and Sprang, with a more modern touch of Frank Miller thrown in. Timm, however, reduced these influences to their essence. "One of the things I learned over the years working in animation is that every time we were doing an adventure cartoon, there was always the drive to make the cartoons look more like comic books, and it really worked against what animation does best. The more lines you have on a character, the harder it is to draw over and over. I knew that simplicity would be better," Timm said, especially since the animation would be farmed out to different studios overseas where control would be difficult.

Shortly after the series went into production, Alan Burnett was brought in to serve as senior story editor and co-producer. His judgment about what would work for the show proved invaluable, and he also wrote superb scripts that included the television debut of Two-Face in (naturally) two parts, climaxing with Two-Face's breakdown when the coin he flips to determine his actions is lost in a hail of similar silver pieces. One of Burnett's best decisions was hiring Paul Dini, a writer and story editor who provided outstanding scripts like the Mr. Freeze episode "Heart of Ice"; Dini eventually became so important to the show that he was promoted to co-producer. A unique contribution of the writing staff was to set the show in a mixture of different eras that mirrored the stylistic synthesis of Timm's character drawings. "If it had been up to me I would have set it literally in 1939," said Bruce Timm. "But writers find it really hard to write stories without falling back on computer screens and things like that." So in the series modern technology coexisted with 1940s roadsters and guys in trench coats. These unique choices by writers and artists gave the show a strong personality, and Timm adds that "a relatively high budget" made fuller animation feasible. Other assets included Shirley Walker's atmospheric music and an impressive cast of celebrity voices supervised by Andrea Romano. *Batman: The Animated Series* was so good that the Fox network also ran it for months in prime time to attract an adult audience, and the show went on to win multiple Emmy awards.

*Batman: Mask of the Phantasm,* a feature film based on the cartoon series, was shown in theaters in 1993, but didn't really find its audience until it was released on video as originally intended. Directed by Eric Radomski and Bruce Timm from a story by Alan Burnett, it seems to have been conceived as an animated answer to *Citizen Kane,* with specific shots inspired by the Orson Welles classic and a story about loss and the passage of time presented in a complex flashback structure. Yet it was perhaps the lighter moments that worked best, particularly a twist on the time-tested use of giant props that showed Batman battling the Joker throughout a miniature city designed as an old World's Fair exhibit.

The TV series evolved over the years, making more use of the Boy Wonder and eventually

The Riddler (Jim Carrey) and Two-Face (Tommy Lee Jones) form an uneasy truce to battle Batman in *Batman Forever* (1995).

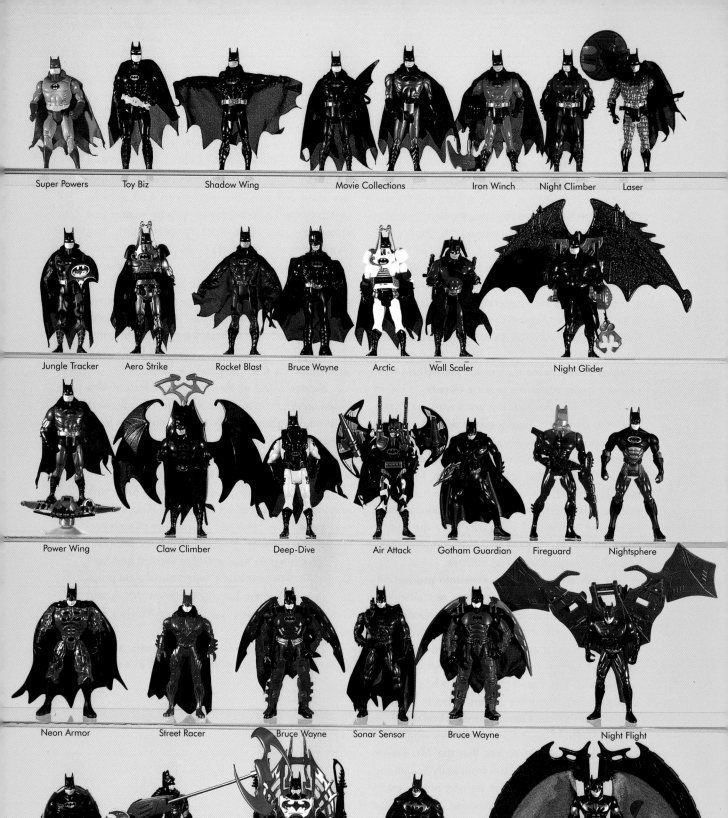

Super Powers    Toy Biz    Shadow Wing    Movie Collections    Iron Winch    Night Climber    Laser

Jungle Tracker    Aero Strike    Rocket Blast    Bruce Wayne    Arctic    Wall Scaler    Night Glider

Power Wing    Claw Climber    Deep-Dive    Air Attack    Gotham Guardian    Fireguard    Nightsphere

Neon Armor    Street Racer    Bruce Wayne    Sonar Sensor    Bruce Wayne    Night Flight

Blast Cape    Batarang    Iceblade    Recon Hunter    Sonar Shield

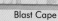

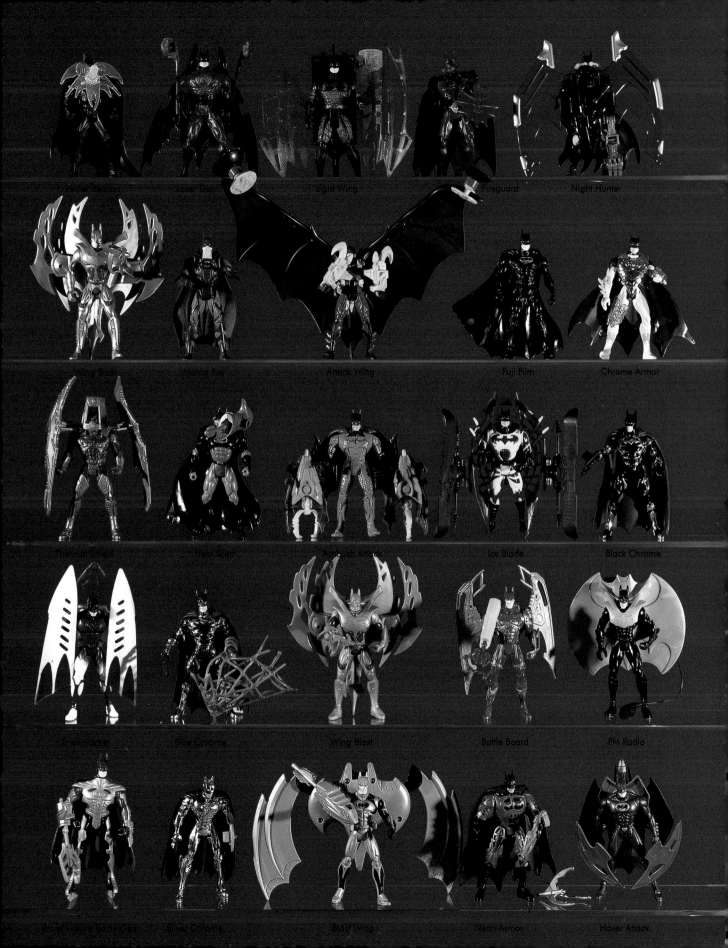

Power Beacon · Laser Disc · Light Wing · Fireguard · Night Hunter

Wing Blast · Manta Ray · Attack Wing · Fuji Film · Chrome Armor

Thermal Shield · Heat Scan · Ambush Attack · Ice Blade · Black Chrome

Snowtracker · Blue Chrome · Wing Blast · Battle Board · FM Radio

Triple Attack Battle Gear · Silver Chrome · Blast Wing · Neon Armor · Hover Attack

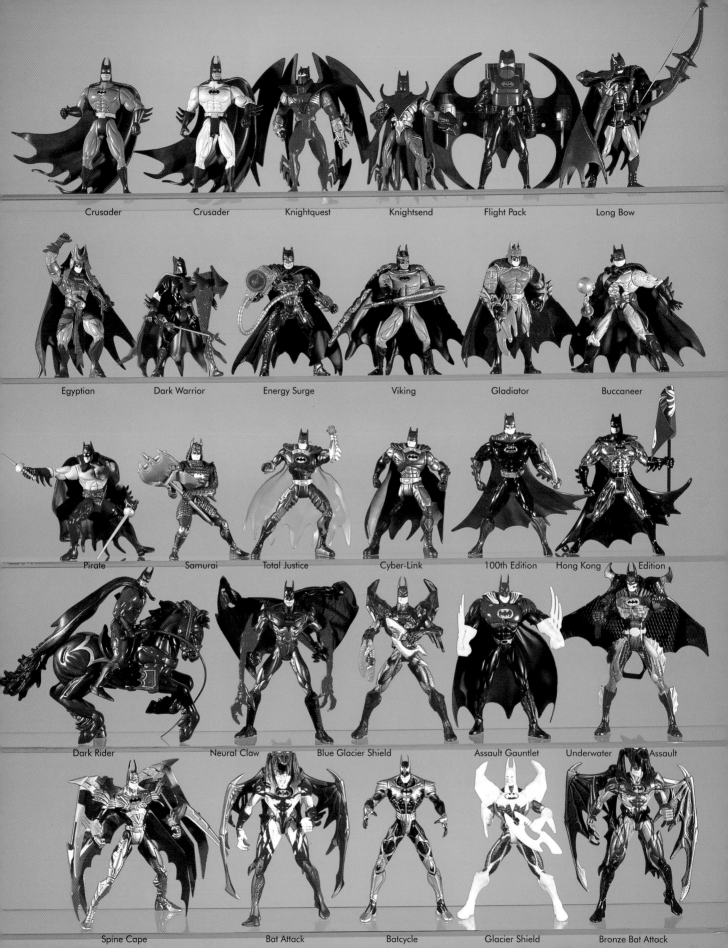

Crusader     Crusader     Knightquest     Knightsend     Flight Pack     Long Bow

Egyptian     Dark Warrior     Energy Surge     Viking     Gladiator     Buccaneer

Pirate     Samurai     Total Justice     Cyber-Link     100th Edition     Hong Kong     Edition

Dark Rider     Neural Claw     Blue Glacier Shield     Assault Gauntlet     Underwater     Assault

Spine Cape     Bat Attack     Batcycle     Glacier Shield     Bronze Bat Attack

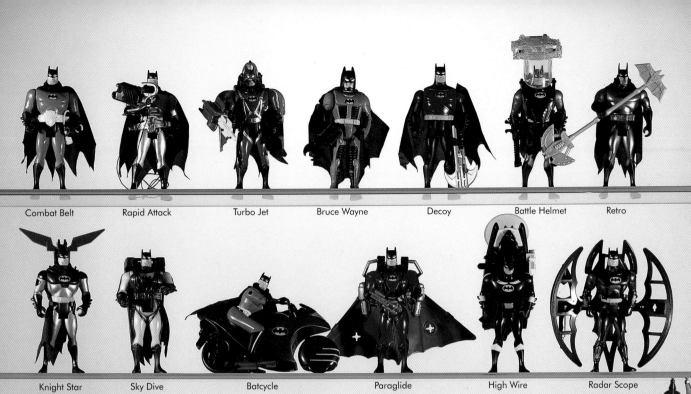

| Combat Belt | Rapid Attack | Turbo Jet | Bruce Wayne | Decoy | Battle Helmet | Retro |

| Knight Star | Sky Dive | Batcycle | Paraglide | High Wire | Radar Scope |

| Piranha Blade | Sea Claw | Air Assault | Vector Wing | Skycopter |

| Lightning Strike | Rocketpack | Cyber Gear | Supersonic | Knockoff | Tornado |

| Land Strike | Bomb Control | Detective | Silver Defender | Nightforce Silver | Street Strike | Knight Glider |

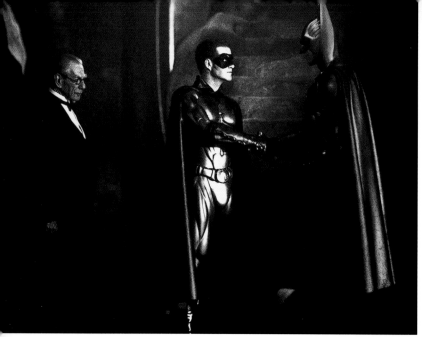

changing its name to *The Adventures of Batman & Robin*. The show went on hiatus after eighty-five episodes, while its creative team went to work on Superman cartoons, but Batman came back with a bang in 1997 when the WB network introduced *The New Batman/Superman Adventures*. The new hour-long show devoted half its time to each hero, except during "World's Finest," a ninety-minute tribute to the old comic book, which showed the Dark Knight and the Man of Steel working together. Modern tastes, however, dictated a certain amount of head-butting and one-upmanship before their uneasy alliance could be formed. The regular Batman episodes, with Superman nowhere in sight, nonetheless provided company for the Caped Crusader courtesy of a young new Robin, Tim Drake, and a revived Batgirl as well. For Bruce Timm, new episodes meant that "I could improve on the original style, because the more graphic and the more angular the designs are, the less they can screw around with them overseas. We've broken it down to even more of a mathematical formula." Timm admits that he "can't even watch" some of the widely admired early shows, but it's that perfectionist attitude that has made him a key figure in basic *Batman*.

The popular animated series led to a DC comic book, *The Batman Adventures*, in October 1992. The first issues, written by Kelley Puckett and pencilled by Ty Templeton, managed to capture the ambience of the show. *Batman Adventures* emerged as a bright, clever comic with attractive art and solid stories that were complete in each issue, a welcome novelty at a time when narratives were often serialized for months or even years. Eventually Paul Dini and Bruce Timm got into the act with their one-shot *Mad Love* (1994), winner of two awards as the best comic book of the year. "I always wanted to be a comic book artist," admitted Timm. "I figured I'd just work in animation until I got better." *Mad Love* featured the most popular figure created for the cartoons, the Joker's long suffering but eternally optimistic gun moll, Harley Quinn. "We really like the character," said Timm, and when Dennis O'Neil offered the opportunity to contribute to the comics, Dini and Timm created *Mad Love* as the back story of Harley, an Arkham Asylum psychiatrist gone wrong. "I'm pretty proud of it," said Timm, and Harley has now been adopted into the mainstream *Batman* comics.

The *Batman* cartoons were sometimes surprisingly serious, but at the same time the *Batman* feature films were becoming increasingly cartoonish. Joel Schumacher, the director of the third film in the series, said he wanted to create "a living comic book, and I think the word *comic* is important." A key factor in determining the tone of *Batman Forever* (1995) was the choice of the hot young comedian Jim Carrey to portray the Riddler. Ignoring the comparatively sneaky comic book villain, Carrey clearly based his performance on the hyperactive version of the Riddler created by Frank Gorshin for the TV series, but Carrey's interpretation was hyperactivity cubed. "His physical capabilities seem to come from another universe," observed Schumacher, and there is little doubt that Carrey's charisma was a key factor in the big box office returns for *Batman Forever*. In what was becoming a

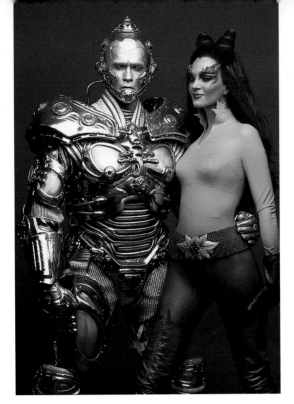

More big stars being bad guys: Uma Thurman as Poison Ivy and Arnold Schwarzenegger as Mr. Freeze in *Batman & Robin* (1997).

187

tradition, there were two villains, but not even Tommy Lee Jones could make too much of Two-Face, who, in the script by Lee Batchler, Janet Scott Batchler, and Akiva Goldsman, lacked most of the qualities that make him potentially the most tragic and terrifying of Batman's foes.

*Batman Forever* also introduced Robin, played by Chris O'Donnell, to the series. As in the early comics he was Dick Grayson, a circus acrobat, but the film piled on the punishment by having his brother as well as his parents murdered on the job (Two-Face got the blame). The scenes under the big top were spectacular and suspenseful, although Schumacher threw caution to the winds by showing Bruce Wayne fighting like Batman without bothering to put on the suit. Nicole Kidman was on hand as the token love interest for the hero, who as usual lasted for only one film. Such details went largely unnoticed, however, in a loud, fast, flashy film full of stunts and special effects, which tended to overshadow actor Val Kilmer in his only outing as Batman.

By the time Schumacher's *Batman*

*& Robin* appeared in 1997, critics had become increasingly skeptical about the series; in fact even the title was a misnomer that should have appeared on the previous entry, since *Batman & Robin* was notable as the feature that introduced Batgirl (Alicia Silverstone). As usual, Batgirl's appearance suggested a degree of desperation. "Alicia's very popular, especially with the young audience," said Schumacher, "and I thought it would be nice to give them a young heroine who was as intelligent and as strong-willed and dedicated to justice as the men." Three good guys seemed to mean three bad guys, including Mr. Freeze (Arnold Schwarzenegger), Poison Ivy (Uma Thurman), and, virtually unpublicized, Bane (Jeep Swenson), once Batman's most merciless menace but here merely muscle for Ivy.

Akiva Goldsman's screenplay seemed somewhat arbitrary in bringing all these characters together, but the visual razzle-dazzle was even more sensational than before. Television star George Clooney was this outing's Batman, bringing along a modicum of his charm but little commitment. Schwarzenegger, a bona fide action star, got top billing on the basis of his track record, but explained "you can only move so much with this heavy armor I have." The combined star power was enough to bring in the bucks, however—especially overseas, where nuances of language or personality were likely to be lost in translation and

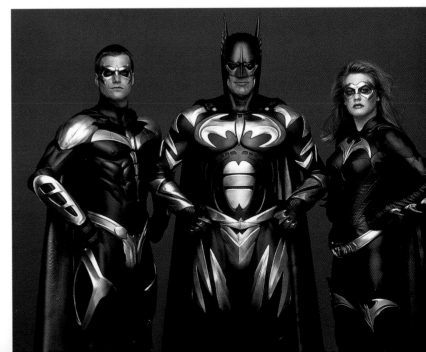

Chris O'Donnell, George Clooney, and Alicia Silverstone model the latest crime-fighting fashions for *Batman & Robin*.

Acclaimed French artist Moebius contributed this drawing to *Batman Black and White.*

Bottom left: Writer Neil Gaiman makes Batman and the Joker cynical show-biz types in *Batman Black and White #2* (July 1976). Art by Simon Bisley.

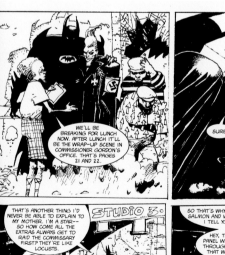

admittedly eye-popping spectacle seemed sufficient. The film's finest performance was provided by veteran actor Michael Gough, returning for his fourth outing as an ailing Alfred, and providing *Batman & Robin* with a welcome human touch. Batman's temporary girlfriend, Julie Madison, played by extremely photogenic Elle Macpherson, barely got on camera.

Meanwhile, the comic books continued to make their mark with a wide range of Batman stories. *Batman Adventures,* the animation-based title, evolved into *Batman & Robin Adventures* (November 1995), and then *Batman: Gotham Adventures* (June 1998), carrying on the tradition of bright, brisk, well-told tales. A new quarterly title, *The Batman Chronicles,* launched in July 1995, contained several complete short stories, a varied format recalling the early days of comic books. Something of the same impulse was behind the award-winning four-issue miniseries, *Batman Black and White* (1996). Editors Mark Chiarello and Scott Peterson intended the series to be a tribute to writer-editor Archie Goodwin, who had first come to prominence in the 1960s by writing eight-page scripts for the black-and-white magazine *Creepy.* Given the limited commitment involved in such short work, *Batman Black and White* attracted an extraordinary roster of creators, including Goodwin himself. Among the highlights was "A Black and White World," drawn by eccentric stylist Simon Bisley from a script by Neil Gaiman, who had become the era's most honored comics writer with his provocative fantasy series *Sandman.* In this postmodern, Pirandelloish tale, both Batman and Joker are portrayed as professional entertainers, talking shop behind the scenes while wearily preparing to stage yet another fight for their audience. Equally surprising for different reasons was Bruce Timm's "Two of a Kind," which he called "a really horrible Two-Face story with lots of sex and violence," but drawn in the fashion of his much more innocent TV cartoons.

Pages 189–96: Drawn in identically shaped panels like a TV storyboard, Bruce Timm's "Two of a Kind" uses an ingratiating art style to tell one of the grimmest Batman stories, about a criminal so damaged he hardly needs a nemesis. Timm has added shading to the line drawings originally published in *Batman Black and White #1* (June 1996).

SHE WAS THE PRIDE OF GOTHAM CITY...

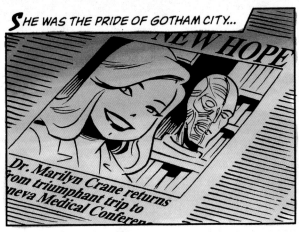

AS BRILLIANT AS SHE WAS BEAUTIFUL...

HER INNOVATIVE, STATE-OF-THE-ART PLASTIC SURGERY TECHNIQUES, COMBINED WITH THE LATEST ADVANCES IN PSYCHO-THERAPY...

...ACCOMPLISHED WHAT *BATMAN* AND THE ENTIRE GOTHAM POLICE FORCE NEVER COULD--

--THE COMPLETE DESTRUCTION OF THE CRIMINAL MASTERMIND, *TWO-FACE.*

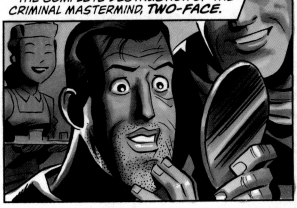

IF I'D KNOWN THEN HOW IT WOULD ALL TURN OUT...

...I WOULD NEVER HAVE LET HER FALL IN LOVE WITH ME...

# TWO
## OF A KIND

STORY/ART - BRUCE TIMM
LETTERS - TODD KLEIN

①

THE TABLOIDS HAD A FIELD DAY WITH IT, OF COURSE. ON THE DAY OF MY RELEASE FROM ARKHAM...

...A WELL-CONNECTED *FRIEND* OF MINE ARRANGED TO HAVE ME SMUGGLED OUT THE REAR ENTRANCE, TO AVOID THE MEDIA CIRCUS OUTSIDE...

THANKS FOR EVERYTHING, BRUCE.

YOU STAY OUT OF TROUBLE NOW, PAL.

I'LL BE KEEPING AN *EYE* ON YOU...

*G*OOD OL' BRUCE...!

*N*OT SURPRISINGLY, THE D.A.'S OFFICE DIDN'T WANT TO HAVE ANYTHING TO *DO* WITH ME, BUT I MANAGED TO LAND A POSITION WITH ONE OF THE SMALLER LAW FIRMS...

*I*T WAS HARDER THAN HELL, ADJUSTING TO "NORMAL" LIFE. I NEVER WOULD HAVE MADE IT WITHOUT MARILYN...

*G*OD...SHE WAS SO *RADIANT* THAT DAY, WHEN WE WENT SHOPPING FOR WEDDING RINGS...

WHY, MARILYN, *DEAR*--

--WHERE *HAVE* YOU BEEN HIDING THIS *GORGEOUS* HUNK OF MAN?

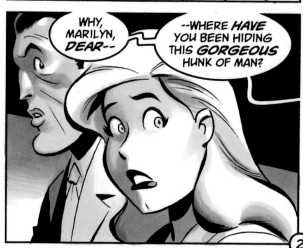

MADELINE--!

HARVEY--THIS IS MY... MY *SISTER*...I...

WE HAVE TO GO--!

OF *COURSE* YOU DO, DARLING!

'BYE, HARVEY!

SEE YOU *SOON*...

I *WANTED* TO TELL YOU...I *SWEAR* I DID...

...THE PSYCHOLOGISTS WERE AFRAID THAT IF YOU KNEW I HAD A *TWIN SISTER*, IT WOULD IGNITE TWO-FACE'S OBSESSION WITH *DUALITY*...

...ESPECIALLY SINCE MADELINE... SHE...SHE'S BEEN IN AND OUT OF INSTITUTIONS HER WHOLE LIFE...

SHE ALWAYS HATED ME. ON OUR ELEVENTH BIRTHDAY SHE BROKE A POCKET MIRROR INTO LITTLE PIECES AND SLIPPED THEM INTO MY MILK. I ALMOST DIED...

GOD, HARVEY, I'M SO SORRY...

*PLEASE*... TELL ME YOU'RE GOING TO BE OKAY...

I LIED...TOLD HER I'D BE FINE. WHAT *ELSE* COULD I DO?

3

I TRIED TO FIGHT IT, BUT I COULD FEEL MY PERFECTLY-ORDERED WORLD STARTING TO UNRAVEL. THEN...THAT NIGHT...

KNOCK, KNOCK!

I THOUGHT YOU MIGHT LIKE TO TREAT YOUR FIANCÉE TO A LATE SUPPER...?

LOVE TO, HONEY, BUT I HAVE TO FINISH THIS BRIEF BEFORE TO-MORROW'S SESS...

MARILYN--!?

C'MON, LOVER...

GIVE US A KISS...!

VERY FUNNY, MADELINE.

GO PLAY YOUR SICK GAMES SOMEWHERE ELSE.

I'LL BET LITTLE MISS GOODY-TWO-SHOES DOESN'T KISS YOU LIKE THAT...

SHUT YOUR MOUTH, YOU LITTLE TRAMP--!

YOU'RE HURTING ME.

IT'S OKAY, BABY-- --I *LIKE* IT ROUGH.

THE ABYSS YAWNED BEFORE ME...AND...

...I....

...FELL...

*POOR MARILYN NEVER SUSPECTED...WHILE SHE HAPPILY PRATTLED ON AND ON ABOUT OUR WEDDING ARRANGEMENTS...*

...I COULDN'T HELP THINKING HOW WONDERFUL HER SISTER WOULD BE IN BED LATER THAT NIGHT. I REALIZED THERE WAS ONLY ONE THING TO DO...

IT'S OVER. IF YOU TRY TO TELL MARILYN ABOUT US, I'LL DENY IT EVER HAPPENED.

*OH,* NO... THAT UGLY LITTLE BITCH HAS BEEN TAKING WHAT'S MINE SINCE THE DAY SHE WAS BORN. WELL--

--*NOT THIS TIME!*

I'LL SEE HER IN *HELL* FIRST--!

I WENT BACK TO MY PLACE AND TRIED TO PUT IT OUT OF MY MIND. CRAZY BROAD! STILL...SOMETHING ABOUT HER TONE WAS GIVING ME THE WILLIES...

I GOT NOTHING BUT BUSY SIGNALS WHEN I TRIED TO CALL MARILYN.

I TRIED TO RELAX, TO CONVINCE MYSELF I WAS JUST BEING PARANOID...BUT TWO HOURS LATER, I WAS STILL GETTING BUSY SIGNALS FROM HER GODDAMNED PHONE...

MY HEART WAS POUNDING TO BEAT THE BAND AS I RACED TO HER APARTMENT...

I TOOK THE STAIRS THREE AT A TIME, BUT ALREADY I KNEW THAT I WOULD BE...

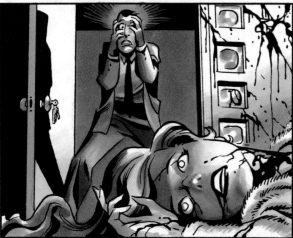

...TOO LATE.

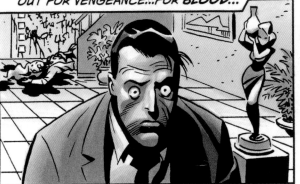

I STAGGERED ABOUT THE APARTMENT, MY MIND WHIRLING...EVERY FIBER OF MY BEING CRIED OUT FOR VENGEANCE...FOR **BLOOD**...

BUT...I WAS **CURED**. THAT'S RIGHT. THAT'S WHAT THEY SAID. CURED. **SANE**. HARVEY DENT WAS NO KILLER...

FORTUNATELY...

...I KNEW SOMEONE WHO **WAS**...

*AAAK RRHH*

SOMEHOW, SHE FOUND ME.

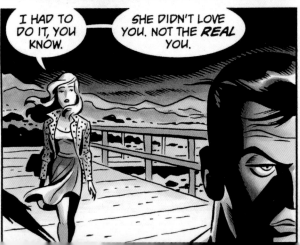

I HAD TO DO IT, YOU KNOW.

SHE DIDN'T LOVE YOU. NOT THE **REAL** YOU.

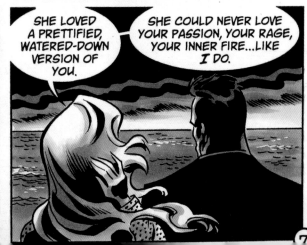

SHE LOVED A PRETTIFIED, WATERED-DOWN VERSION OF YOU.

SHE COULD NEVER LOVE YOUR PASSION, YOUR RAGE, YOUR INNER FIRE...LIKE **I DO**.

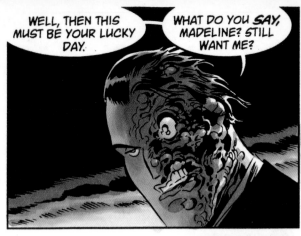

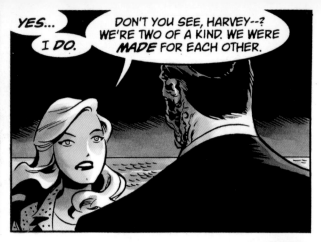

The regular Batman comics are currently caught up in another long-term, multiple-issue event called *No Man's Land,* depicting the havoc wrought by an earthquake in Gotham City. "It is, in a lot of ways, the most ambitious thing we've ever undertaken," said Dennis O'Neil, "and it's a story we've never told before. It's an absolutely glorious opportunity for us to fall on our faces, but I do think from time to time you have to undertake something you're not sure you can bring off." Not only are Gotham's landmarks destroyed, including the Batcave, but in *No Man's Land* the federal government writes the city off as an impossibly costly lost cause, effectively turning the ruins over to Gotham's ungodly gaggle of goons. "It's the story of about two dozen very gallant people saying, 'We're not going to let the bad guys have the city. We're going to take it back,'" said O'Neil.

*No Man's Land* was basically the brain-child of editor Jordan B. Gorfinkel, and he explained that "each story takes place in a different section of Gotham that's like a little fiefdom." Each segment will feature a different creative team, ranging from regulars to new recruits like screenwriter Bob Gale. "Readers will get quicker gratification," said Gorfinkel. "You can tune in or out, but if you stick with it you'll get the richness, the various layers of the tapestry." Writer Chuck Dixon confessed, "I was really upset when they said we're just going to fill in the Batcave. I don't think we will ever go back to the status quo we all knew, but I see the reason for what they're doing to shake things up."

"Batman naturally goes through an evolution every decade or so," said Jordan Gorfinkel. "He is one of the most popular continuing characters in fiction, and the way to keep him that way is to figure out what the future is."

Another recent project took that idea literally, attempting to envision a role that might suit Batman

in the years to come. Writer Mark Waid and artist Alex Ross predicted a dystopia, with super heroes at war with one another, in the powerful and popular miniseries *Kingdom Come* (1996). In realistically rendered paintings with substantial impact, Ross showed an aged, ambiguous, battered Batman, reduced to patrolling Gotham aided by an army of awesome robots.

On a more upbeat note, the *Batman* animation team launched a new television series, *Batman Beyond,* early in 1999. Producers Bruce Timm, Paul

The Batcave collapses as an earthquake takes its toll on Gotham in the series *No Man's Land.* Script by Alan Grant, pencils by Mark Buckingham, and inks by Wayne Faucher for *Batman: Shadow of the Bat #73* (April 1998).

SCENE                              B.G.                      SC                          B.G.

Dini, and Alan Burnett became involved in the futuristic *Batman Beyond* after a new show was requested that might skew toward younger viewers. "In desperation we came up with the concept for *Batman Beyond,* which we thought was the only thing we could do that would reinvent the character without wrecking the continuity we had done," said Timm. They invented the idea of an eighty-year-old Bruce Wayne, living fifty years from now, passing on his knowledge to a jet-powered young successor. "There was the opportunity to do more of a science-fictional Gotham City, and the more we talked about it the more we liked it," said Timm.

Bruce Timm created the *Batman Beyond* character drawings on these pages. Glen Murakami drew the color storyboards and the original Batman concept drawings at far left.

This Alex Ross painting for the futuristic
dystopia *Kingdom Come* (1996) shows
one of the gigantic robots that an aging
Bruce Wayne uses to maintain control of
Gotham City.

Original 1997 concept sketch by
Alex Ross for a Batman graphic novel.

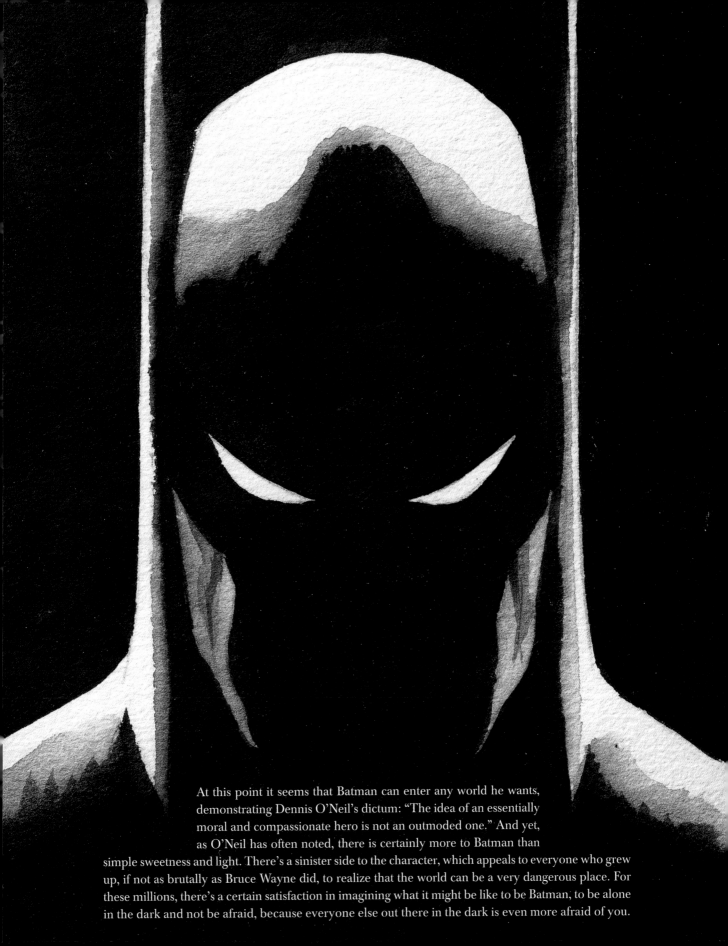

At this point it seems that Batman can enter any world he wants,
demonstrating Dennis O'Neil's dictum: "The idea of an essentially
moral and compassionate hero is not an outmoded one." And yet,
as O'Neil has often noted, there is certainly more to Batman than
simple sweetness and light. There's a sinister side to the character, which appeals to everyone who grew
up, if not as brutally as Bruce Wayne did, to realize that the world can be a very dangerous place. For
these millions, there's a certain satisfaction in imagining what it might be like to be Batman, to be alone
in the dark and not be afraid, because everyone else out there in the dark is even more afraid of you.

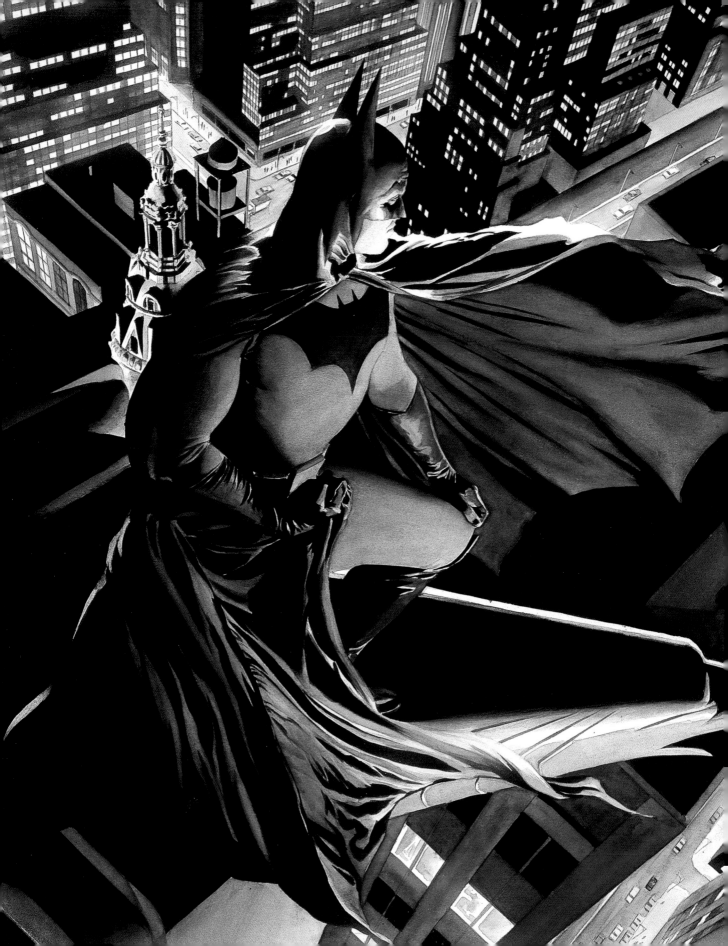

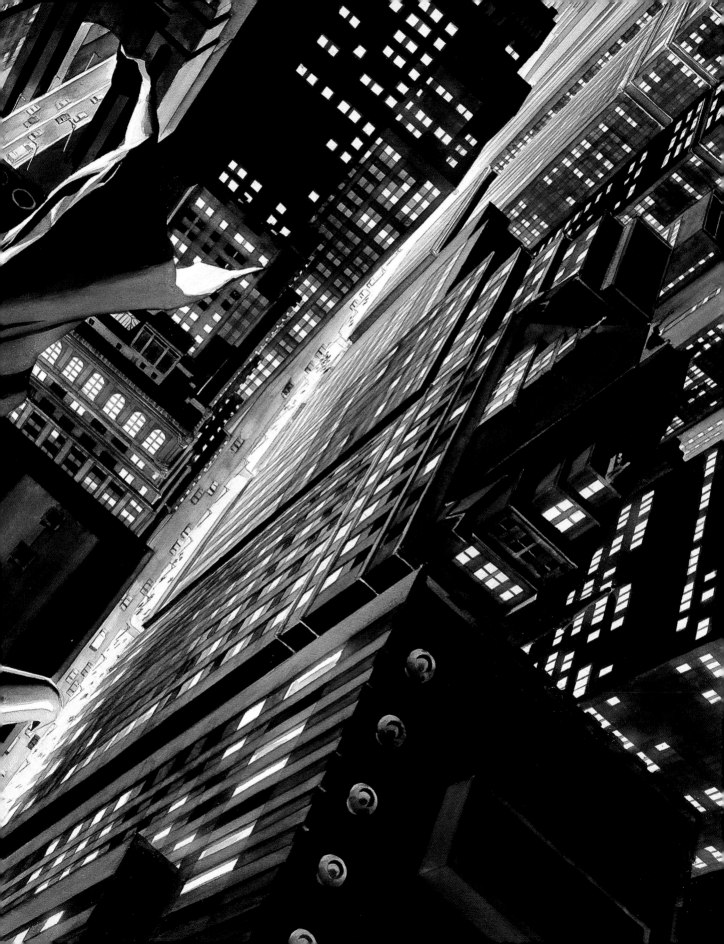

# ACKNOWLEDGMENTS

Not even Batman really works alone, and this book about him includes contributions from a whole army of heroes. Notable among them are the recurring team of talents who are starting to look like some sort of perennial Justice League. Thanks to Chip Kidd for his dynamic designs, Geoff Spear for shooting relics from the Batcave, Chin-Yee Lai for much appreciated design assistance, Alex Ross for the striking paintings under the dust jacket, and to Steve Korté, an exceptional editor, a real Batman fan, and a good friend.

The text could hardly have been prepared without the participation of many gifted contributors to the Batman saga, all of whom generously granted interviews: the late Bob Kane, the late Vin Sullivan, and Gene Colan, Chuck Dixon, Irwin Donenfeld, Dick Giordano, Jordan B. Gorfinkel, Bob Haney, Kelley Jones, Michael Keaton, Paul Levitz, Todd McFarlane, Frank Miller, Sheldon Moldoff, Dennis O'Neil, Jack Schiff, Julius Schwartz, Dick Sprang, Bruce Timm, and Len Wein. Bruce Timm also contributed an elegantly enhanced version of his Two-Face story, and Harry Colomby kindly helped to set up the Michael Keaton interview.

Countless comic book creators, critics, and collectors made the fruits of their expertise available for our research. DC librarian Allan Asherman was once again a pillar of strength and a purveyor of sage suggestions. David Anderson allowed us to photograph his astonishing array of toys, and the Mad Peck Studio Archives kept their creaking doors wide open. Will Murray provided pearls of perspicacity on pulps, while Anthony Tollin came up with precious pulp covers and proclaimed the last word on old radio. Randy Scott at Michigan State University, Dana Hawkes at Sotheby's, and Bill Jourdain supplied us with rare art. Marc Witz took fine photographs of antique newsprint. Invaluable help was also offered by Mike Chandley, Jon B. Cooke, Ray Kelly, B. Koppany III, Jim Mooney, Rich Morrissey, Martin O'Hearn, Rick Roe, Albert Silverstein, Mike Tiefenbacher, and Rob Yeremian, and by two of the industry's legendary figures, Jerry Robinson and Roy Thomas. The manuscript was perused by a pair of notable sticklers for detail, Joe Desris and Mark Waid, but they are certainly not to blame for any errors that may have crept in anyway.

At Chronicle Books, thanks are due to Sarah Malarkey and Mikyla Bruder in editorial, to Shawn Hazen and Michael Carabetta in design, and to Jason Mitchell in publicity. And at Writers House, my agent, Merrilee Heifetz, remains a fearless champion of the underdog.

The kind souls who selflessly helped this book along at DC Comics include Ed Bolkus, Georg Brewer, Richard Bruning, Marc Campbell, Mark Chiarello, Dorothy Crouch, Marilyn Drucker, Trent Duffy, Chris Eades, David Erwin, Eric Fein, Lawrence Ganem, Bob Greenberger, Patty Jeres, Alyssa Kaplan, Charles Kochman, Jay Kogan, Lillian Laserson, William Ortiz, Sandy Resnick, Jesus Reyes, Cheryl Rubin, David Tanguay, Elisabeth Vincentelli, Darren Vincenzo, and Cindy Yeh. All of them are greatly appreciated.

And this book about Batman is dedicated with affection to Lynn Brooks, someone who also looks great in black.

Overleaf: Painting by Alex Ross for
*Batman: War on Crime* (January 2000).

# INDEX

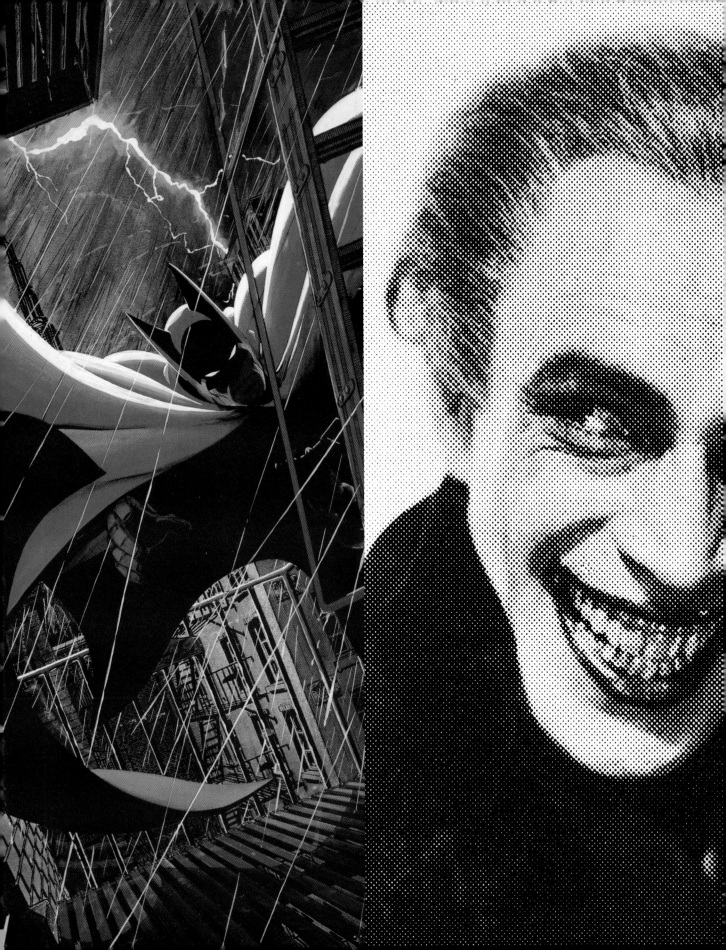

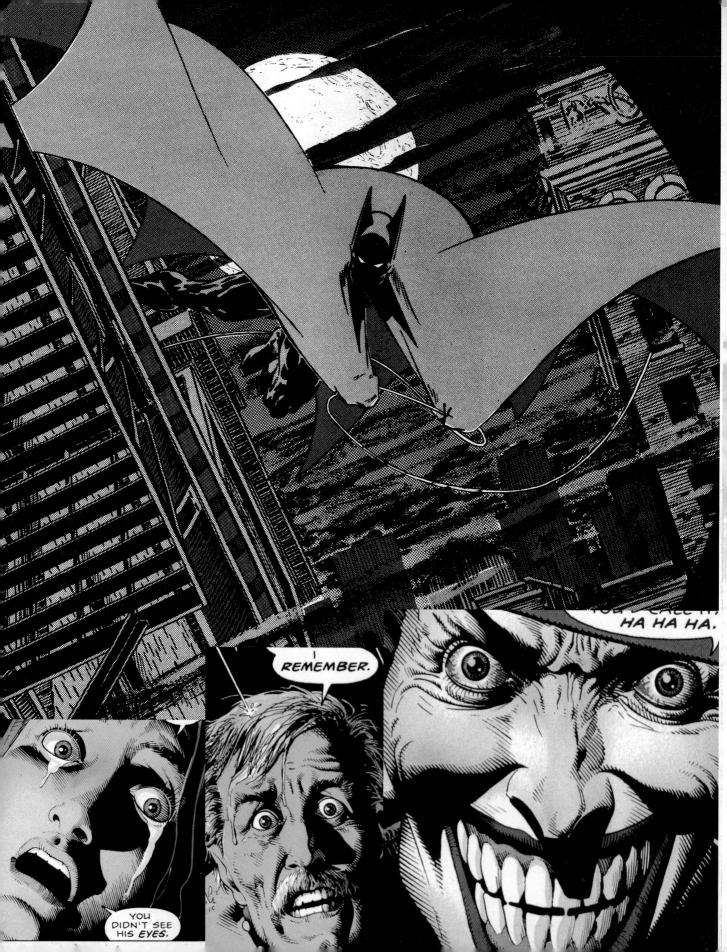